Photoshop 7.0

A *to* Z

The essential visual reference guide

Peter Bargh

Focal Press

OXFORD AMSTERDAM BOSTON LONDON NEW YORK PARIS
SAN DIEGO SAN FRANCISCO SINGAPORE SYDNEY TOKYO

Words and design: Peter Bargh
All photographs: Peter Bargh, unless stated
e-mail peter@bargh.co.uk

Focal Press
An imprint of Elsevier Science
Linacre House, Jordan Hill, Oxford OX2 8DP
225 Wildwood Avenue, Woburn MA 01801-2041

First published 2002

British Library Cataloguing in Publication Data
A catalogue record for this book is available from the British Library

Library of Congress Cataloguing in Publication Data
A catalogue record for this book is available from the Library of Congress

ISBN 0 240 51912 4

For information on all Focal Press publications visit our website at:
www.focalpress.com

Thanks to:
Jeremy Cope at Adobe PR, for helping me become a beta tester for version 7.0.
Marie Hooper at Focal Press, for her encouragement.
Steve Handley, for his initial design concept.
Katie Teesdale, for her love, happiness, support and gravel.

And finally, a special thank you to everyone who made
Photoshop 5.5 and 6.0 A to Z a huge success.

This week I have mostly been watching Fitzcarraldo.

Printed and bound in Italy

Contents

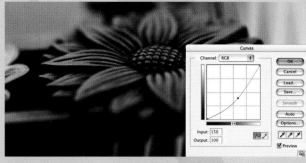

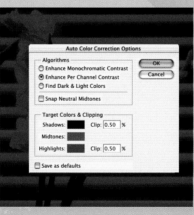

Introduction

Photoshop is, arguably, the most complex image editing program sold, but it's equally the most versatile when you become familiar with its tools and functions. Many of the reference books written about Photoshop are as complex as the program, but they don't have to be. *Photoshop 7.0 A to Z* has been produced to present the program in a visual way and in a logical order.

It's too easy to get lost wading your way around a 300 page book trying to find out how a certain feature works. In this book you look up the mode, tool or filter, presented in a logical A to Z order, to find a visual reference with handy tips and quick keys.

The book can be used as a helpful guide to keep near your computer, giving you nuggets of essential information as you work. It will also give you plenty of ideas to try out on your own pictures.

It's really important when working with a program like Photoshop that you set it up to work better for you. To do this there are a selection of preferences that are used to take the program off the original settings and customize it to your liking. I've include an explanation of all these in the appendix, along with an area where you can make notes of filter settings.

Because of the logical steps Adobe have made with their upgrades, this book is also suitable for owners of earlier versions of the program; there's a comparison of all the versions of Photoshop, including LE, and the new budget program from Photoshop called Elements in the appendix.

As an English author I would naturally prefer to use English spellings, for example colour instead of color, but as the book will be sold throughout the world I've adopted the US spelling for the word color. This ensures the book is consistent with the Photoshop users' manual and interface.

I've also used Apple Mac commands throughout the book along with Mac screengrabs from OSX, simply because I've used a Mac for years in favour of the PC. Essentially Photoshop runs the same whichever platform you work on. The main difference is when a keyboard shortcut includes the Command key on a Mac you would use the Ctrl key on a PC. Similarly when the Option key is used on a Mac the Alt key should be used on the PC, and the Return key on the Mac is Enter on the PC. You'll also see subtle differences in the look of palettes on a Mac over a PC, but all the options are in the same place. Enjoy!

Pete Bargh

Peter Bargh, 2002

Actions

MENU **WINDOW →**
 ACTIONS

QUICK KEY **F9**

An action is a way of automatically applying a technique to an image using a pre-recorded series of commands, or a

You can turn part of an action on or off, as well as record, play or edit new or existing actions.

script, that is triggered by pressing one or a combination of keys. Many actions are already supplied with Photoshop and can be found at the bottom of the Actions menu by clicking on the arrow at the top right of the Actions palette. They can also

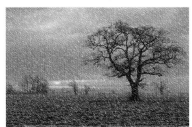

be found in the Presets folder. An action can be as simple as opening a new canvas or as advanced as creating a drop shadow on an existing picture or, as in our example (left), making snow.

You can also create your own Photoshop actions using the Automate mode, so if there are techniques you find particularly fiddly or ones you'll want to use again, record the commands as you run through them and assign the action a shortcut key.

To record a new action open an image and select New Action from the hidden menu or click on the page icon at the bottom of the palette. This

displays a new palette. Name your action, choose a destination folder, a shortcut key and a color for the button display.

The shortcut can be a single F button or any combination of an F along with Shift and Control keys. Click on the record button and run through the various steps to produce the desired result. You'll see each step appear in the menu as it's recorded. When you've done click stop.

Now when you want to apply the recorded effect just click on the designated shortcut key. Actions can also be applied to several images in one go using the Batch command or created into droplets. **(See Batch command and Droplets)**

Tips

● If a command cannot be recorded you can insert it manually using the Insert Menu command.
● If you make a mistake, keep going, you can edit the script later.
● Some settings may need modifying for different images. Clicking on the box to the left of the action will stop the script at that point and bring up the dialogue box so you can manually adjust before continuing the script.

Active layer

This is the layer that is currently selected. To select a layer click on the layer icon in the layers palette. The layer will become highlighted and when a filter effect or brush is applied it will only affect the highlighted layer.

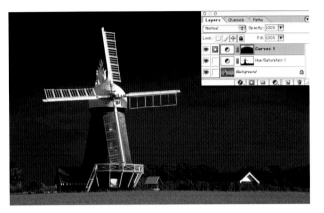

Airbrush

A painting tool that applies a color in much the same way as a real airbrush. Photoshop 7.0 has removed the airbrush from the toolbar and added it to the brush options bar. Now you simply choose airbrush as a style and select how you want it to work from the brush palette.

Hold down the mouse and drag it around to spray color evenly onto the canvas. Hold it in the same place and color builds up while spreading outwards. Covering an area that's already sprayed increases color depth.

As with all brush modes you can specify size, blending mode and opacity from the bar that appears at the top of the page when you click on a brush tool. There's also an option to adjust flow.

Tips

● Select a start point, hold down the Shift key and click an end point to paint a straight line.
● Use the Airbrush on low pressure with black paint to create shadows.
● Switch on Caps lock to turn the Airbrush standard cursor into a precision crosshair.

Adjustment layer

MENU LAYER →

NEW ADJUSTMENT LAYER →

An adjustment layer is a layer that you can apply effects to that will change all the layers below it in the stack. If you then turn off the eye icon next to the layer it will turn off the effects for that particular adjustment layer. It's great for hand coloring black & white pictures as well as controlling levels or curves.

You can delete these layers at any time to remove the effect.

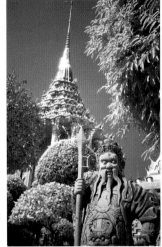

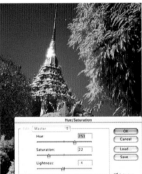

A Hue/Saturation Adjustment layer was used to color this infrared black & white original. Make a selection of an area and save it as an Adjustment layer. You can then adjust the color of just that selection without affecting the rest of the picture, as illustrated here. At this stage I was trying out a violet colored temple.

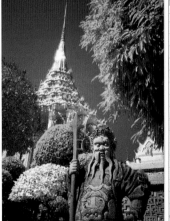

The finished picture. Each of the 15 layers can now be changed to alter the color of individual elements within the picture. And as each layer has a mask you can change the area colored using the Brush and Erasor tools.

Tip

● In Version 5.5 open from Layer→New→Adjustment Layer.

a

Alpha channels

Are ideal for saving selections separate from the RGB or CMYK channels. Carefully draw round a subject and chose Select→Save Selection once you're happy with the selection. This is then stored at the bottom of the Channels palette as a separate channel, known as the Alpha channel.

It can be recalled and the selection applied to the image at any time by calling up Load Selection from the Select menu. This saves you having to reselect a subject later. Up to 21 Alpha channels can be added to an RGB image allowing you to produce very complex selections that can be recalled to make changes to a variety of detailed parts of the image at any time.

Alpha channels can also be used to store fifth color info for special printing jobs.
(See Channels)

Tip
● Alpha channels can be combined to add selections together.

Anchor points

QUICK KEY J SELECTS IT
FROM TOOLBOX

The small square boxes that are placed around an object when you make a selection with the Pen tool. The points can be moved when they've been placed using the Direct Selection tool.

Anti-aliasing

Aliasing occurs when the sharp edges of pixels appear jagged on the straight edges of an image or text.

Photoshop uses anti-aliasing to smooth out the edges by making the pixels semi-transparent so that they pick up color from surrounding pixels. It's useful when cutting or copying and pasting selections onto new backgrounds. Anti-aliasing can make the image look a little blurred when viewed close up.

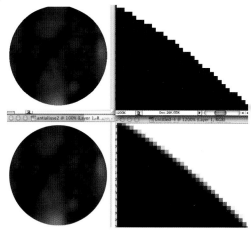

Pixels make round edges look jagged. Using anti-aliasing smooths the 'jaggies' by adding midtone pixels to the harsh edge. Here two circular selections have been made – one with anti-aliasing on (bottom) and one with it off (top). Then the selections were copied and pasted onto a white background. Notice how sharp the top cutout looks.

Apply image

MENU IMAGE →
APPLY IMAGE

Used to blend one image layer and channel with another. The source and destination image have to be the same size. I found the effect works well using the same image with the blend option. It's very much a trial and error process but well worth the effort as seen here as I've appeared to change the season in one simple step. **(See Calculations)**

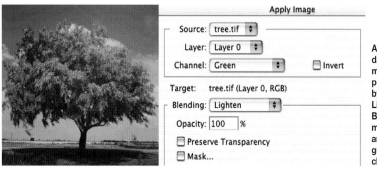

A winter day, made possible by the Lighten Blend mode and green channel.

 Brush: 21 | Mode: Normal | Opacity: 100% ▶ | Style: Tight Short | Area: 50 px | Tolerance: 0% ▶

Art History Brush

QUICK KEYS **SHIFT+Y ALTERNATES BETWEEN HISTORY AND ART HISTORY BRUSHES** A feature first seen in version 5.5 that will appeal to artists as, with a little experimentation, it can create some stunning painterly effects.

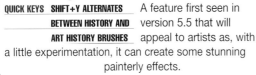

You choose from a variety of patterns and select the Blending mode and opacity before painting over an existing image. The more you paint over the same area the greater the effect. The larger the brush size the bigger the paint daubs and less realistic the effect.

Colorful images like this is suitable for the Art History Brush attack.

Setting Fidelity to a low value produces brush strokes that have more color than the source point (left). A high value maintains the source color (right).

Tip

● Using one of the other custom brushes from Photoshop's Goodies folder will produce more unusual results.

Here the cross brush was used to give a pastel/starburst effect.

With a small brush and careful choice of the palette options paint effects can be quite realistic (above).

Choose too large a brush size and the effect could go completely wrong (left). You could use this sort of treatment as background to text, though.

Try filling the picture with a color (black in the example above) and paint from the previous history state on the colored fill.

(left) Although this isn't a particularly stunning example (I never said I was a painter!) it shows you can get depth by painting over larger brush strokes.

a

Artifacts

Digital photography, like any form of image capture, can produce faults. In digital photography they're referred to as artifacts and can be caused by a number of problems including flare from the camera's lens, electrical interference or low resolution CCDs. Low resolution CCDs cause curved edges to appear jagged as the curve takes on the square edges of each pixel – known as Aliasing.

Blooming is less of a problem now but occurred on earlier CCDs when the electrical charge exceeded the pixel's storage capacity and crossed into adjacent pixels causing image distortion. We've all seen the TV presenter with the stripy shirt appearing as a strange colored pattern. The same thing happens on CCDs and it's known as color fringing.

This photo from a digital camera's economy mode, shows the high level of compression has caused the unusual artifacts in certain areas.

Artistic filters

MENU FILTER ➔
 ARTISTIC ➔
Change your picture into a painterly image using this collection of filters that mimic natural or traditional artists' effects. Each filter has a selection of sliders which I'll explain for the Colored Pencil (below). For the rest I've used the same image and included settings I made, but you should experiment with your photos, because each filter suits different images. Also try using the Edit➔Fade option with a Blend mode.

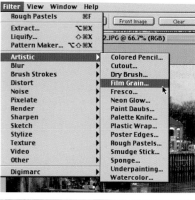

COLORED PENCIL

Produces a rough crosshatch effect by drawing in a pencil style over the original using the background color. Edges are retained and the original background image shows through the pencil strokes. Moving the pencil width slider to the left makes the pencil lines thin while sliding to the right makes them thick.

Stroke pressure controls the accuracy of the lines over the original image. Moving over to the left fills the image with color and to the right produces deep and defined lines.

The paper brightness slider affects the color of the pencil. Move it to the right for the maximum color. Moving the slider to the middle produces a progressively gray pencil effect and to the right it goes black.

Above left: Pencil Width: 9, Stroke Pressure: 4,
Paper Brightness: 0

Above right: Pencil Width: 2, Stroke Pressure: 13,
Paper Brightness: 49

Right: Pencil Width: 2, Stroke Pressure: 4, Paper Brightness: 25, Difference filter 70%

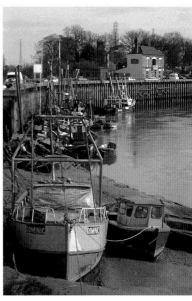

DRY BRUSH
Paints edges using a dry brush technique that appears midway between an oil and watercolor effect. The range of colors is simplified as the filter looks at nearby pixels and blends them into areas of common color.
Brush Size: 9, Brush Detail: 9, Texture: 2

CUTOUT
Builds up the image as though it's created by a collage of several pieces of torn colored paper. It has a similar look to a posterization effect.
Number of levels: 6, Edge Simplicity: 3, Edge Fidelity: 1

NEON GLOW
Adds a glow to parts of the image. The glow color is selected by clicking the glow box and choosing a color from the color picker.
Size: 12, Brightness: 24, Color: Green, Fade filter 80% with Hue blend mode

FILM GRAIN
Applies a pattern of grain that simulates real film. The higher you set the grain the more like fast film the effect becomes.
Grain: 5, Highlight Area: 5, Intensity: 2

FRESCO
Converts the image into a coarse stippled effect using short, rounded, quickly applied brush dabs. Good for a Classic painting effect. Brush Size: 2, Brush Detail: 6, Texture: 1, Fade filter by 59% and Darker blend mode.

ROUGH PASTELS
Makes an image appear as though it's on a textured background, covered in colored pastel chalk strokes. Stroke Length: 16, Stroke Detail: 5, Texture: Burlap, Scaling: 67%, Relief: 38, Light Direction: Right

a

PAINT DAUBS
A nice effect varied by altering the brush size to between 1 and 50, with a selected brush type that includes simple, light rough, light dark, wide sharp, wide blurry and sparkle.
Size: 7, Sharpness: 10, Brush Type: Simple

PALETTE KNIFE
Similar to cutout, but with more blurred edges to emulate a palette knife style of painting. Will only suit certain images.
Stroke Size: 9, Stroke Detail: 2, Softness: 7, Fade 90% with Darker blend mode

PLASTIC WRAP
Create Terminator style morphing by coating the image with a shiny plastic effect that accentuates surface detail.
Highlight Strength: 19, Detail: 9, Smoothness: 7

SMUDGE STICK
Uses diagonal strokes to smudge or smear the darker areas and soften the image while lighter areas become brighter and lose detail.
Stroke Length: 2, Highlight Area: 7, Intensity: 8

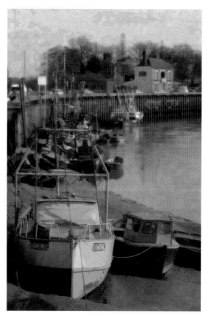

SPONGE
This is supposed to give an appearance of the image being painted with a sponge. Hmmm!
Brush Size: 0, Definition: 8, Smoothness: 13, Fade filter 44% with Luminosity blend mode

UNDERPAINTING
Makes the image appear with a textured background that shows through the surface.
Brush Size: 17, Texture Coverage: 26, Texture: Sandstone, Scaling: 149%, Relief: 6, Light Direction: Top right

POSTER EDGES
Creates poster style effects by reducing the number of colors in the image and adding black lines around edges. Edge Thickness: 10, Edge Intensity: 7, Posterization: 0, Fade 42% with Difference blend mode

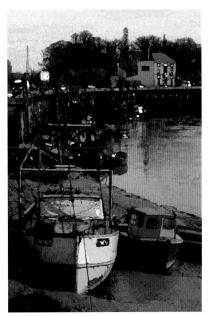

WATERCOLOR
Saturates colors and paints in a watercolor style by simplifying image detail. Can become too contrasty if you're not careful.
Brush Detail: 14, Shadow Intensity: 2, Texture: 3

Tip

● As with most filters and styles once the effect has been applied you can fade the result using the Edit → Fade command and using a Blend mode make the result very different than the original filter effect. Here's a couple of examples using the Artistic filters, but turn to the Fade page for more ways to use this excellent control.

Above Film Grain, Cutout and Dry brush were applied in succession each using fade and a blend mode. Right: Fresco faded followed by a duplicate layer with threshold command and Saturation blend, reduced to 70%. The key is experiment – you never know what will happen.

Assign profile

MENU **IMAGE →**
 MODE →
 ASSIGN PROFILE

An option that lets you select a color profile to your image so that it will always request being opened in this mode or will indicate that a different profile is being used.

Audio Annotation tool

If you have a microphone plugged into the audio-in point of your computer you can record short audio messages and place them on a picture. The annotation appears as a small speaker icon which, when clicked, will replay the recording. This is a great tool for designers who want to leave messages to the next person who will work on the image. It's also open to abuse!
(See Note)

Auto Color correction

MENU	IMAGE →
	ADJUSTMENTS →
	AUTO COLOR
QUICK KEYS	CTRL+SHIFT+B

A new feature in version 7.0 that's accessed by clicking on the Options button from the Curves dialogue box. This window allows you to preset the way that each of the auto correction modes works. Selecting Enhance Monochromatic Contrast clips all channels identically to ensure the photo holds its color values while making highlights appear lighter and shadows appear darker. Applying Auto Contrast from the Image→Adjustments menu has the same effect.

Enhance Per Channel Contrast maximizes the tonal range in each channel.

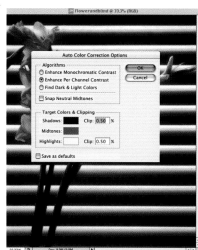

This produces a more dramatic correction, but as each channel is adjusted individually a color cast may be removed or added. Applying Auto Levels uses this algorithm. Find Dark & Light Colors locates the average lightest and darkest pixels and uses these to maximize contrast while minimizing clipping. This happens when the Auto Color command is used.

Tip

● Add the same effect as placing a color filter over the front of you camera, by altering the color of the highlights or shadows. Below left: Here I selected maximum red from the color picker, which has produced a lith style effect. If you looked at the channels now you would see that the green and blue channel thumbnails were black. Below right: Here's the result of a red shadow selection and a green highlights. Don't forget to reset to white or any future auto adjustments will come out wrong.

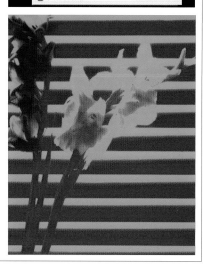

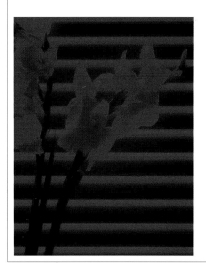

Auto Contrast

MENU	IMAGE →
	ADJUSTMENTS →
	AUTO CONTRAST
QUICK KEYS	CTRL+ALT+SHIFT+L

Auto mode that looks at the brightest and darkest parts of the image and adjusts the picture's highlights and shadows. It works well on some images, but it's often better to adjust the picture using Levels or Curves.
(See Levels)

BEFORE

AFTER

Auto Levels

MENU	IMAGE →
	ADJUSTMENTS →
	AUTO LEVELS
QUICK KEY	CTRL+SHIFT+L

Scanned images using the auto setting rarely turn out with correct color or density so you need to adjust brightness and contrast.

Auto Levels looks for the brightest and darkest points and adjusts contrast so both maintain detail. It's a quick and easy fix, but learning how to adjust Levels manually produces better results.
(See Levels)

Automate

MENU	FILE →
	AUTOMATE

A series of pre-written auto tasks used to make contact sheets, multi-format prints, batch conversions and format pictures for your Web page.

BEFORE

AFTER

Using any of the three Auto modes from the Image → Adjustments menu can provide a quick fix, but there are times when you have to choose the mode with care. The beauty with Photoshop is you can always undo an adjustment if you don't think it has worked well.
On the right are two examples of when things can go wrong.

The first example, of the couple on the steps, lacks contrast and has a slight warm color cast, so the obvious choice would be Auto Color, but this introduced a blue cast (middle), Auto Contrast actually got it about right here (bottom).

The sunset picture also looks a little dull, Auto Contrast did nothing, Auto Color did nothing and Auto Levels made a right mess of it (middle). The only option here was to use Curves and adjust manually which has enriched the photograph (bottom).

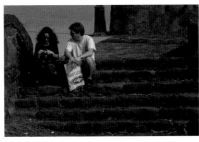
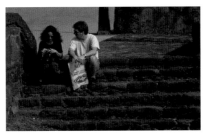
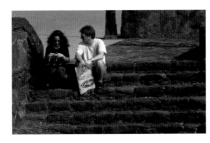

Background color

QUICK KEY X ALTERNATES BETWEEN BACKGROUND AND FOREGROUND COLOR The default is white which appears in the lower box of the tools palette. You can change the color from white by clicking on this box and using the color picker to select a new one. One reason for doing this is when making gradient fills which

progress from the foreground to background color. Erasing part of an image leaves the background color. **(See Foreground color)**

Tip
● To fill a selection with the Background color press Command+Delete.

Background eraser

A feature that first appeared on version 5.5 that makes selections even easier. Rub over the area you don't want and the Eraser makes it transparent. Then when you copy and paste to a new layer it will look more natural.

Eraser Tool	E
Background Eraser Tool	E
Magic Eraser Tool	E

Discontinuous erases the sample color wherever it appears in the picture. Contiguous erases pixels that are connected and Find Edges preserves edge sharpness.

Tip
● Change the tolerance level when working on different areas of the image. A higher percentage can be selected when there's a definite variation between the edge of the selection.

Batch processing

MENU **FILE →**
 AUTOMATE →
 BATCH

If you've ever had to deal with a pile of images that all needed converting from one format or color mode to another you'll welcome this feature. Batch processing takes a selection of images from a folder and performs action sequences that you've pre-recorded in the Actions palette. You can specify whether you want the processed files to replace the existing ones or create new versions in a different destination folder.

(See Actions)

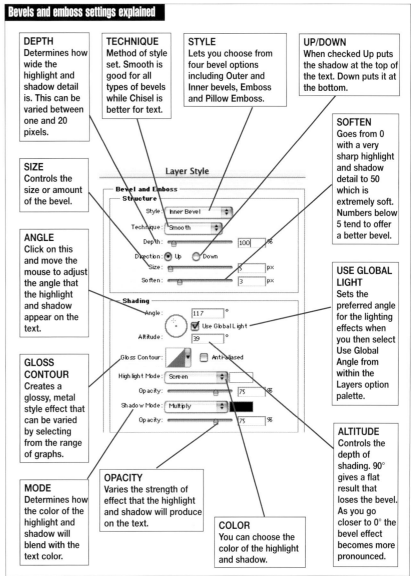

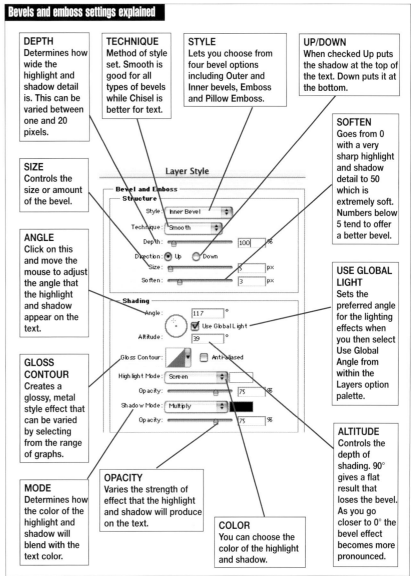

Tips

● Reduce the number of saved history states and deselect the Automatically Create First Snapshot option in the History palette for better batch processing.
● To change formats when batch processing make sure you include a Save As command in the original action sequence and close the file. Then choose None for the destination when setting up the batch process.

Bevels

MENU **LAYER →**
 LAYER STYLE →
 BEVEL AND EMBOSS

A mode that you can use to produce stylish type that will leap off your page. It can also be used on colored shapes to create 3D panels and buttons.

Using the Effects palette you can adjust the highlight and shadow of the bevel to create shallow or deep 3D effects.

Results vary depending on the resolution of your image so experiment with the settings to find a suitable effect. Turn Apply on so you can see the changes as you play. Here are several I made using a 7x3cm canvas with a resolution of 300ppi and 50 point text.

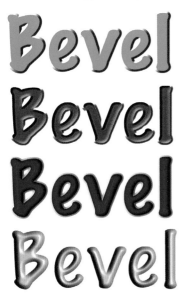

Just a few examples of some of the effects you can obtain using Bevel effects.

Bevels and emboss settings explained

DEPTH
Determines how wide the highlight and shadow detail is. This can be varied between one and 20 pixels.

TECHNIQUE
Method of style set. Smooth is good for all types of bevels while Chisel is better for text.

STYLE
Lets you choose from four bevel options including Outer and Inner bevels, Emboss and Pillow Emboss.

UP/DOWN
When checked Up puts the shadow at the top of the text. Down puts it at the bottom.

SIZE
Controls the size or amount of the bevel.

ANGLE
Click on this and move the mouse to adjust the angle that the highlight and shadow appear on the text.

GLOSS CONTOUR
Creates a glossy, metal style effect that can be varied by selecting from the range of graphs.

SOFTEN
Goes from 0 with a very sharp highlight and shadow detail to 50 which is extremely soft. Numbers below 5 tend to offer a better bevel.

USE GLOBAL LIGHT
Sets the preferred angle for the lighting effects when you then select Use Global Angle from within the Layers option palette.

ALTITUDE
Controls the depth of shading. 90° gives a flat result that loses the bevel. As you go closer to 0° the bevel effect becomes more pronounced.

MODE
Determines how the color of the highlight and shadow will blend with the text color.

OPACITY
Varies the strength of effect that the highlight and shadow will produce on the text.

COLOR
You can choose the color of the highlight and shadow.

Bézier curves (bay-zee-ay)

Curves created using Photoshop's Pen tool are called Bézier curves, named after French mathematician Pierre Bézier.

The shape of a curve is created by the position of anchor points and direction lines that can be moved to change its shape and direction. They're used to make perfect selections around smooth or curved objects.

Bitmap images

An image made up of a grid of squares (pixels) also known as a Raster image and not to be confused with Bitmap mode.

Bitmap images are resolution-dependent which means the number of pixels used to make up the image is fixed.

A bitmap is good at reproducing subtle colors, but jagged effects can occur when the image is enlarged.

Bicubic interpolation

Used to increase the image size by adding pixels based on the average of the colors of all eight surrounding pixels. It also boosts contrast between pixels to avoid a blurring effect that's usually evident from interpolation. It's the slowest of the three interpolation processes, but it's the most precise and gives the smoothest gradation between tones. **(See Interpolation)**

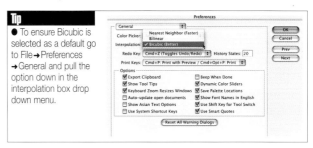

Tip

● To ensure Bicubic is selected as a default go to File→Preferences →General and pull the option down in the interpolation box drop down menu.

Bitmap mode

MENU **IMAGE →**
 MODE →
 BITMAP

Converts the picture into a grid of black & white pixels. The option won't be available if you're trying to convert a color image.

Discard color first by selecting Image→Mode→Grayscale. Set output in the dialogue box to your inkjet printer's resolution.

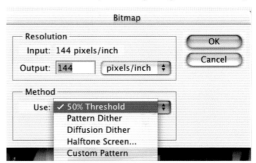

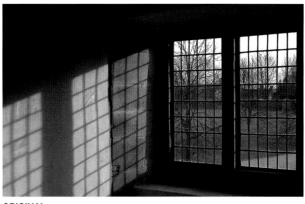

ORIGINAL
This color original of the window, shot on a Nikon Coolpix 995 digital camera, needs converting to grayscale first.

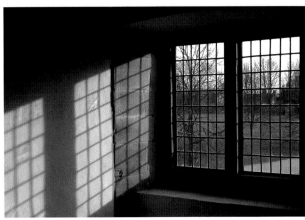

GRAYSCALE
The color image converted to grayscale using Image→Mode→Grayscale.

50% THRESHOLD
Pixels with a grey values above mid-gray convert to white and the rest become black resulting in a very high contrast, black & white image.

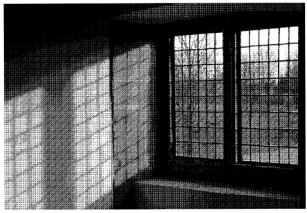

PATTERN DITHER
Converts the image into a geometric pattern of black & white dots that produce a range of grays when viewed.

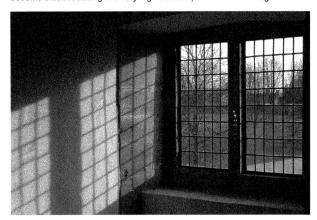

DIFFUSION DITHER
Produces a film-like grain that's useful for viewing images on a black & white monitor.

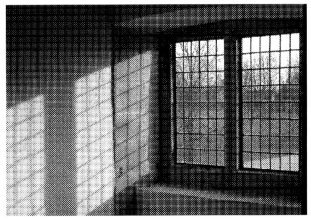

HALFTONE SCREEN
Converts a grayscale image to simulate a printer's halftone dots.

CUSTOM PATTERN
First define your own pattern and then apply this pattern as a texture screen.

Blending modes

A range of modes selected from within the Options or Layers palettes. The modes control how the pixels in the base image are affected by a Brush, Editing tool or other Layer. Here's what happens when a photograph of the moon is placed on a new layer and blended with a sky.

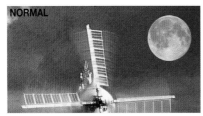

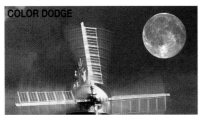

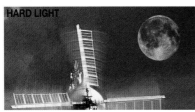

As well as using the Blend mode for the obvious merging of objects within layers it can also be used to add creative coloring by blending two duplicate layers with different colors, as seen in this example of two

boys who were asked to pull mean and moody faces. Above shows the two color layers, green on the base and purple above.

NORMAL
The default mode, which appears as Threshold when you're working with bitmap or indexed color images. When the layer or brush is set at 100% the pixels produce the end color and are not affected by the base image. Change the opacity and the colors blend and form an average.

DISSOLVE
When two layers are combined there's no effect unless the active layer has been feathered and then a splattering effect appears in the feathered area to produce the dissolved colors. Could be used for graphical illustration work but has little benefit for photographers.

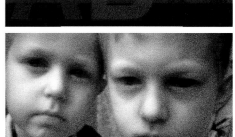

COLOR BURN
Merges the darker colors of the upper layer or paint with the base layer. Blending with white has no effect on the overall image. Can be to harsh for many applications.

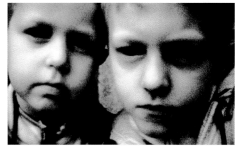

SCREEN
Opposite performance to Multiply with the end color always lighter. Painting with black leaves the color unchanged while white produces white. The active layer becomes lighter. This is a useful mode to use when you are making multilayer composites.

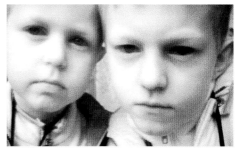

DARKEN

Looks at the color in each layer and selects the darker of the base or blend layer as the final color. Lighter pixels are replaced, darker pixels stay the same.

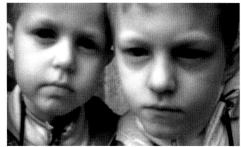

MULTIPLY

Painting over the base color with the blend color produces a darker color. Painting with black changes base color to black, white leaves color unchanged. Painting repeatedly over the same area produces progressively darker colors and is similar to coloring with a felt tip pen.

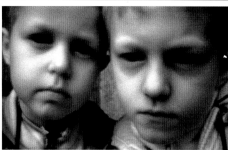

LINEAR BURN

A new option in version 7.0 that looks at the color values in each channel and decreases the brightness of the base color to reflect the blend color. Produces a less solarized result than color burn.

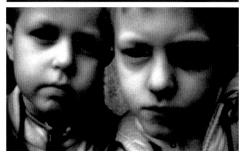

LIGHTEN

Looks at the color in each layer and selects the lighter of the base or blend layer as the final color. Pixels darker than the blend color are replaced and lighter pixels stay the same. There's no sign of our green layer in this one.

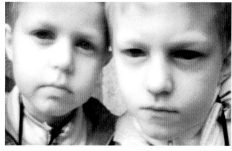

COLOR DODGE

Uses the upper layer or paint to add color and brighten the color of the base layer. Blending with black doesn't affect the image. Has the opposite effect to color burn and is less useful.

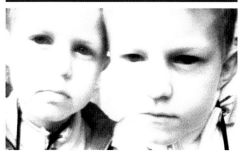

LINEAR DODGE

A new one for version 7.0 that looks at the color information in each channel and increases brightness in the base color to reflect the blend color. Blending with black has no effect.

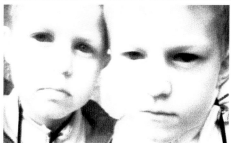

b

OVERLAY
Similar process to Multiply, but Overlay holds onto the base color's highlights and shadows while mixing with the active layer to produce an image with more contrast. Use this mode with a Paintbrush to build up a hand-coloring effect.

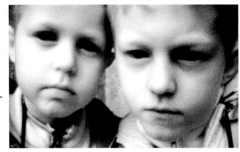

SOFT LIGHT
Similar to Overlay, but more subtle. If the blend color is lighter than 50% gray, the whole image will lighten. If it's darker than 50% gray, the image will darken. How much depends on the paint color used. When you merge layers you benefit from a lighter image.

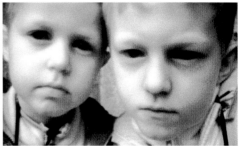

LINEAR LIGHT
New on version 7.0. Similar to Vivid light but it adjusts brightness to dodge or burn colors. If the blend color is lighter than 50% gray, brightness is increased to lighten the image. If it's darker than 50% gray, brightness is decreased to darken the image.

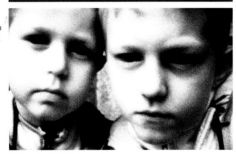

PIN LIGHT
New to version 7.0, this replaces colors, depending on the blend color. Darker pixels are replaced when they are lighter than 50% gray, while lighter pixels are unaffected. Lighter pixels are replaced when the blend color is darker than 50% gray, while darker pixels are unaffected.

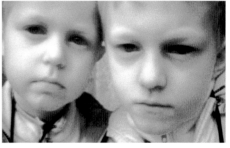

HUE
Produces a combined color that includes the luminance and saturation of the base color and the hue of the blend color.

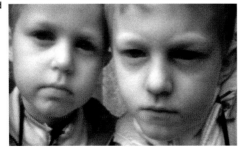

SATURATION
Takes the hue and luminance of the base color and blends it with the saturation of the applied color.

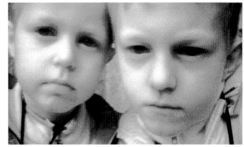

HARD LIGHT
Adds color together and, like Soft Light, lightens image areas lighter than 50% gray and darkens the Blend color if it's already darker than 50% gray. Painting with black or white produces pure black or white. A harsh overlay.

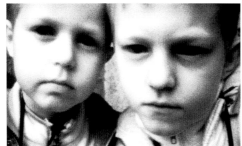

VIVID LIGHT
Appears on version 7.0. Similar to Linear light, but adjusts contrast to dodge or burn colors. If the blend color is lighter than 50% gray, contrast is decreased to lighten the image. If it's darker than 50% gray, contrast is increased to darken the image.

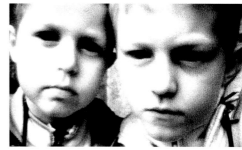

DIFFERENCE
Subtracts either the blend color from the base color or the base color from the blend color, depending on which has a larger brightness value. Base colors are inverted when blended with white, but blending with black has no effect.

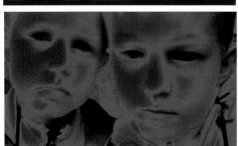

EXCLUSION
A similar, but lower contrast effect to the Difference mode. I've never found a suitable use for this blend mode.

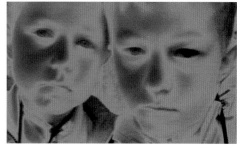

COLOR
Produces an end color with the luminance of the base color and the hue and saturation of the blend color. It's a good mode for hand-coloring black & white images as it keeps the gray tones.

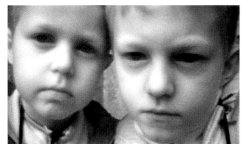

LUMINOSITY
Notice how it's the base color that is strong here. That's because this mode mixes hue and saturation of the base color and the luminance of the blend color and creates the opposite effect of Color mode.

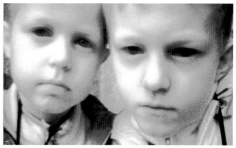

Blur filters

MENU **FILTER →**
 BLUR →

A series of effects accessed from the filter pull down menu and used to soften all, or part, of an image by reducing the defined edges between pixels. Quite silly really – you have a camera that's been carefully engineered to give razor sharp images that you're now going to make blurred! The beauty with a digital image is you can control how much and

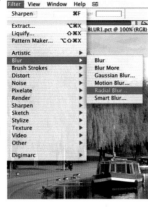

where the blur will occur. So consider having infinite control of depth-of-field or the ability to soften wrinkles and hide freckles while keeping the eyes sharp. Now you're thinking! There are six options in the Photoshop filter menu that include Blur, Blur More, Gaussian Blur, Motion Blur, Radial Blur and Smart Blur.

BLUR

Smoothes out color transitions in an image by averaging out pixels next to hard edges of defined lines and shaded areas. This is a good mode to help smooth out harsh looking pictures created using a digital camera.

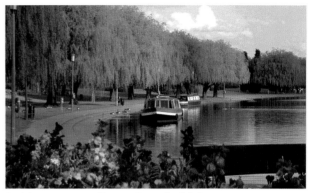

Straight shot from an Olympus Camedia digital camera.

Blur filter applied.

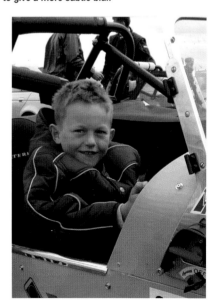

Fade Blur filter applied to give a more subtle blur.

BLUR MORE

Similar effect to the Blur filter, but up to four times as strong. Helps reduce the effect of pixelation in digital pictures.

The original was taken using a Nikon Coolpix 990 digital camera. Left is before Blur More is applied and right is after. The result is soft so I sharpened the image and have enlarged the eye in each example so you can see the difference.

Before

After

Sharpened

GAUSSIAN BLUR

An adjustable blurring effect, controlled by one slider that adjusts the pixel radius in 1/10 pixels from 0.1 to 250. It adds low-frequency detail that can produce a hazy effect.

The picture in the preview window can be adjusted in size so you can watch the result on a localized area or the whole picture. The preview appears quicker if the area is highly magnified.

The screenshot above right shows the effect of setting a low radius and you can still see detail in the background. The below right picture shows what happens if a high radius is set – the whole background goes unnaturally blurred.

You should adjust the radius to suit each picture and the file size also affects the setting. A larger file size would need a higher radius to have any effect.

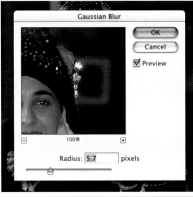

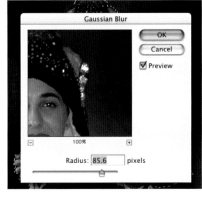

Tip

● To blur a background when there's a difficult subject to cut around, such as hair. Draw a very rough selection using the Lasso tool at a short distance from the hair and feather dramatically (150 pixels on a this 5Mb image). Then when you apply blur it will look more natural and less like a cutout.

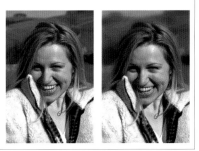

The first thing to do is make a selection of the area that you want to make blurred.

I find it easier to select the subject that you want to stay sharp and then invert this selection.

Draw around the subject using the Lasso tool, and use the Shift and Ctrl keys with the Lasso tool to add or subtract from this selection.

Once completed and with the selection inverted to the background I find it useful to expand by one pixel and feather by one to ensure a less harsh edge.

MOTION BLUR

Recreates slow shutter speed effects by blurring adjacent pixels at user selectable angles through 360°. You can also control the intensity of the blur producing a streak with a length of between 1 and 999 pixels.

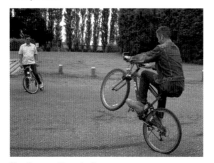

Hardly an action shot!

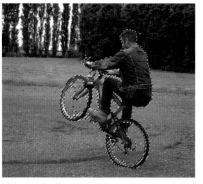

Make a selection around the cyclist and apply Motion Blur in the direction of the bike. Notice I cleaned up the background at the same time. We don't want him crashing into all the posts!

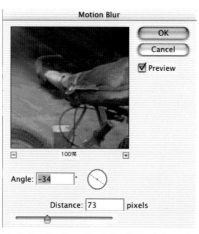

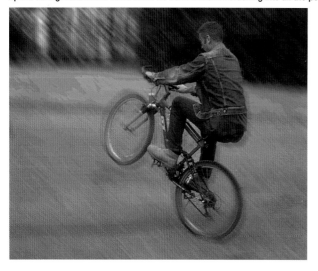

Left: The result of our blur, a bike that appears to be moving.

Above: Look what happens if the Motion Blur angle is changed. Now the biker looks as though he's either pulling a wheely or crash landing to earth.

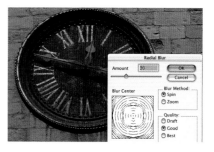

RADIAL BLUR

Recreate zoom lens or rotating blurring effects with this mode. Ticking the Spin box makes the image look as though it's, wait for it, spinning. You then specify a degree of rotation by dragging the slider across while viewing a graphical representation of the rotation.

Tick the Zoom box to blur along radial lines and produce the same effect as adjusting a camera's zoom lens during a long exposure. You can adjust the depth from 1 to 100 pixels. You also have the option of Draft for fast, but grainy results or Good and Best for smoother results. Unlike in-camera effects you can also move the centre point of the effect off-centre by dragging the pattern in the graphic preview box.

Above: The Radial Blur filter can take ages to process, even on fairly high spec computers. **Below:** But the results can be worth waiting for. Time flies when you're having fun!

b

SMART BLUR

Smart Blur first appeared in version 4.0 of Photoshop and leaves edges sharp while blurring lower contrast parts of the image, often resulting in a posterization or watercolor style effect.

Radius and Threshold sliders are provided to control the blurring effect by the depth of pixels affected and their values. There's also a quality box that has low, medium or high quality blur options. And a final box to set the filter to work on the entire selection in Normal mode, or for the edges of color transitions using Edge Only and Overlay.

Edge Only produces a graphic black & white edge effect while Overlay Edge blends the graphical edge effect with the original image.

A careful blend of all four can produce some very creative images, but can also be used to reduce film grain or blemishes without affecting the overall result.

Smart blur produces lovely painterly images, but loses detail so use with care.

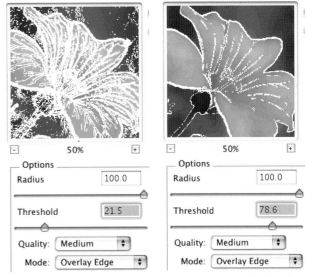

Options	
Radius	100.0
Threshold	21.5
Quality:	Medium
Mode:	Overlay Edge

Options	
Radius	100.0
Threshold	78.6
Quality:	Medium
Mode:	Overlay Edge

While in the Overlay Edge mode try adjusting the threshold and see how it affects the amount of edge detail that appears on the image. A higher threshold ensures more of the image appears beneath the edge effect.

Tips

● Turn off Preserve Transparency in the Layers palette to apply a Blur filter to the edges of a layer.

● Create pencil drawings by running the Smart Blur set to Edge Only mode (middle).

● Then Invert Image→Adjust→ Invert to get a black sketch on white paper (right).

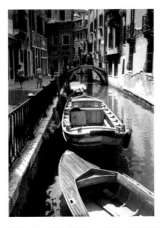
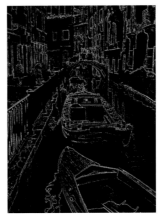
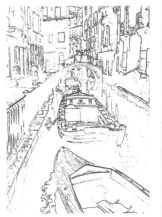

Borders

MENU SELECT ➜

 MODIFY ➜

 BORDER

It's easy to add a border to your whole image or a selection. With an area selected choose the Border command and enter a width in pixels. The mode will be grayed out from the menu if you haven't made a selection.

The thickness of border is relative to the original image size – a 3 pixel border on a 300 pixel wide image will look twice as thin as one with a 600 pixel width.

When applied you'll have a second set of marching ants which you can fill using the Bucket tool or Edit➜Fill command. Choose the color border you want and set this as the foreground color before applying the fill.

Tips

● Don't go mad! Black or neutral colors can look more striking than a vivid red or blue. You don't want all the attention on the border!
● Thin borders set a picture off – thick ones can be messy.
● Borders made using the Border mode always have a softer inner edge. To produce a sharp defined border use the Stroke command. **(See Stroke)**

Brightness

MENU IMAGE ➜

 ADJUSTMENTS ➜

 BRIGHTNESS/CONTRAST

Adjust the intensity of the image using this slider control. You can go from –100 to +100, which gives the equivalent of about three stops exposure control that you'd experience using slide film.

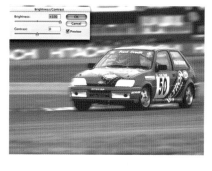

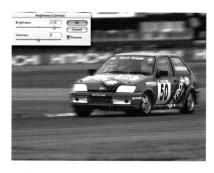

While the Brightness control is a quick and easy option, it tends to clip the highlight or shadow detail and can result in a loss of valuable pixel information that cannot be returned once the image has been saved and closed.

It's better to use the Levels or Curves adjustments for more precise control of brightness and contrast. **(See Levels and Curves)**

b

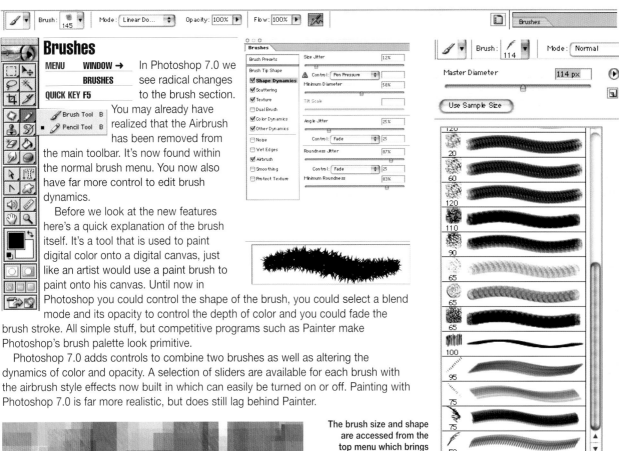

Brushes

MENU WINDOW →
BRUSHES
QUICK KEY F5

In Photoshop 7.0 we see radical changes to the brush section. You may already have realized that the Airbrush has been removed from the main toolbar. It's now found within the normal brush menu. You now also have far more control to edit brush dynamics.

Before we look at the new features here's a quick explanation of the brush itself. It's a tool that is used to paint digital color onto a digital canvas, just like an artist would use a paint brush to paint onto his canvas. Until now in Photoshop you could control the shape of the brush, you could select a blend mode and its opacity to control the depth of color and you could fade the brush stroke. All simple stuff, but competitive programs such as Painter make Photoshop's brush palette look primitive.

Photoshop 7.0 adds controls to combine two brushes as well as altering the dynamics of color and opacity. A selection of sliders are available for each brush with the airbrush style effects now built in which can easily be turned on or off. Painting with Photoshop 7.0 is far more realistic, but does still lag behind Painter.

The brush size and shape are accessed from the top menu which brings down a scrollable list.

You can use the brushes to make creative backgrounds. Here a selection was made from an image. Then we created a custom brush using the Define Brush mode and started to paint. Saturation mode was used to create the colorful canvas, left, which was then treated to Motion Blur to create the background image above. (See Define Brush)

Brushes

(Cont)

Photoshop 6.0 changed the way we saw brush options and now version 7.0 takes us a stage further. In previous versions you double clicked on the Brush tool to open the options palette and from there you could select the brush size, opacity and blend mode. Now a convenient bar appears across the top as soon as you click on any tool. This makes it much quicker to edit, once, of course, you become familiar with the new way of working.

The 65 brushes that appear as standard in this bar can be edited and added to. Where you used to double click on an icon to bring up an editing palette you now have a special Brush Presets palette where you can choose loads of editing options.

Selecting Brush Tip Shape offers what version 6.0 had – control over the diameter, hardness and spacing of the brush along with the angle and roundness.

The diameter is selected in pixel width and can be anything from 1 to 999 pixels wide. Hardness determines how sharp the edge of the brush is and ranges from 0% to 100%. Spacing (see above right) varies the gap between each shape when you paint and can be set between 1% and 999%. A setting of 100% produces a shape that touches edge to edge, 50% overlaps by half so every alternate shape touches and 150% leaves a gap half the width of a shape between each shape. Got the idea?

The angle comes into play when you've changed the roundness and is great for creating calligraphy style brush strokes.

To illustrate the effect of the Spacing feature I first created an oblique-shaped brush and increased spacing in increments of 100% for each of the arrows I've drawn on the canvas.

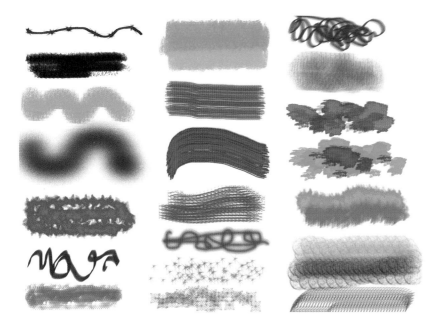

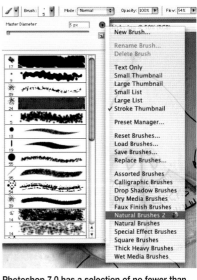

Photoshop 7.0 has a selection of no fewer than 212 preset brushes in 11 groups. These can be accessed by clicking on the arrow to the right of the brush icon on the menu bar and then on the arrow at the side of the brush diameter slider from the brush palette.

From here you can also change how the brush palette displays the brush icons and load or save brushes.

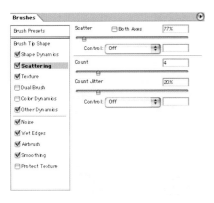

Varying the size of a paint brush is essential when working with different images. Where a large background may suit a chunky brush, retouching a very small area would need a brush tip that may be just one pixel wide. This level of adjustment is made in the Brushes menu bar, which has a selection of pre-set sizes to choose from, but custom sizes can be also be created. It's not just paint brushes that benefit from size – you can also adjust the Eraser, Smudge, Dodge & Burn tools, and, in this example, the Clone tool which made it much quicker to duplicate the boat. Its color was then changed.

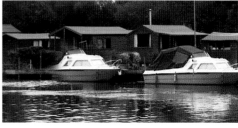

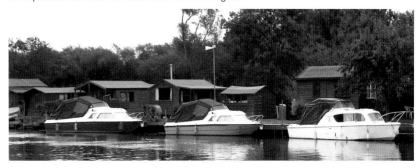

Almost any shape of brush is possible, created using the new Brush Presets palette normally found in the palette well. The palette can be dragged out of the Well and positioned where convenient on the screen.

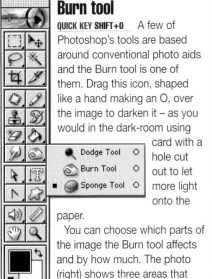

Burn tool

QUICK KEY SHIFT+O A few of Photoshop's tools are based around conventional photo aids and the Burn tool is one of them. Drag this icon, shaped like a hand making an O, over the image to darken it – as you would in the dark-room using card with a hole cut out to let more light onto the paper.

You can choose which parts of the image the Burn tool affects and by how much. The photo (right) shows three areas that were painted over with the Burn tool using different settings.

Toggle between the Burn, Dodge and Saturate icons using Shift+O. Use the opacity setting to vary the strength.

The Burn tool offers three options: Highlight darkens the light parts of the image (top), Midtones affects the mid-grays (middle) and Shadows alters the dark parts (bottom).

Button mode

This is a pretty looking interface that's an alternative to the normal Actions palette and is selected from the black triangle drop down menu.

Each Action is assigned a color, making it easy to group similar Actions. This mode is useful for less experienced users of the Actions feature, but scripts can't be edited so more advanced users should stay clear. **(See Actions)**

| History | Actions | Tool Presets | |
|---|---|---|
| Vignette (selection) | | Frame Channel - |
| Wood Frame - 50 pixel | | Cast Shadow (typ |
| Water Reflection (type) | | Custom RGB to G |
| Molten Lead | | Make Clip Path (s |
| Sepia Toning (layer) | | Quadrant Colors |
| Save As Photoshop PDF | | Gradient Map |
| Focal RGB.pct t... ⇧F12 | | Aged Photo |
| Blizzard | | Light Rain |
| Lizard Skin | | Neon Nights |
| Oil Pastel | | Quadrant Colors |
| Sepia Toning (grayscale) | | Sepia Toning (lay |
| Soft Edge Glow | | Soft Flat Color |
| Soft Focus | | Neon Edges |
| Soft Posterize | | Colorful Center (c |

abc**defghijklmnopqrstuvwxyz**

Calculations

MENU IMAGE ➜
 CALCULATIONS

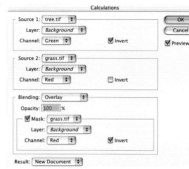

This mode lets you merge two channels from one or two images and save the result as a new channel in one of the existing images or create a new image.

The Calculations palette gives you various options including Blend method and is useful if you want to combine masks or selections.

Calibration

The phrase 'what you see is what you get', or 'wysiwyg' (pronounced whizzywig) couldn't be more important. When you view an image on the computer screen you want it to appear exactly the same when it prints out – oh if life were so simple! Computer monitors can be wildly out – just like your neighbour's television, and a high contrast, vivid color image on screen is likely to be disappointingly dull when printed.

It's because the image on the monitor is an RGB file that's projected light, while the printed image is a CMYK version that you view by reflected light. To get round this you need to calibrate your system.

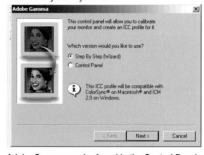

Adobe Gamma can be found in the Control Panel from the Start menu of a Windows PC.

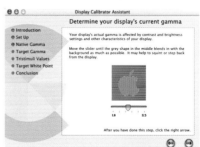

Mac OSX gamma adjustments can be found in the display control panel in System Preferences.

Adjust your monitor using Adobe's Gamma file which should be located in your Window's Control Panel. Mac users can use the Apple utility that is in the control panel, or System Preferences on OSX. These easy-to-follow wizards help you adjust brightness, contrast and gamma to ensure life-like prints.

You also need scanner and printer profiles set up to ensure that the file keeps consistent color as it moves through your system.

Canvas size

The canvas is the base to your picture, like an artist would add paint to his you add pixels to yours. When an image is opened the canvas size is the same as the image. If you want to extend to one side or to the top or bottom you need to increase the canvas size. Click on the square where you want your existing canvas to be extended from.

Here I've illustrated how to increase the canvas from 6x4.5in to 6x6in. I clicked in the bottom middle of the Anchor grid of nine squares so that the extended area appears at the top of the existing canvas.

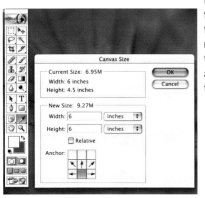

Channels

MENU WINDOW →
CHANNELS

Each file in Photoshop is made up of channels that store information about the image. A freshly created RGB file has a channel for each of the three colors, and a CMYK file has four channels, while Duotones and Index color images have just one.

You can add channels to store info about the picture. For example, Alpha channels can be added to save selections as masks. Then when you want to perform a similar cutout in the future you load the Alpha channel to bring the marching ants into play on the selected layer.

Channels can also be edited individually so you could blend certain ones, or fiddle with the color of just one channel – useful when you want to make a selection based on a certain color which would be easier to do in its own environment.

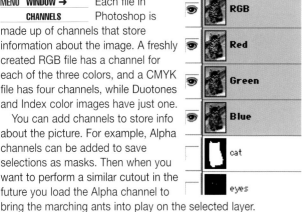

Tip

● Individual color channels appear as black & white. If you'd prefer to see them in color go to File→Preferences →Displays & Cursors and select the Color Channels in Color option.

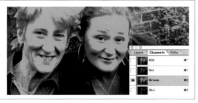

Channel Mixer

MENU IMAGE →
ADJUSTMENTS →
CHANNEL MIXER →

The Channel Mixer is one of those tools in Photoshop that you come to once you have a little more experience. By adjusting the colour of the individual R, G and B channels you can change the colour of an element within the picture. In this example a simple adjustment of the red slider in the red channel was reduced from 100% to 0%.

The Channel Mixer can also be accessed from the Adjustment Layer submenu.

You could play around mixing channel colours all day! If you don't like the result, click on cancel and start again.

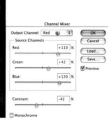

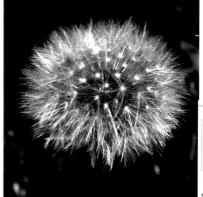

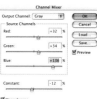

Tips

● Click on monochromatic filter and recreate black & white filter effects using the slides to adjust the colours in each channel. Experimentation is the key here!

C

Check spelling

MENU EDIT →
CHECK SPELLING A new feature of version 7.0 that proves useful if you are using the type tool to work with text in Photoshop. This automatically runs through

your work and finds anything that isn't spelt correctly or doesn't appear in its dictionary and suggests an alternative.

If, for example, it found grashopper it would suggest the correct grasshopper and you could then click on 'change' to have the word automatically substituted. This sort of feature is available with all word and DTP (desktop publishing) packages and is a welcome addition to Photoshop.

Clipping path

Puts an invisible path around an image to ensure the background is transparent when the image is dropped into an illustration or desktop publishing page.

To create a clipping path first draw around the subject to make a selection then click on the arrow at the right of the paths palette and select Make Work Path, then Save Path. Finally select Clipping Path.

Save the file as an EPS or TIFF which keeps the clipping path data which can then be read by the DTP software to allow a transparent background or text to wrap around the subject.

A clipping path was drawn around the wooden carving so it can be dropped into a DTP layout without a background, and text wraps around it.

Clone Stamp tool

Adobe followed most of the other software programmers in version 6.0 by giving the oddly named Rubber Stamp tool a more sensible title of Clone Stamp tool. This particular tool is responsible for many photographers taking up digital imaging.

The first time you see bits of rubbish being wiped right out of an image or spots and blemishes being removed from your partner's face you'll be in awe. All that's happening is

the Clone Stamp tool is being used to pick up or

sample pixels from one place and drop them somewhere else. It's one of the most used devices to remove or add detail to an image.

There are several ways to use it. For starters it acts like a brush so you can change the size, allowing cloning from just one pixel wide to hundreds. You can change the opacity to produce a subtle clone effect. You can select any one of the options from the Blend menu. And, most importantly, there's a choice between Clone align or Clone non-align.

To use it place the cursor over the sample point, hold down the Alt key and click the mouse. Then move the cursor to the point where you want the sample to appear and click the mouse to dump the pixels. If you hold down the mouse button and drag you'll paint from the sample area. Select Aligned from the Clone Stamp options palette and the sample cursor will follow the destination cursor around keeping the same distance away. When unaligned the sample cursor starts where you left off. Both choices have their advantages.

(See Pattern Stamp tool, Patch tool and Heal tool)

Dust from scans of unclean transparencies can easily be removed. Select similar areas of color or pattern from nearby and sample from those to clone over the spot. Zoom in on screen and vary the brush size on different areas.

The letter C appears at top right.

You may think areas of sky would be easy areas to clone, but that's not always the case. As the tones subtly change you could easily end up with an obvious line. Sample from a point as near to the area that you are cloning over.

The face was fairly easy to clone over. Keep a steady hand and follow patterns in the wool when cloning.

Can you spot any difference between this one and the one below? Look at the pattern in the sheep's wool at the arrow point. It's repeated in the top shot. In the bottom version I sampled from a different place. In this example you have to look hard to spot it, but that could have been a real obvious clone on some images.

Here I sampled from the edge of the rock and followed it up in the direction of the arrow.

When cloning fine detail look around for similar areas and try to follow a path that will make the sample look natural. In this part I cloned from the arrow heads and followed their direction.

The end picture, cropped at the right, to provide a more pleasing composition. Free at last!

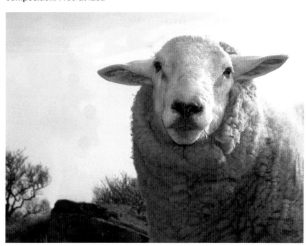

C

Some programs allow cloning to be applied at different percentages to produce a smaller or larger version of the original. Photoshop doesn't (right), but you can get round this by adding a new layer. Then take your sample point from the original layer and clone with the new layer active. Then use the Transform tool to rescale the cloned image (below).

Clone aligned ensures the clone sample point stays at the same distance from the cursor as you move around cloning. This is useful when, as in our example above, you're cleaning up blemishes or dust in a sky. The sampling point (indicated by the arrow tip) will follow at the same distance from the cursor (cloning over the scratch) so the sampled pixels will usually be a similar color and texture. It's generally the best method to use and only falls down when, as in our example, it cloned the steeple when a blemish was just to the right. Here you would take a new sample to the right of the blemish.

Clone unaligned keeps the sample point where you left off so when you move the cursor it stays put. This is useful when you want to take a certain part of the image (sky in our case) and paint it in various other similar parts.

You can take your sample point from one image and then reposition the cursor on a different one to clone onto it.

Play God and create new life. This started out with just four birds!

Clouds filter

MENU	FILTER →
	RENDER →
	CLOUDS

This useful addition to the Filters menu creates cloud effects that can be used as effective backgrounds to your pictures. Before selecting the filter make sure your background color is set to white and the foreground to the color sky you'd like. Blue creates natural skies while orange will deliver a sunset effect and black will produce a stormy sky.

Open a new canvas and set it to the size you want to end up with and select the filter. If you don't like the clouds that are created, try again – it's random.

Draw around your subject to make a selection, then copy and paste the selection onto an image created using the Clouds filter. Try experimenting with colors for unusual effects.

If the cloud effect is too harsh make the original canvas smaller, apply clouds then increase its size.

Go to Image→Adjust→ Hue/Saturation (Ctrl+U), click on Colorize and adjust Hue to change color.

Use the Gaussian or Motion Blur filter to soften the effect.

CMYK

When a digital image is printed it's converted from RGB into CMYK. CMYK is the standard method of printing and uses Cyan, Magenta and Yellow inks to make up the various colors.

A 100% combination of C, M and Y should produce black, but in reality it's a murky brown color so the Black ink (K to avoid confusion with the Blue of RGB) ensures black is printed where necessary.

Collage

Strictly speaking a collage is a collection of photographs mounted together, but Photoshop creates a perfect alternative by bringing several photos together to form one larger image that hasn't seen a drop of glue or sticky tape.

It's a great technique to use to create a family tree, group photo, promo, surreal image or, as below, a panel to go on a Web site or stationery header.

Using Layers makes the job much easier and more controllable. Here masks and blend modes allow lower layers to react with ones above. The binary text was created using the text tool and then distorted, skewed and stretched, to give it a forward look.

Color Balance

MENU	IMAGE →
	ADJUSTMENTS →
	COLOR BALANCE
QUICK KEYS	CTRL+B

Used to remove or create a color cast. The Color Balance palette has three sliders to control the color. Moving the top slider left adds cyan and reduces red. Move it to the right to add red and reduce cyan. The middle slider controls magenta and green and the bottom, yellow and blue. Precise values can be keyed in the top boxes. You can also select where you want the color to change, placing emphasis in the highlights, shadows or midtones. The final option is to Preserve Luminosity which maintains the original brightness when it's turned on.

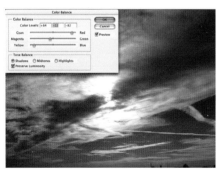

The above original lacks that extra something. Maybe a vivid glowing sunset. Applying lots of yellow and red gives a strong sunset that would make any shepherd delighted!

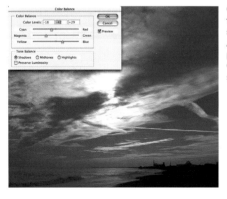

Or how about blue for a stormy winter sunrise effect? Almost anything's possible with the Color Balance sliders.

Daylight film is designed to produce a natural looking range of colors for outdoor photography or indoor shots taken with flash.

Take a photo indoors without flash and you'll end up with a color cast. This will be green if the light source is fluorescent or orange if it's tungsten light.

Some flashguns are so harsh that they create a blue color cast. The walls in a room can also reflect light to add a color to your subject. Any color cast can be removed, or added, using Photoshop's Color Balance mode.

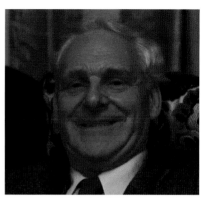

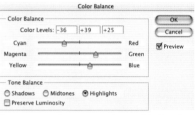

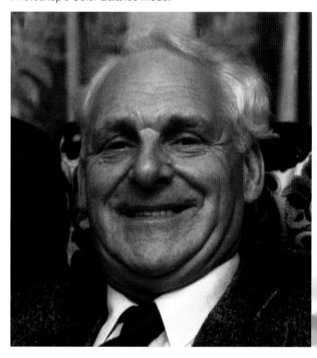

Color burn
(See Blending modes)

Color Channels
(See Channels)

Color dodge
(See Blending modes)

C

Color Range

MENU SELECT → Photoshop's
COLOR RANGE Color Range is
a versatile tool to help you select
and change the color of a part of
your picture. This could easily be a
model's lipstick, car paint work or,
as in this case, red pupils.

With the picture on a new layer
call up the Color Range palette. To
make it easier to see what you're
doing click on Selection at the
bottom of the palette to turn the
preview window into a grayscale
image. For this exercise also select
Sampled Colors from the menu at
the top of the palette.

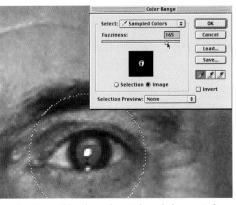

The Fuzziness slider above the preview window controls
the range of reds either side of the one you picked.
Adjusting the slider to the right increases the selection,
and to the left decreases the selection.

Now click on the left-hand Eyedropper tool and position your cursor over a part of
the red pupil and click once. You'll see areas of white appear on the grayscale preview.
These are red pixels that are similar in color to the red you've just clicked on.

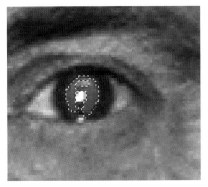
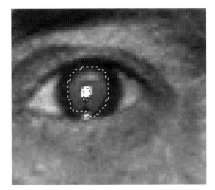
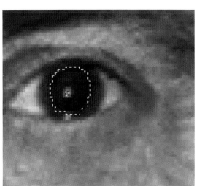

Each eye was selected using the
+ Eyedropper in the Color Range
window and fuzziness was set to
ensure all the red area was
selected. Then hue/saturation
was used to turn the eye to a
suitable color.

Another method is to let
Photoshop pick the color you
want to change. Go to the Select
menu and pull down the Red
option. Now you'll see the
Fuzziness scale cannot be
adjusted and everything that's red
in the image has been selected.
You can also use this method to
select highlights, midtones or
shadows. It couldn't be used in
this example though because the
shirt would have been highlighted
too. Now turn to the Patch tool to
see how we get rid of wrinkles.

WHICH MASK?

The Color Range palette
also lets you choose
which type of mask to
put over the image as
you work. We've been
using None, but the
menu box, labelled
Selection Preview at the
bottom of the palette,

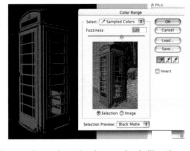

has four other options. Grayscale makes the image look like the
palette's preview. Black Matte (above) shows the unselected
area black. White Matte makes the unselected area white. Quick
Mask puts red over unselected areas.

Tip
● Press CTRL to change the grayscale preview to the color image or click inside
the preview box.

34

C

Colorize

MENU **IMAGE →**
 ADJUSTMENTS →
 HUE/SATURATION

Turned on in the Hue/Saturation palette to create a monocolor image. If you want to tone a black & white image first convert it to RGB, Image→Mode→RGB Color. Adjust the Hue slider and watch the image go from blue through the colors of the rainbow and back to blue. Stop when the image is the color you like and save. Use lightness and saturation sliders to vary color further.

I've included a range of examples here using a black & white infrared photograph with the various settings made. You could use these as starting points to colorizing your own photographs. The color tonal range is displayed below the rainbow color bar in the preview window.

Tick the preview box to ensure you see the effect as you adjust the sliders.

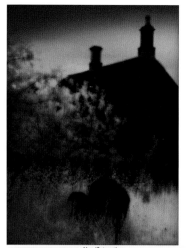

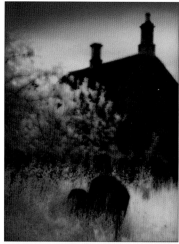

Original grayscale image

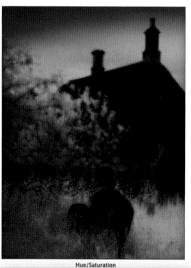

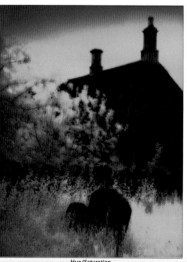

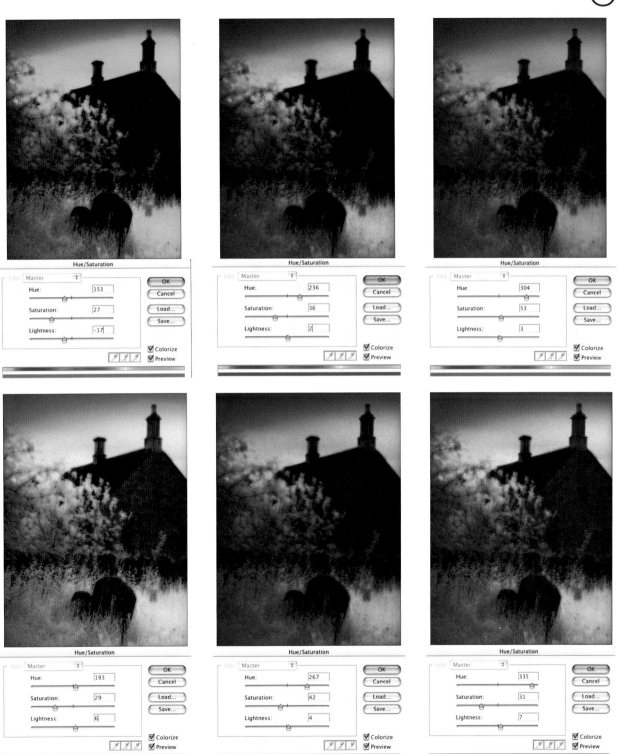

C

Color Sampler tool

An Eyedropper tool that is used to place up to four sample points on the photo so you can compare colour and density of each spot using measurements displayed in the Info palette. A second set of measurements appears at the side of the current values, showing the adjustments you make when using controls such as levels, curves, contrast and brightness. In this example I placed four samples in the highlight areas of the waterfall so I could adjust curves and ensure there was still detail in most parts.

Color Settings

MENU EDIT →
 COLOR SETTINGS Allows you to set up color profiles so that images you open up use a pre-selected color space. Spend some time setting this up correctly and you'll maintain consistent color when the image is displayed and printed. Mac OSX users will find the item under the Photoshop menu not the Edit menu.

Compression

Digital images can have huge file sizes. A 10x8in RGB image with a resolution of 300ppi, for example, has a file size of 21Mb. A few of these will start to fill up your computer's hard disk and a quick calculation finds you'll only ever fit 30 on a CD. It doesn't have to be this way. There are several file formats that change the data to reduce the file size – a method known as compression.

Two types exist – Lossy and Lossless. Lossy removes data for good, Lossless keeps it all safe. JPEG is the common storage format used by most digital cameras and Kodak's Picture CD. JPEG is a Lossy version and can affect the picture quality if it's highly compressed.

Conditional mode change

MENU FILE →
 AUTOMATE →
 CONDITIONAL
 MODE CHANGE Add this to an action to keep the color mode of a file the same when the action is being performed.

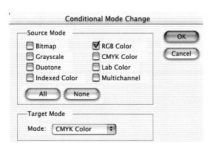

Contact sheet

MENU FILE →
 AUTOMATE →
 CONTACT SHEET Photoshop has a neat conversion that takes a collection of images and turns them into low resolution thumbnails that are positioned like a contact sheet.

It's a good way of keeping a record of your images and also to submit with CDs so the client can have a rough visual of what's included in the package.

You can choose the size of sheet and the number of pictures displayed across the page. The quality is a bit disappointing, but it's quick and easy to use.

Tip

● The contact sheet is saved with a white background.

If you would prefer a different color use the Fill tool with a neutral tone selected for the paint and click on the transparent area to deposit the color of your choice.

Red might clash! Black's a safe choice.

Contact Sheet II

Source Folder

Choose... FW:BACK UP:Backup PIX on CD:Petespic10:Infrared pics:

☑ Include All Subfolders

OK
Cancel

Document

Width: 8.268 inches

Height: 11.693 inches

Resolution: 240 pixels/inch

Mode: RGB Color

☑ Flatten All Layers

Thumbnails

Place: across first

Columns: 5 Width: 1.637 inches

Rows: 6 Height: 1.295 inches

☑ Use Filename As Caption

Font: Arial Font Size: 12 pt

The pictures appear on the contact sheet in the same way that they have been saved. It's a shame you can't preview and rotate the pictures before you save the contact.

AlportIR750 | bradfieldchurch.tif | CastleskyIR750 | cambIR750.tif | cornwall.tif
FenceIR750 | hillsborough par... | Infraredbench.tif | IvyIR750 | IvyNo IR
JapanIRSFX | LakesIR750 | library.tif | PassIR750 | park2.tif
SheepIR750 | ShelterIRHIE.tif | Stones2IR750 | Stones3IR750 | StonesIR750
TreeIRHIE.tif | treepond.tif | WhirlowcafeIRH... | WhirlowIRHIE.tif | WhirlowIRHIE3.tif

Contiguous
(See Magic wand)

Contrast

MENU IMAGE →
ADJUSTMENTS →
BRIGHTNESS/
CONTRAST

The range of tones between black and white, or highlight and shadow.

A high contrast image is one where there's dark and light tones, but not much in between. Shots taken into the sun, or with the sun high in the sky are often high contrast.

A low contrast image is one that doesn't have many tones in the lightest or darkest areas so it looks quite gray and flat. Pictures taken in mist or dull conditions are often low contrast. In the traditional darkroom contrast is controlled using special variable-contrast paper – in the digital lab you simply adjust the sliders and watch the preview.

This is a very basic method of tonal adjustment and can cause the image to lose detail, which could be saved if you adjust contrast using the more advanced Levels or Curves. **(See Levels and Curves)**

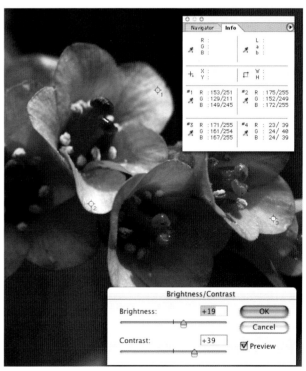

This photograph was taken with a Nikon D1X and was incorrectly set to underexpose so the image came out very dull and lacking contrast. Look at the Color Sampler tool values in the Info palette and see what happens to the highlights when contrast is raised using the Brightness/Contrast control.

C

Contrast
(Cont.)

Here's what happens when you adjust contrast of a black & white print. I adjusted the slider in 15 point increments going from -75 to +75.

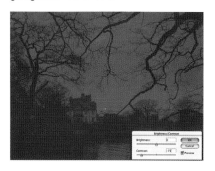

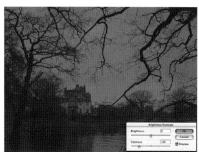

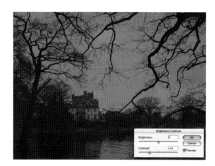

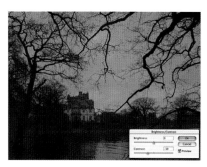

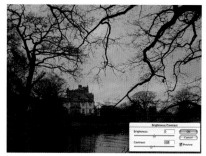

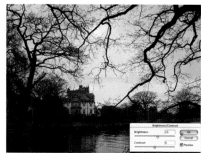

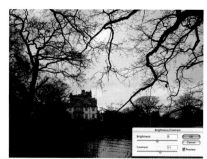

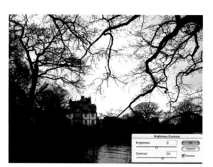

 Tip

● You don't have to adjust the contrast of the whole picture. You can make selections of areas and individually adjust contrast to suit each component – just like printing in clouds using a different grade of paper in the darkroom.

Adjusting contrast in a color image makes colors look dull and subdued when contrast is decreased (left) or vivid when contrast is increased (right). Edges can become overly enhanced so the result looks very digital.

Convert to profile

MENU **IMAGE →**
 MODE →
 CONVERT TO PROFILE

This changed from its previous title of Profile to Profile in version 5.5. It lets you convert a picture into a different color space so you can ensure a more accurate result when viewing or printing. For this book I was given a CMYK profile by the printer which I used to convert all the RGB images before sending them to be printed.

Cursor

The cursor is where all the action is. It's the point of the brush, the insertion point, the Cloning source, etc. and is controlled by the mouse or keyboard arrows.

The way it appears can be changed by going to File→ Preference→Displays & Cursors.

Paint cursors can be set to Standard, Precise or Brush Size. The brush or tool icon appears when the cursor is set to Standard, a crosshair appears on Precise and a shape the size of the brush being used appears with Brush size. Which you use is a matter of personal preference and may vary depending on the work you're doing. Try all three in different circumstances and pick whichever works best.

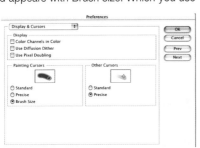

Tip

● The standard curs0r shows an icon of the tool you are using. It's much better if you change to the precision or brush size icons. (See Appendix D)

Crop tool

Use this to be more creative with your composition and cut out wasteful surrounds. Click and hold down the mouse to draw a frame around the subject. Then use the handles to resize or reposition. When you've included everything you want click in the centre to make anything outside the frame disappear.

Photoshop 6 introduced a new version of the crop tool that masks all the area surrounding the crop frame in a colour and opacity of your choice. It's factory set at 75% black which gives a useful gray mask. This is much clearer to work with than previous versions and gives you a far better indication of the effect the crop will have on the image.

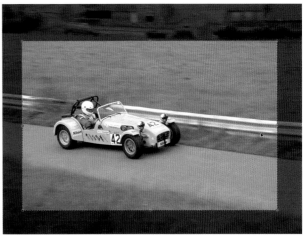

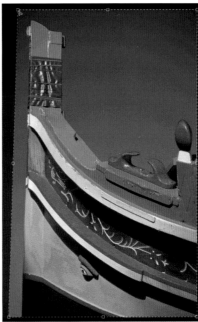

A tighter crop on this shot above adds emphasis to the car. The Crop tool darkens the surrounding area to make it easier to judge the crop.

You can also click on perspective to allow the Crop box to be adjusted to straighten out perspective problems and badly squared shots, like this boat example, or off-vertical scanned images.

C

Curves

MENU	**IMAGE ➜**
	ADJUSTMENTS ➜
	CURVES
QUICK KEYS	**CTRL+M**

Curves is an advanced tonal control that offers the most accurate contrast, color and brightness adjustments of any Photoshop feature.

Its palette has a graph with vertical and horizontal scales representing input and output brightness.

When you first open this you'll see a straight line running through the graph at 45° from the bottom left to the top right. The bottom left represents the shadow area, top right is highlights and the mid-point is midtones. You can drag the line by clicking on it and holding down as you move the mouse.

Moving the midpoint up has a lightening effect and down darkens the image. Use the Eyedropper tool and Ctrl+click anywhere on the image and its brightness value will appear as a point on the line. You can then move this point up or down to darken or lighten that part of the image. The picture will look natural, providing you create either a straight line or an arc. The best results are usually achieved with a very shallow S shaped curve, and is the reason why its called Curves.

You can reverse the graph if you prefer the shadow detail to be at the top right and the highlights at the bottom left by clicking on the arrow on the horizontal bar.

Tips

● If you know what shape curve you want. Select the Pen icon and draw the line in the box. This can be quicker than dragging the line around.

● Hold down the Alt key and click on the grid to make it finer.

Dragging downwards from a point in the middle of the line darkens the midtones without clipping detail from the highlights or shadows.

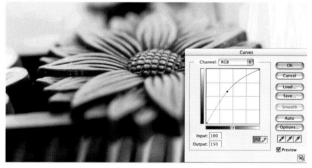

Dragging upwards from a point in the middle of the line lightens the midtones without clipping detail form the highlights or shadows.

Tip

● A new feature in Photoshop 7.0 lets you enlarge the Curves palette by clicking on the icon in the bottom right of the box. This helps you have more precise control of the curves graph. When you've done click on the icon again to reduce it.

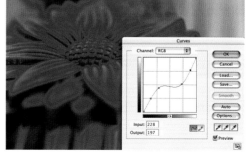

Harsh curves can create posterization. Keep them smooth!

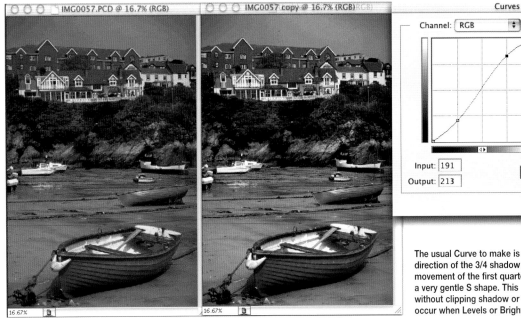

The usual Curve to make is a slight downward direction of the 3/4 shadow areas and a slight upward movement of the first quarter highlight areas, creating a very gentle S shape. This gives a boost to contrast without clipping shadow or highlight detail that could occur when Levels or Brightness/Contrast is used.

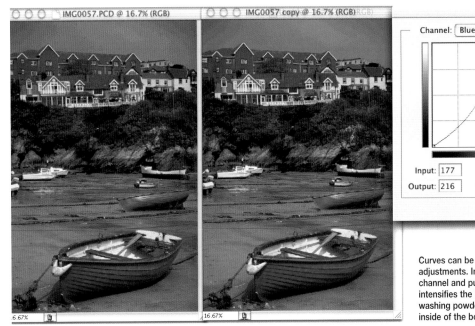

Curves can be used to make minor or major color adjustments. In this example I have selected the blue channel and pulled the highlight area upwards which intensifies the blue in the highlight area. Look how washing powder white the house framework and the inside of the boat are now.

Tip

● If you want extremely accurate control over your image, scan in or convert to 16-bit, instead of 8-bit, giving you a total of 48-bit color in an RGB image. Photoshop doesn't have layers in a 16-bit image, but you can edit the curves using this file and then compress back to 8-bit once you have a perfectly corrected image.

Tip

● If you need to make complex selections that require layers and masks and you are working with the 16-bit image, make a duplicate of the image Image → Duplicate and save this as 8-bit. Work up the selection on the 8-bit image and save this selection Select → Save Selection. Then go back to the 16-bit version and load the saved selection Select → Load Selection. Now perform your curves adjustments.

C

Curves
(cont.)

Left: Pull the left part up from the bottom to top and the right down from top to bottom and totally reverse the image into a negative. Then drag the highlight area across to the right to wipe out all the detail and make the background totally white.

Right: You can also select up to 15 points on the line and pull them in either direction to create snake patterns and very interesting results. This is a mode to experiment with, especially if you enjoy creating surreal effects. If you stumble across a style you like you can save it to reuse on other images later.

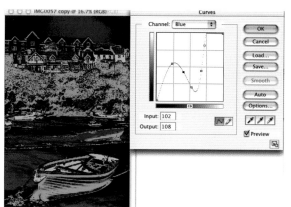

Better black & white

● Curves can be used to enhance your black & white pictures. Simply open up the picture and the Curves palette. First set up target white and black points for the Eyedropper (see Setting White and Black points). With targets set, click on the left-hand Eyedropper tool in the curves palette and, using your mouse cursor, place the Eyedropper icon on the darkest part of the image that you still want to contain minimal detail (deep shadow areas) and click. Do the same with the right-hand Eyedropper on the brightest area that you want minimal detail in (bright highlights) and click to produce an image with a more satisfactory tonal range. You must also choose the area that you click on with care as you could clip detail from the image if you select an area that's lighter or darker than necessary.

The original has a bad color cast.

Saturation is reduced so it becomes monocolor.

The shadow area is picked using the Eyedropper.

And then the highlight point selected which was in the bright sky area.

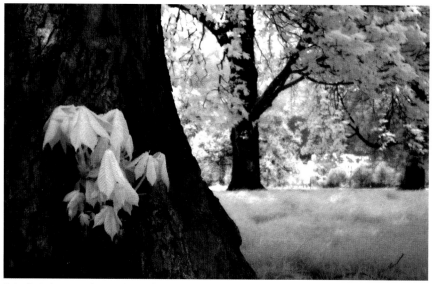

A duplicate layer was then made and Gaussian Blur was applied. Then the layer was blended in Overlay to finish off the improved infrared feel.

Custom color table

Images produced to be used on the Web need small file sizes. Photoshop reduces the number of colors from millions down to just 256 when it saves files as GIFs

and the colors that are used can be saved as a custom table. This picture of geese would contain these 256 colours when reduced.

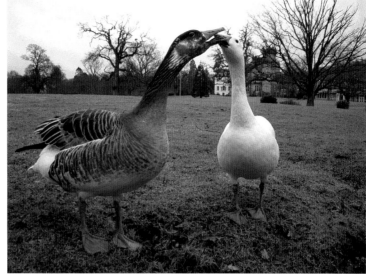

Custom Shape tool

Custom Shapes are selected from the toolbar and when selected they allow you to draw vector shapes that have editable path outlines. They can also be resized without any loss in definition as they are resolution independent.

Shapes can be filled with colors, patterns or images. You can also distort using the Transform tool and save as a selection which can then be saved as a clipping path.

Rectangle Tool	U
Rounded Rectangle Tool	U
Ellipse Tool	U
Polygon Tool	U
Line Tool	U
Custom Shape Tool	U

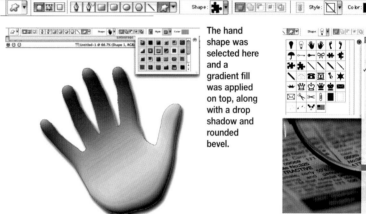

The hand shape was selected here and a gradient fill was applied on top, along with a drop shadow and rounded bevel.

The full selection of Custom Shapes that come with Photoshop 7.0 are seen here.

The Jigsaw piece Custom shape was selected and its path made into a selection. Then the new image was pasted into the selection – Edit→Paste Into. This creates a new layer with a layer mask that can then be edited.

Darken mode
(See Blending modes)

Define Brush

MENU EDIT →
 DEFINE BRUSH

A useful feature hidden away within Photoshop's brush edit menu is the Define Brush mode. Selecting part of any image, followed by Edit → Define Brush, will allow the selection to be used as a brush pattern. The new brushes appear in the Brush palette.

You can also create your own simple graphics and use them as a brush pattern. (See Brushes)

Define Pattern

MENU EDIT →
 DEFINE PATTERN

This is similar to define brush, but requires you to make a rectangular selection and then save this as a pattern using the Edit→Define pattern option. Your saved pattern appears in the pattern group of presets and can then be used to paint a stitched pattern on a canvas using the Pattern Stamp tool. (See Pattern Maker)

A sample area was selected from the rocks (above) and then, once defined, the pattern was selected from the drop down menu (left) and used to paint the rocky pattern (below). Use this to make effective backgrounds.

Defringe

MENU LAYER ➜
 MATTING ➜
 DEFRINGE

No matter how hard you try, when cutting round a subject you usually leave a few pixels from the old background. When you paste the cutout to the new background the unwanted pixels may stick out like a sore thumb. This orange flower, for example, cut out from a typical green foliage background has a few dark green pixels around the edge that show up when it's pasted to its new blue background.

The Defringe command changes these green pixels to orange to produce a cleaner effect. Like most commands, you can enter a pixel value, in this case, a width of between 1 and 200 pixels, depending on the nature of your original selection.

The above left is the straight cutout and above right is after a defringe value of 50 was applied to the pasted image. Below is the full version. I tidied up the centre as well by Cloning out the stray petals.

De-interlace filter

A filter used to smooth moving images captured on video.

Desaturation

MENU IMAGE ➜
 ADJUSTMENTS ➜
 DESATURATE

QUICK KEYS SHIFT+CTRL+U

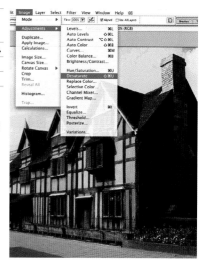

This mode takes all the color out of an RGB image, changing it to black & white without you having to convert it to grayscale. This is useful if you then want to add a color tone. You can also produce this by dragging the Saturation slider to the left in the Hue/Saturation mode.

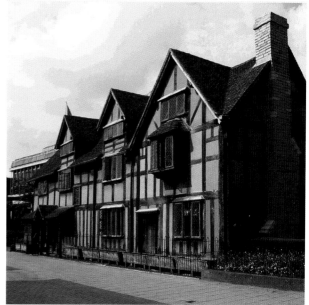

Deselect

MENU SELECT ➜
 DESELECT

QUICK KEYS CTRL+D

Removes the 'marching ants' selection from the image. Ctrl+Z would put them back again.

d

Despeckle filter
(See Noise filter)

Difference mode
(See Blending modes)

Direct selection tool
QUICK KEYS SHIFT+A This is used to pick up Anchor points on a Path made by the Pen tool and either move the entire path, change a point or create a Bézier curve around the subject.

Dissolve mode
(See Blending modes)

Distortion filter
MENU FILTER → A collection of filters
DISTORT → that distort the
image. If you have an older computer be patient, some of these filters are memory intensive and apply to your image at a snail's pace.

Use them with care. If applied to a full image, like the main example, the result may look naff. They are illustrated like this so you can compare the affect of each on the same photo.

Use them creatively on selections within an image and the filters can be much more valuable. Below are a few examples of things to try.

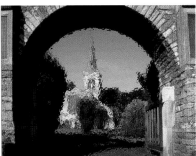

Above: A window created through an archway using the Glass Distort filter. Below: Distorted ripples in the water using the Shear filter. Above right: An oval selection around the flower was inverted and the background was then treated with the Wave filter. Below right: The Zigzag Pond Ripple used was in a selection of just the water.

DIFFUSE GLOW

Creates an effect similar to looking through a soft diffusion filter by adding see-through white noise to the image and a glow, fading from the centre of the selection. Can be used to simulate infrared film effects. The palette has sliders to control the graininess, amount of glow and clear amount.

GLASS

Applies a distorted effect that looks like the view through a bathroom window. There's a choice of four styles and others can be created and loaded manually.

The palette has sliders to control the distortion level, smoothness and scale which can then be viewed in the preview window.

DISPLACE

Changes the image into a pattern that's previously been saved as a Displacement Map. These can be created from your own images or you can use one of the 12 supplied in the Displacement Maps folder within

Photoshop's Plug-Ins folder. These include Tiles, Streaks and Honeycomb. The palette has options to tile a Displacement Map that's too small for the image you're applying it to or stretch it to fit. A tiled Map is the same image repeated to fit to the edges. The stretched version creates interesting effects and can be varied by changing the percentages in the horizontal and vertical scales.

OCEAN RIPPLE

Similar effect to the Glass filter, offering two sliders to control ripple size and magnitude.

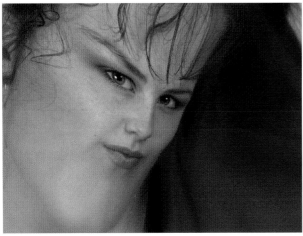

PINCH

A slider that varies from −100 to +100 to make the centre of the image appear to expand like a balloon or squeeze in like an hour glass.

RIPPLE

Another effect like Ocean Ripple that creates a water pattern on the selected area.

The slider controls the amount of ripple and a pull down menu has three ripple sizes.

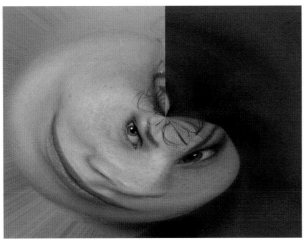

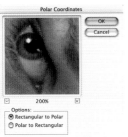

POLAR COORDINATES

Unusual effect with two options to convert the image from either rectangular to polar coordinates or vice versa. Can be used with text to stretch it round an image, or combined with a few other filters to create strange backgrounds.

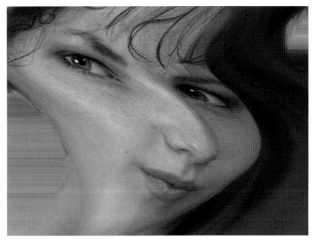

SHEAR

Displays a grid and a straight vertical line that you pull around to make a curved shape. This shape transfers to the selected image, distorting it along the curve.

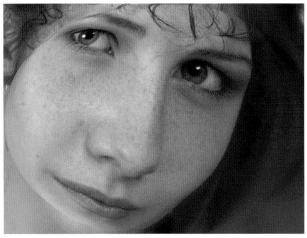

SPHERIZE
In Normal mode it produces a similar effect to Pinch. In Horizontal Only the image becomes thinner or thicker as you adjust the slider and in Vertical Only it becomes shorter or taller.

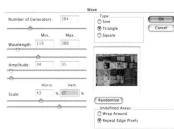

WAVE
An advanced version of the Ripple filter with seven slider and five buttons to choose from that control the number of wave generators, the distance between waves, the height and the type. Experiment at your leisure or press the Randomize button and let it choose a value.

TWIRL
Creates a spiral effect similar to the way water goes down a plug hole. It works in a clockwise or anti-clockwise direction depending on where the slider is set.

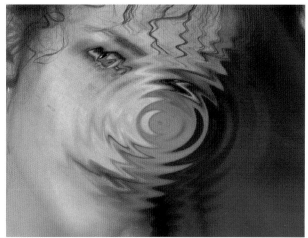

ZIGZAG
Another Ripple style distortion but one that includes the realistic Pond Ripple option. Apply this to water and it will look just like you've thrown a pebble in before taking the photograph.

d

Document Size

Click on the small arrow in the bottom left-hand corner of the image to show a five line menu. One option is Document Size that displays two values. The first is the size of the file if it's flattened to remove Layers data. The second is the value including Layers data and Channels.

Dots per inch (dpi)

This is the measurement used to determine output resolution of a printer or monitor and is often confused with PPI (pixels per inch) which is the capture resolution of cameras and scanners. A 200dpi print means there are 200 dots laid down across every inch of the paper. The latest 2880dpi printers are capable of placing 2880 dots of ink in an inch, but several of these are used in each pixel to ensure the highest color accuracy and that's where the confusion lies. It's understandable to fall into the trap of thinking that you need to create an image with 2880ppi to get the best results from a high spec printer when generally no more than 300ppi images are necessary.

When viewing on a monitor you need even less, as the typical resolution of a monitor is just 72dpi.

Dodge tool

Works like the darkroom dodging device. Hold the paddle over your image and the areas it covers will become lighter.

The palette's options include a menu to set for dodging midtones, highlights or shadows, along with an opacity setting to vary the strength of the dodging effect.

The dodge tool has been used on the background of this image to produce a misty appearance. I also lightened the shaded areas of the pagoda.

Droplet

MENU FILE →
 AUTOMATE →
 CREATE DROPLET

This feature first appeared in version 6.0 and creates a droplet based on pre-recorded action. The droplet is an icon that appears on the desktop that you drag a picture on to to

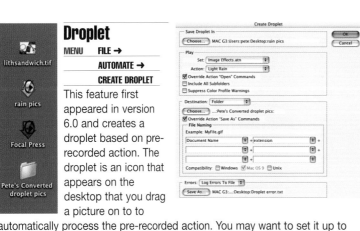

automatically process the pre-recorded action. You may want to set it up to adjust a digital camera picture. Here you could pre-record an action that changes the resolution from 72ppi to 240ppi, adds a faint orange hue to give a feeling of warmth and a touch of Unsharp mask to improve the digital image.

Drop shadow

MENU LAYER →
 LAYER STYLE →
 DROP SHADOW

Photoshop 6.0 introduced this to create drop shadows more easily. All you do is make a selection, go to the filter and apply the shadow. From the palette menu you can choose the Blend mode, opacity,

angle, distance, blur and intensity – play around until you're happy with the results. When you're happy you can apply the effect to your image and save the shadow for use later.

I often use the Drop shadow feature on a small selection of photos placed on one canvas to create a feeling of several pictures being laid down on a piece of paper. The shadow makes them look raised from the canvas. Here's how it's done.

First open the pictures you want to use. Then resize them so they will all fit on the new canvas. Now select one and copy it. Going to File→New produces a canvas the same size as the copied photo. Adjust the size so that it's about two centimetres larger in height and width than the total of the photos, and paste the first one that's still in the clipboard. It will appear in the middle of the canvas. Use the Move tool to get it into the right place. Now copy and paste the remaining pictures, moving each into place. Apply the Drop Shadow on one of the images and then drag the Shadow Effects onto all the other picture layers in the layers palette.

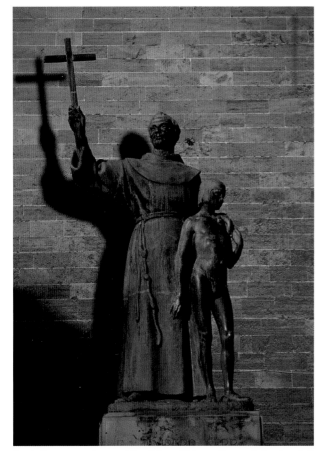

A selection was made around the statue, which was then copied and pasted onto a new layer and a drop shadow created on that new layer.

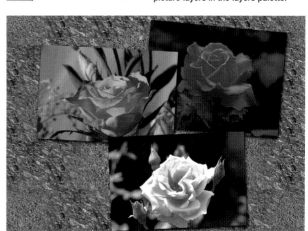

After gently rotating each image, I took advantage of the Pattern Stamp tool to paint the sand and marble textures for a natural background.

Duotone mode

MENU IMAGE ➔
 MODE ➔
 DUOTONE

Grayscale images display up to 256 shades of gray, but a printing press only reproduces around 50 levels per ink. Grayscale images printed with black ink look coarser than ones printed with two or more inks.

Duotones are images with two colors that increase the tonal range of a grayscale image and look stunning when subtly applied. When black is used for shadows and gray for midtones and highlights you produce a black & white image. Versions printed using a colored ink for the highlights produce an image with a slight tint that significantly increases its dynamic range.

You need to be in grayscale mode before you can enter the world of Duotones (Image➔Mode➔Grayscale). Choose a Duotone preset by clicking on Load and locate it in the Presets folder, or create your own color by clicking on the colored ink squares to call up the color wheel.

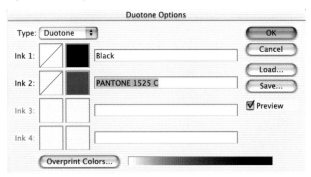

Select a color you like and watch the bar at the base of the palette appear as a range of hues from black to white. If you stumble across a Duotone color effect you'd like to keep click on save and put the *.ado file in a folder. It can then be called up from the Load option when required.

If you're new to color tone adjustments and only intend printing out on an inkjet printer it would be safer to use the Variations edit mode, which is far easier to adjust and can be applied to RGB files. **(See Tritones and Quadtones or Variations)**

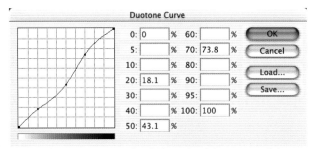

You can edit the duotone curve by clicking on it to bring up a new dialogue box. Moving the curve right makes colors print heavier in the shadows while moving it to the left makes colors print lighter in highlights.

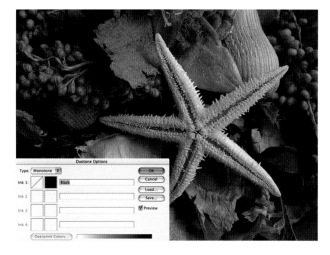

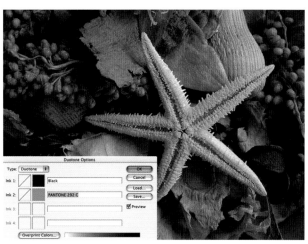

Duplicating images

MENU IMAGE → Opens up an identical copy of the image and
** DUPLICATE** keeps the original open. You can also use the
drag and drop method to duplicate one image onto another and
avoid using up any RAM. Just click on the image you want to
copy, hold down the
mouse and drag the
cursor over to the
destination canvas. If,
as in this example, you
drag a color image
onto a black & white
one it will be
automatically
converted.

Tip

● The Duplicate image mode is helpful if you work with 16-bit files and find the
missing features a handicap. Simply duplicate the image, save as an 8-bit file and
anything you do on this can then be transferred back to the 16-bit version. This is
useful when want to make complicated selections. If you make a selection using a
Quick Mask in the 8-bit copy and then hold down the Shift key as you drag the
selection from the 8-bit image to the 16-bit image it ensures the selection is in
register on the 16-bit version.

Duplicating layers

MENU LAYER → Adding a duplicate layer in the same image
** DUPLICATE LAYER** is useful when you want to produce
complex multi-
layered images
using Blend modes.
Layers can also be
duplicated from
one image into
another using the
same drag and
drop technique, as
described in
duplicating images,
or copied and
pasted.

Tip

● Hold down the Alt
key as you duplicate
the image to add
'copy' automatically to
the end of the title.

Dust & Scratches filter
(See Noise filter)

Edges

An edge is formed where adjacent pixels have high contrasting values. Photoshop has a number of filters that detect these and apply contrast reducing or increasing effects to soften or sharpen the image accordingly.

The top half of the picture (left) is an enlarged part of the stem of the plant in the picture above.

The Find Edges filter picks up all the areas of edge contrast and produces an almost posterized version that highlights these edges.

Elliptical marquee tool
(See Marquee tools)

Embedded profile mismatch

This box appears when you open a picture that has an embedded profile that is different to the one you use for your working color space. You then have three options. For best results you should select Convert providing you have set up your color management correctly.

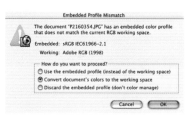

Emboss filter
(See Stylize filters)

Equalize

MENU IMAGE →

ADJUSTMENTS →

EQUALIZE

A quick fix that can help brighten up a dark scanned image that cannot be improved using Auto Levels. When you apply the Equalize command Photoshop redistributes the brightness values of the image's pixels so that they more evenly represent the entire range of brightness levels. It does this by finding the brightest and darkest values in the image and then adjusts the levels so that the brightest value is white and the darkest value is black. It then equalizes the brightness by distributing the intermediate pixels evenly throughout the grayscale.

You can also equalize just a selected area of an image by using one of the selection tools before you go to the equalize menu. In this mode you also have the option of applying the values within that selected area to the whole photo.

Equalizing picture A would produce picture B. This is because the photo has dominant areas of tone such as the black trousers which caused the process to overcompensate. By making a selection of the top half in Picture C and choosing 'Equalize entire image based on selected area' you get a better result as illustrated in picture D.

Eraser

Use this to remove pixels, replacing them with the background color, or to a previous state using the Erase to History option, or to an underlying layer.

Eraser Tool	E
Background Eraser Tool	E
Magic Eraser Tool	E

The Eraser options bar lets you select the opacity of the Eraser and can be set to gradually fade out in a selected number of steps.

You can choose from three brush styles including Paintbrush, Pencil and Block (users of version 6.0 please note that the Airbrush is now selected from a separate icon) and also vary the size of these from the Brush options box.

The Paintbrush has a Wet Edges option that produces a stronger effect towards the edges of the brush stroke.

The Erase to History option was selected here with a point before desaturation took place. Then when you erase you bring back the original color.

Tip

● Shift+E rotates through the varies brush options.

56

Exclusion mode
(See Blending modes)

Exif data

Most digital cameras now capture and store information about the picture such as exposure details, file properties, etc., and this data, known as Exif data, stays with the picture and can now be read by Photoshop. This is very useful when you are learning photography and want to compare pictures and see what works and what doesn't.
(See File Browser and File info)

Exporting files

MENU **FILE →** Photoshop comes
 EXPORT → with two plug-in
modules to export files to GIFs (using File→Save for Web or Paths to Adobe Illustrator). Paths to Illustrator converts Photoshop paths created with the Pen tool into Illustrator files.

Exporting from clipboard

As with most programs that handle pictures and text, when you copy an item it is saved in the program's clipboard. Photoshop is just the same, so pictures can be copied and then pasted into other programs.

Exposure correction

When an image is too dark or too light, caused by either poor scanning or a badly exposed original, it can be corrected using several Photoshop features.
(See Levels, Curves and Brightness)

Auto Levels have been applied to brighten up the right-hand side of this highly filtered image

Extract

MENU	FILTER →
	EXTRACT
QUICK KEYS	CTRL+ALT+X

This feature, introduced in Photoshop 5.5, makes selecting objects from their background easier and is especially useful on complex cutouts such as hair.

You first draw around the edge that you want to cut out using the Edge Highlight tool. Then fill the inner area with the Fill tool. When you click 'preview' the command goes to work and produces a foreground cut out on a transparent background.

If you're happy with the preview cutout click on OK and the extraction is applied. In a few moments you are delivered a cutout that can then be dropped onto another background.

Version 6.0 has a few new features added to make the selection process even easier. Draw around the edge using the Smart Highlight tool and it calculates how easy it is to select the object and adjusts the thickness of pen to suit. If the edge detail is complex it makes the pen line thicker and if the edge is well defined the pen line becomes thinner.

Paint over the edge that you want to cut round ensuring foreground and background areas are both covered by the highlighter. Use a larger sized highlight brush to paint over areas that aren't easy to define such as the hair where fine strands appear. Select a smaller size brush for the definite edges such as this girl's blouse.

The Smart Highlight tool, introduced on version 6.0, automatically adjusts pen thickness as you draw around the subject you want to extract.

Cutting round the hair on this photo could be really difficult to do using one of the normal Selection tools.

When the selection is complete click in the centre, using the bucket/fill tool and then click on preview to see the extraction take place.

Depending on the speed of your computer's processor and the size of the image this could take a few minutes, or longer, to perform the task.

Extract
(Cont.)

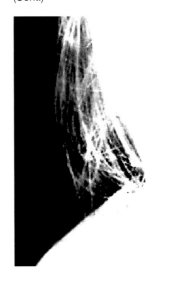

The extracted image can be viewed in a number of ways. The preset version appears with a transparent background, but you can also select a gray, white (above middle) or black matte (above right) which are often more useful to display how good the cutout is. You can also select your own color, using the color picker. Version 6.0 even has an option to view the cutout as a mask (left).

It helps to look at the preview in the mask mode when using the new Clean Up and Edge Touch up editing tools. Both are used after the preview has been made to improve the accuracy of the extraction.

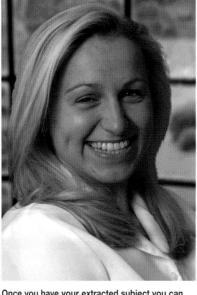

Once you have your extracted subject you can either drop the picture onto an existing canvas or create a new one with an interesting background. Here the green canvas effect (right) was achieved in Photoshop using the Clouds filter, followed by Contrast adjustment, Gaussian Blur and a dark vignette. You could also use one of your own photos as a ready-made background as I have done here with the picture of an old leaded window frame (above).

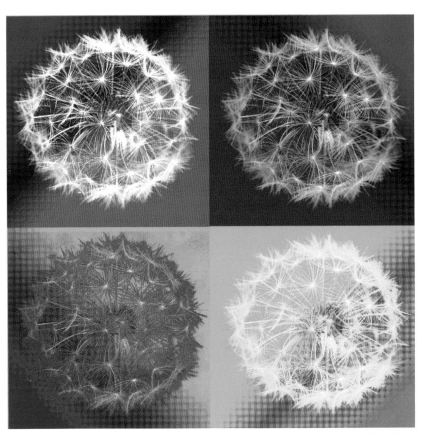

The extract mode is great for cutting round hair, but not for more complex subjects such as Dandelion Clocks. This example was brushed over using the Magic eraser before being pasted into this grid of color. If the Extract tool had been used I would have had to paint within all the inner areas of the seeds and it would have taken for ever!

Eyedropper

This tool is normally used to select the foreground or background color and the only control you have is selecting the sampling area which can be accurate to one pixel, 3x3 or 5x5. Simply position the dropper end over the area you want to sample and click the mouse to take the sample which becomes the foreground color.

Holding down the Alt key

when you click selects the background color. The Eyedropper also appears in several other palettes, including Replace Color, Color Range, Levels, Curves and Hue/Saturation.

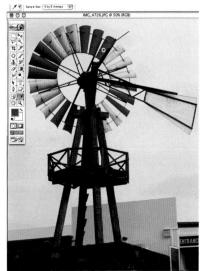

Tip

● Some areas of the image that you wanted to keep may have been erased. If this happens set the History brush onto the stage prior to the extraction and paint back the missing pixels.

Tip

● Hold down the Alt key while using the Airbrush to convert it into an Eyedropper.

Fade command

MENU	EDIT →
	FADE
QUICK KEYS	CTRL+SHIFT+F

The fade feature in the filter menu of version 5.5 has been moved to the edit menu on version 6.0 and now allows any filter or color change to be reduced in strength using this fade control. The effect can also be adjusted using the fade with a Blend mode making the filter appear as though it's on a separate layer to give a completely different feel. Definitely one to experiment with.

The Fresco effect from the Artistic filter menu has created a moody oil painting (middle). The Fade command, set to Luminosity Blend mode, gives added sparkle in the greens which is further enhanced by increasing brightness and contrast (bottom).

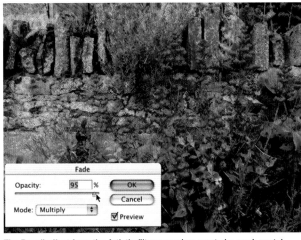

The Pencil effect from the Artistic filter menu has created a weak pastel result (left). The Fade command, set to Multiply Blend mode, increases contrast to give more vibrant coloring (above).

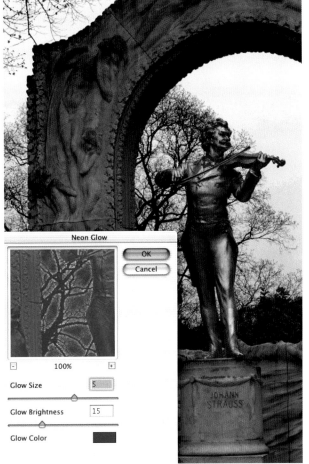

Taking the fade mode a stage further, I've applied few filter effects to this photograph of the Johann Strauss statue and then used the Fade command in various Blend modes to show what affects can be achieved. Turn the page for a visual feast.

The Neon glow filter was applied to the six examples on this page, followed by the Fade command, set to Color Dodge, Darken, Difference, Hue, Saturation and Pin Light Blend modes. Each had opacity adjusted to suit the filter fade.

f

In the three examples above the Diffuse Glow filter from the Distort filter set was applied first, followed by the Fade command, set to Difference, Color and Vivid Light Blend modes.

In the three examples below the Charcoal filter from the Sketch filter set was applied first, followed by the Fade command set to Color Dodge, Overlay and Dissolve Blend modes.

f

In the three examples above the Channel Mixer from the Image → Adjustments menu was applied first, followed by the Fade command, set to Darken, Difference and Linear Burn Blend modes.

In the three versions below the Find Edges filter from the Stylize filter set was applied first, followed by the Fade command set to Color Dodge, Luminosity and Overlay Blend modes.

Feathering

MENU	SELECT →
	FEATHER
QUICK KEYS	CTRL+ALT+D

Useful feature that's used to soften the edge of a selection before you cut out or add a filter effect.

You control the pixel width of feather from the selection area inwards and outwards. The result is a gradual softening rather than a harsh edge.

A small feather of one or two pixels is all that's needed to make a cutout appear less obvious when pasted on a new background. A large feather of around 30 is better when you're adjusting the brightness, contrast or color of a selection within an image. As with most features it's best to try several settings before committing the image to disk.

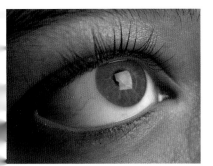

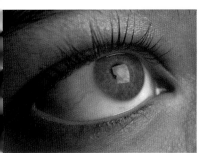

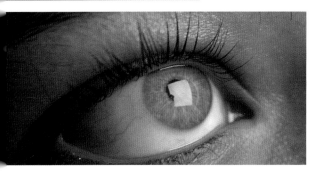

Feathering can be used to remove red-eye caused by flash or to color the pupils. Left top is what happens if you don't feather the selection. Left middle has a large feather so the red has bled into the white. In this example a +20 feather gives the best result with, apart from the choice of color, a realistic feel. A feather of +20 will not always be right, it depends on the total size of your image. Start at +20 and repeat stages until the ideal most effective size is discovered.

Feathering is ideal for wedding and portrait photography where a vignette is required. Simply make a selection, feather, then paste onto a new white canvas. Left: Selection made with no feather. Middle: 100 feather. Bottom: 200 feather.

f

File Browser

If you've had a go with Adobe Elements you'll already be familiar with this new Photoshop 7.0 addition – a File Browser that looks much like a Windows Explorer interface. Folders on the left, when double clicked, open up on the right so you can view the contents. Select a folder of images and the contents appear as easy to view thumbnails that can be changed in size.

The layout can be changed so you can view small, medium or large thumbnails, and text alongside the pictures. Clicking on a thumbnail creates a large preview back on the left with information about the photograph. If you have pictures taken with digital cameras and haven't changed format it will also show details of the camera used and full exposure details.

You can also rename thumbnails in the browser, which alters the name of the original in its folder. You can also alter the orientation from horizontal to vertical or vice versa and when you next open the image in Photoshop it will automatically rotate to the correct format.

Below: The browser seen in Large Thumbnail view. Top right: In Medium Thumbnail view. Right: Showing file info using Details option.

File conversion

Photoshop files can be converted into other formats suitable for different uses. When you save an image, select File→Save As and pull down the Save As menu bar in the palette to see a list of file formats to choose from. Then drag the cursor over the one you want to save in that format. Help screens will appear where necessary.

File format

Digital pictures can be saved in numerous formats, each having distinct advantages, well most do! The JPEG format is one of the most popular, so is TIFF, EPS, GIF and not forgetting Photoshop's very own PSD format. (See the entries of individual file formats).

File optimizing

You should always optimize pictures when saving them for Web use. The idea is to remove any color that can't be seen be a Web browser as well as resizing to suit the viewing conditions (usually Mac or PC monitor) and saving it all in the most suitable format (usually JPEG or GIF). This is made easier when you use the Save for Web option in Photoshop.
(See Save for Web)

File info

MENU **FILE →** A dialogue box with
 FILE INFO several sheets. The
first has spaces to add a picture caption, headline and special instructions that can be saved and used on future projects. The second has room to enter key words. Next is the category file, then credits, copyright option and contact details. Each one can be accessed by Caps+1, Caps+2, etc. The last is new to version 7.0 and reads Exif information that was recorded by a digital camera such as shutter speed, aperture and file size.
(See Exif Data)

Filling color

MENU **EDIT →** Works like the Bucket
 FILL tool and drops color into
the selection. Choose to fill using the foreground or background color in the palette. You can also adjust opacity and select a Blend mode to vary the result.

Tips

- When filling a selection, use the Feather control first to get a softer fill effect (see images below).
- Press the Ctrl+Delete keys to fill the canvas or selection with the foreground color.
- Press Alt+Delete to fill the selection with the background color.

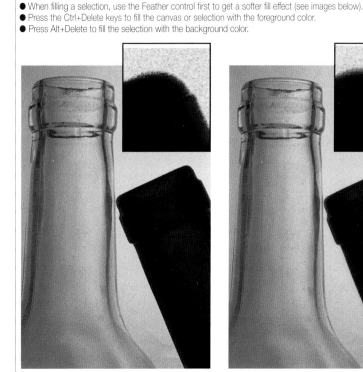

Fill Layer

MENU LAYER →
NEW FILL LAYER → A time saving feature that was introduced with version 6.0. Lets you fill a layer with a solid color, gradient or pattern. Fill layers do not affect the layers underneath them, but can be used in a composite picture to add a color, gradient or pattern to an image which becomes more effective when the fill layer's opacity is reduced.

Here I set the fill layer to gradient and added an orange gradation. Notice how the layer blocks the layer below. I then selected Multiply from the Blend mode menu to allow the layer below to come through. The original blue of the lower layer has now blended with the yellow in the fill layer to create a green band.

The old tower ruin, far right, gives you some more examples of what can be done.

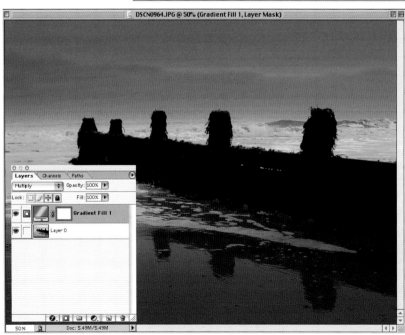

Setting the foreground color to black will introduce a dark and moody gradient (above), while orange gives a sort of sunset effect (right).
You could also add a pattern fill (below)...but maybe not for this shot!

Filters

These are effects that change the look of the photograph by altering the pixels. There are many filters supplied with Photoshop, but many more can be added from third party developers.

Filters are found in the, surprise, surprise, filter menu and are listed individually in this book. The filter effect, and time taken to apply it, will vary due to the number of pixels in the picture. A low resolution picture (above left) will process quickly, but the effect may be very harsh, whereas a high resolution image (right) delivers a more subtle result.

Find and replace text

MENU EDIT →

FIND AND REPLACE TEXT

Another new word-based feature that's new to version 7.0 This is used to search through text and

replace one word, punctuation or sentence with another. Just key in what you want to replace in the 'Find What' box and what you want to change it to in the 'Change To' box. Then click 'Find Next'. The program searches for the words and highlights the first example it comes to. You then can change just the found words or change all occurrences or change the found ones and then let it find the next.

Fit image

MENU FILE →

AUTOMATE →

FIT IMAGE

An automated feature that resizes the image so that it will fit within a certain predetermined canvas space. If, for example, you have the measurements set to 680x480 and apply the Fit image command to a 600x600 picture it would reduced it to 480x480. This helps when you need to resize pictures to suit a newsletter or catalogue format with predetermined picture boxes.

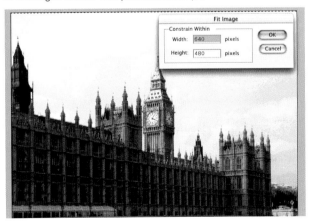

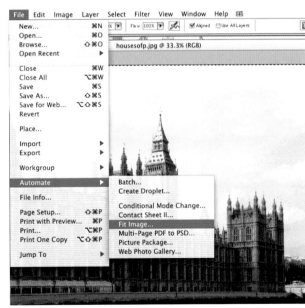

Here a landscape format of 640x480 pixel measurements was selected to suit viewing on a basic monitor. This reduced the height of the portrait format picture to 480 pixels.

f

Flatten image

MENU **LAYER →** **FLATTEN IMAGE** Images with individual
layers can only be saved in the
Photoshop PSD file format and
need to be merged (flattened) if you
want an alternative format. Merging
layers reduces the size of the file so
it's worth doing if you're totally
happy with your results.

In this example eleven layers
are used which result in a 25Mb
image (above). When merged
the file size becomes just
5.72Mb (below).

Tip

● If you want to keep the image with layers but need a version in another file
format, choose File→Save a Copy to create a flattened duplicate.

Foreground color

QUICK KEYS SHIFT+X
The foreground
color is used to
paint, fill
and stroke
selections and
appears as the
upper square in
the toolbox. You
can change the

color by either sampling from an image using the Eyedropper,
clicking on the colored square to call up the color picker, or
choosing Window→ Show color to bring up the Color palette.

Freehand Lasso tool
(See Lasso tools)

Freehand Pen tool
(See Pen tools)

Full screen mode

QUICK KEYS F SELECTS IT FROM TOOLBOX If, like me, you have loads of desktop
icons floating around untidily and, often,
several applications open at once you may find it becomes
difficult to work with Photoshop and its many palettes. The full
screen mode, selected from the toolbar, removes all the clutter

to make it much
easier to see the
image. Choose full
screen with menu
items when you need
to access modes or
full screen when
working on a picture.
The F key runs
through each option
in a cycle.

Fuzziness setting

A similar feature to Tolerance that determines how many colors
are selected by the Eyedropper tool in the Color Range mode.
Sliding the control to the right increases the fuzziness and
allows a larger range of colors to be picked.

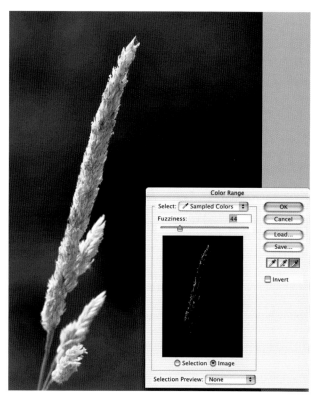

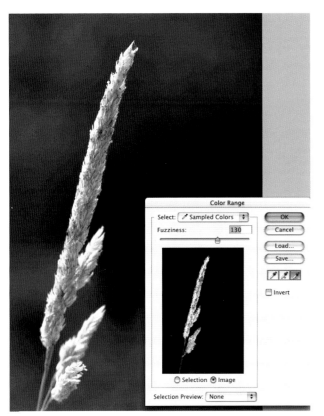

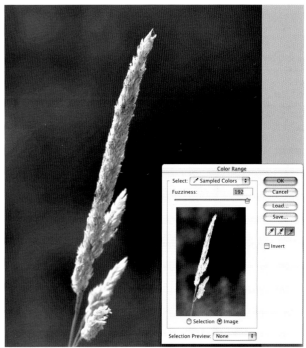

The same example with a higher fuzziness setting of 192 picks up all the grass, but also much of the background too.

In this example I have taken a sample from the grass using the Eyedropper tool and a high fuzziness setting of 130. The preview shows that the selection includes all the grass and avoids picking up background pixels.

Tips

● Avoid high fuzziness levels – they create blurred edges and settings too low can cause jagged edges and missing selected pixels.

● Keep your finger held down on the mouse button as you move around the preview image with the Eyedropper icon. This will continually adjust the selection.

abcdef**g**hijklmnopqrstuvwxyz

GIF format

Global light

Glow effect

Gradient Editor

Gradient Fill

Gradient Map

Gradient Mask

Gradient tool

Grain

Graphic tablet

Grayscale mode

Grid

Guides

Gamut warning

MENU	VIEW →
	GAMUT WARNING
QUICK KEYS	SHIFT+CTRL+Y

The range of colors a computer monitor can display is known as the gamut and the monitor's gamut has a larger range of colors than an inkjet printer can often output. If you don't watch out the vivid colors you've been editing will appear looking dull and lifeless. The Gamut warning's job is to prevent disappointment when you work in RGB mode. It does so by highlighting all the pixels that are out of gamut so you can modify the color before printing. Go to File→Preferences→ Transparency & Gamut to adjust the color used as a warning.

A small exclamation mark also appears above the color in the Color Picker and Color palette when a color is out of the printer's gamut. You should adjust the saturation to reduce the areas indicated in the warning to a minimum using the Sponge tool or saturation control. **(See Saturation and Sponge tool)**

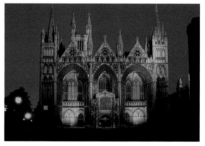

The rich blue sky visible as darkness falls is way beyond the gamma of a printer and when the warning is set, in this case to display out of gamma colors as red, the picture is washed in red (below).

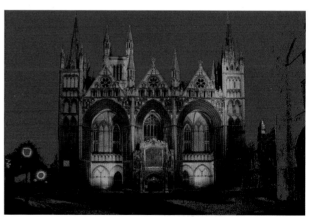

Pressing the keys Shift+Ctrl+Y while viewing the color picker will also show you the out of gamut range of color using the preselected color, in our case red. Move the Eyedropper outside this range to ensure a safe printable color.

Gaussian blur
(See Blur filter)

Glass filter
(See Distortion filter)

Global light

MENU **LAYER →**
 LAYER STYLE →
 GLOBAL LIGHT

Several layer effects, such as Drop Shadow and Inner Bevel, give you control over the angle of lighting. Selecting Global lighting ensures that all the layer effects have the same lighting angle so the result looks more natural. If you don't want all the layer effects to be uniform go into the effect you want to have its own light and turn off the use global lighting option.

GIF format

A GIF (Graphics Interchange Format) is an image with a reduced palette of 256 colors or less that's ideal for viewing on the Web. Photoshop files can be converted to GIFs using File→Save As, File→Export or from within Adobe's Image Ready program which is now supplied as part of Photoshop 5.5. GIFs can be saved as normal or interlaced versions that appear gradually on screen as they download from the Web.

Glow effect

MENU **LAYER →**
 LAYER STYLE →
 OUTER/INNER GLOW

A glow effect looks particularly effective when produced around type and can be made to appear from inside or outside the selection in any color. The mode is great for creating fancy headlines for Web sites or newsletters.

Glow can be used on text (right) selections around images (left) or vector art (below right). You can control the opacity, blur and intensity of the glow along with the Blend mode from within the Effects palette.

g

 Mode: Screen Opacity: 100% Reverse ☑ Dither ☑ Transparency

Gradient tool

QUICK KEY G Interesting skies, colorful backgrounds and rainbows are all easily created by selecting the Gradient icon from the toolbox. This brings up a choice of five gradient patterns, from the options bar, that include Linear, Radial, Angular, Reflected and Diamond – each designed to create a smooth blend from one color to another.

As with most Photoshop tools you can adjust the opacity and Blend mode to control the effect the gradient has on the base image.

There's also a decent range of preset

| | Gradient Tool | G |
| | Paint Bucket Tool | G |

color gradients to choose from, or you can edit your own by double clicking on the icon to brings up a Gradient Editor dialogue box. **(See Gradient Editor)**

Adjust the Editor to create a rainbow style color and then set it to screen mode and apply it using the Gradient tool. Create the rainbow on a new layer and use the blend mode to introduce a stormy sky.

Gradient Editor

The Gradient Editor appears when you click on the gradient currently displayed in the options bar (top of page). From the editor you can select any of Photoshop's predesigned gradients and edit these or make your own from scratch. You can select any color and adjust its position on the scale. The bottom sliders control the position of the color and the top ones the strength, or opacity, of the color. Click on the top of the bar to bring up a marker, which can be dragged to position and you change the opacity using the box below.

The Gradient tool has a selection of presets that can be loaded. The set above is Pastels and there are seven other sets to choose from.

Gradient Fill

MENU LAYER →

NEW FILL LAYER →

GRADIENT

The Gradient Fill is placed on a new layer so it can be edited without affecting the underlaying layers. You can select any of the five gradient styles and adjust the angle and scale. This cannot be done using the gradient tool unless you undo and draw again so it makes it more versatile.

To create the Gradient Fill just click on the image at

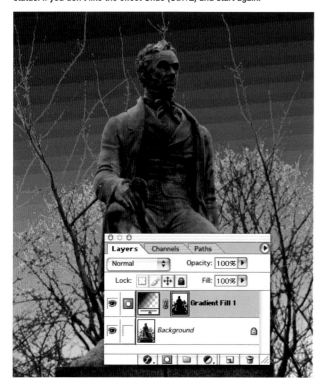

the desired start point, drag to the end point and release to flood the image with color. In this example I selected the sky so that the fill didn't affect the statue. If you don't like the effect Undo (Ctrl+Z) and start again.

Tips
● Ticking the Dither box prevents any banding in the gradation.
● The Gradient tool doesn't work on Bitmap or Index color images.

The Gradient Fill appears in the channels box as a Gradient Fill Mask when it has been applied over a selected area.

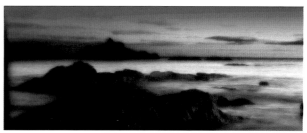

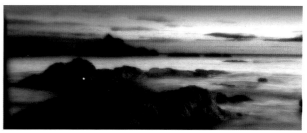

Tip
● To have more control of where the gradient begins reduce the picture so you can draw the gradient line outside the picture area. In this example It's made the gradient less harsh.

A blue/transparent gradient was used on this already heavily edited image. You control how much of the image is affected by dragging the mouse across the picture at different lengths. Top to bottom: long, medium and short drag.

Gradient Map

MENU IMAGE →
 ADJUSTMENTS →
 GRADIENT MAP

This converts a color image to grayscale and then lets you apply one of the pre-selected gradients to replace the gray tones with new, posterized colors. You can edit the gradient and watch the preview to help achieve the desired result. The left color replaces blacks the right one replaces whites and any in the middle will replace gray tones. It's like having full control of the posterization mode.

When you select a gradient from the editor your image is instantly turned into a graphical color display. Thousands of combinations can be created easily and then you can go off and change colors using Hue/Saturation or, as below, copy the layer, add a new style and blend.

There's no limit to what you can do. Here I copied a layer with a Steel Bar gradient map and then added a blue gradient and faded this using Normal (below left) and Multiply (below right).

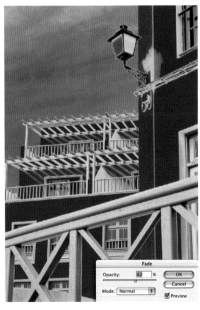

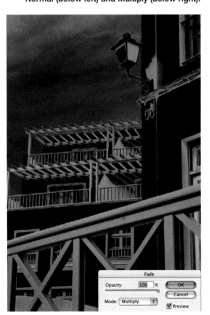

g

Gradient Mask

MENU LAYER →
 ADD LAYER MASK →

Adding a Gradient Mask to a layer makes the image take on the gradient when blending with other layers. This is useful for complex image creation. The mask can then be edited to change the shape of the gradation by adding or subtracting from it. **(See Layer masks)**

Use the Radial Gradient tool to add a dark vignette. This is a useful tool for low key vignettes on wedding and portrait photos.

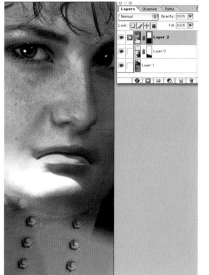

To show how the Gradient Mask can be put to use I've merged three photographs – a portrait sculpture and metal girder. The metal girder was first rotated to suit the angle of the neck on the sculpture, then a black to transparent mask was added to the sculpture layer so that the image fades to transparent. This was repeated on the girl layer and now you can't see the joins.

Grain

Film-like grain can be added to pictures using either the Noise filter or the Diffuse Glow with the Glow slider turned down and Grain increased.

You could also try creating your own grain pattern and add it as a new layer using a Blend mode.
(See Noise filter)

Graphic tablet

A graphic Tablet such as the Wacom Graphire II has a special pen that replaces the computer mouse to control the on-screen cursor. Using a pen gives you much more natural control and makes it much easier to draw or paint and trace around objects when making cutouts.

Photoshop has support for most tablets and using one opens up some extra features such as pressure sensitivity when using the airbrush. These appear on the options bar along the top of the image. The pen can often be reversed so the other tip can be used as an eraser.

Tablets can go up to sizes as large as A3 which are used by designers. There's even one available that displays the image so you can draw around the actual picture.

This Wacom table, like many others, has a transparent sheet that lifts so you can place a photo or artwork under and trace around this to draw a replica on screen.

Grayscale mode

MENU	IMAGE →
	MODE →
	GRAYSCALE MODE

Produces an image made up of 256 gray tones from black to white. You can't adjust Hue or Saturation in this mode, but Brightness and Contrast can be controlled. Use this mode to convert original color images to black & white.

Tip
● An image converted from color to grayscale may look a little flat. Adjust levels to brighten up the tones.

Tip
● Before converting to grayscale have a look at the tonal range in each channel. You may find that the tones in one channel look better than the other two and if you covert to grayscale while in this channel it will use the brightness values of just that one channel.

Grid

MENU **VIEW →**
 SHOW GRID
QUICK KEYS **Ctrl+'**
A non-printing grid of horizontal and vertical lines that's used to arrange elements symmetrically within an image and to straighten up sections, making it perfect for use with the Transform→Perspective feature.

Selections snap to the grid so it's easier to create and align the same sized boxes.

It can be difficult to edit a picture when the grid is turned on because the lines may get in the way. Using the quick keys to switch back and forth will make it easier to work.

Tip

● Select View→Snap to Grid and the painting tools will follow the grid making it easy to paint in straight lines.

Guides

MENU **VIEW →**
 SHOW GUIDES
QUICK KEYS **Ctrl+;**
These are horizontal or vertical lines that can be pulled out from the edge rulers to appear over the image. If the rulers aren't visible go to View→Show Rulers.

Guides can be used to align text or for laying out parts of the image in a symmetrical pattern. Go to Preferences→Guides & Grid to choose the guides' color and style (straight or dotted line). The guides will not print and can be removed or repositioned using the Pointer tool.

As with the Grid, Paint tools will snap to the guides if the Snap to Guides option is selected from the View menu.

Go to Preferences to change the number of lines per cm and the subdivisions. Choose a different color if the subject clashes with the current choice.

h

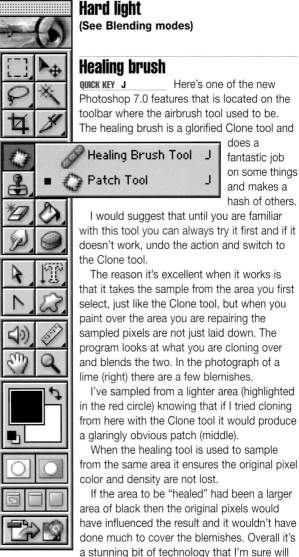

Hard light
(See Blending modes)

Healing brush

QUICK KEY J _____ Here's one of the new Photoshop 7.0 features that is located on the toolbar where the airbrush tool used to be. The healing brush is a glorified Clone tool and does a fantastic job on some things and makes a hash of others.

I would suggest that until you are familiar with this tool you can always try it first and if it doesn't work, undo the action and switch to the Clone tool.

The reason it's excellent when it works is that it takes the sample from the area you first select, just like the Clone tool, but when you paint over the area you are repairing the sampled pixels are not just laid down. The program looks at what you are cloning over and blends the two. In the photograph of a lime (right) there are a few blemishes.

I've sampled from a lighter area (highlighted in the red circle) knowing that if I tried cloning from here with the Clone tool it would produce a glaringly obvious patch (middle).

When the healing tool is used to sample from the same area it ensures the original pixel color and density are not lost.

If the area to be "healed" had been a larger area of black then the original pixels would have influenced the result and it wouldn't have done much to cover the blemishes. Overall it's a stunning bit of technology that I'm sure will find its way into the competitors' products soon.

A close-up section of a scanned Polaroid Instant Black & White slide. As you can see it's a very dusty example. This would be very slow to sort out using the Clone tool, but this area took just over a minute using the Healing brush.

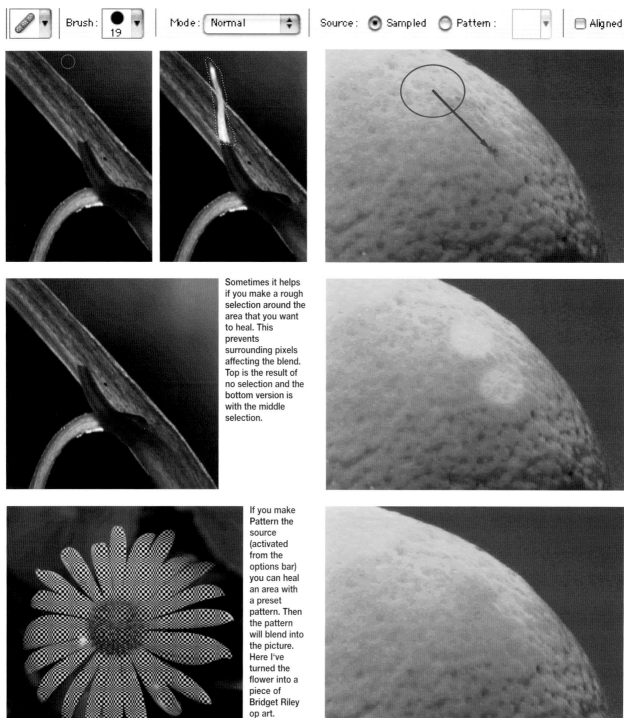

Sometimes it helps if you make a rough selection around the area that you want to heal. This prevents surrounding pixels affecting the blend. Top is the result of no selection and the bottom version is with the middle selection.

If you make Pattern the source (activated from the options bar) you can heal an area with a preset pattern. Then the pattern will blend into the picture. Here I've turned the flower into a piece of Bridget Riley op art.

Here's where the Healing brush (bottom) is far more practical to use than the Clone tool. Try removing the couple of blemishes using the sample point indicated with the Clone stamp and you will create light blotches.

Help

QUICK KEYS **CTRL+?** Photoshop 6.0's help menu has a new, brighter interface and, as well as linking to all the stuff provided on the CD that comes with the program, it goes direct to the Web as an extra resource. This ensures we can keep on top of the program and receive any updates that Adobe throw at us.

Highlights

The brightest parts of the image with detail that will still print. These can be adjusted using the clear triangle on the slider control that appears on the right-hand side of the Levels graph.

Histogram

MENU **IMAGE →** **HISTOGRAM** A graph that plots the image in a series of pixel values from 0 (black) to 255 (white) and looks like a mountain range profile.

The horizontal scale represents shadow to highlight detail and the vertical axis is the number of pixels at a particular point. You can view the histogram of each of the RGB channels individually or as a group. It's used to check whether your image is suitable for printing and can be edited in the Levels palette by adjusting highlight, shadow and midtone sliders.

A low key image appears with most of the peaks concentrated in the shadow area at the left-hand side.

A high key image has the peaks in the highlight area to the right.

The average tone image should have a graph that rises from the far left, peaks across the middle section and falls to the far right.

History brush

QUICK KEY Y Use this to paint in details from a previous stage of editing. Click on the box that appears in the History palette at the stage in the image editing process that you'd like to apply and paint onto the new level.

 This is a great option if you're

> History Brush Tool Y
>
> Art History Brush Y

considering hand-coloring a black & white image. Cheat by starting off with a color image and convert it first to grayscale to discard all color information and then back to color. The black & white image can then be colored using the History brush. Click on the left of the opening image to turn on the History brush icon. Then click on the latest stage and begin to paint.

Tip

● Set the brush opacity to around 50%, turn the Impressionist feature on and brush erratically over the image for a surrealistic watercolor wash.

History palette

Every task you perform in Photoshop 5.0 upwards is recorded as a step, or state, in the History palette. This allows you to go back up to 100 previous stages when an image you're working on starts to go wrong. A slider on the left-hand side can be dragged slowly through the stages to help you find when things start to go wrong. Simply click on the last stage that you were happy with and start again to change history – if it was just that simple in life!

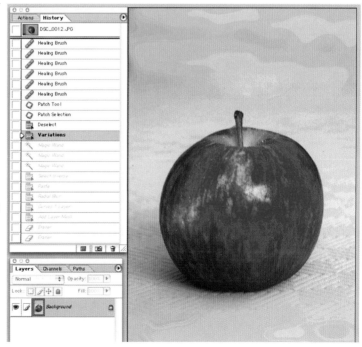

84

Hue

Hue is the image color and varying the Hue slider changes the overall color. The scale runs through the colors of the rainbow starting at the left with blue.

 This picture of a fairground ride shows the effect the Hue slider has over the color when adjusted in 30 unit increments. **(See Blending modes)**

Hue: 0 (original)

Hue: +180

Hue: +150

Hue: +60

Hue: +30

Hue: -90

Hue: -120

Hue: +120

Hue: +90

Hue: -30

Hue: -60

Hue: -150

Hue: -180

Image Assistant

A new feature that appeared in version 6.0 under the Help menu offering two assistants (wizards) – Export transparent image and Resize image. These guide you

through tasks that you may be struggling to understand. We expected more to be added, but nothing's changed in version 7.0.

ImageReady

ImageReady is a Web image editing program that's bundled with Photoshop. It has the same interface and allows seamless connection from within the program. We see a jump from version 3.0 with Photoshop 6.0 to version 7.0 with Photoshop 7.0. The program allows you to slice a picture up so that it can

be used more effectively on a Web page. You can also optimize pictures, create rollovers and edit animation.

Image resolution

The measure of digital image quality, stated in pixels per inch (ppi). The more pixels per inch the higher the resolution. Not to be confused with sharpness, which is affected by a number of things, including lens quality.

The resolution needs to be high enough to suit the viewing media and should not be confused with dpi (dots per inch). If, for example, you only ever look at the images on a computer monitor for Web use you only need a resolution of 72ppi for Macs and 96ppi for a PC and each pixel will be displayed as a dot. If, on the other hand, you're wanting to send the images to a magazine or book publisher you'll need a resolution of at least 300ppi, while most desktop inkjet printers require files with 150 to 240ppi and lay down several dots per pixel to ensure accurate colors. **(See dpi)**

Image size

MENU IMAGE → Is the physical
** IMAGE SIZE** size of the file,
measured in kilobytes (K) or megabytes
(Mb), that appears at the bottom left of
your image. The larger and more
complex an image the bigger its file will
be. As an example, a simple 4x6in
grayscale image, saved at 175ppi, has a
file size of around 700K. The same file
saved as an RGB increases to just over
2Mb and as a CMYK image to nearly
3Mb. A 300ppi 10x8in image suitable for
magazine repro is 27.5Mb. Start adding
Layers, or a History palette, and the file
could quadruple in size.

You can either resize or resample a
picture in Photoshop. Resizing allows you
to adjust the number of pixels per inch
and keeps the same amount of data by
adjusting the dimensions to suit the new
pixel setting. Resampling keeps the same
dimensions and removes or adds pixels
to reach the new pixel setting you key in.
Increasing the number of pixels is usually
referred to as interpolation.

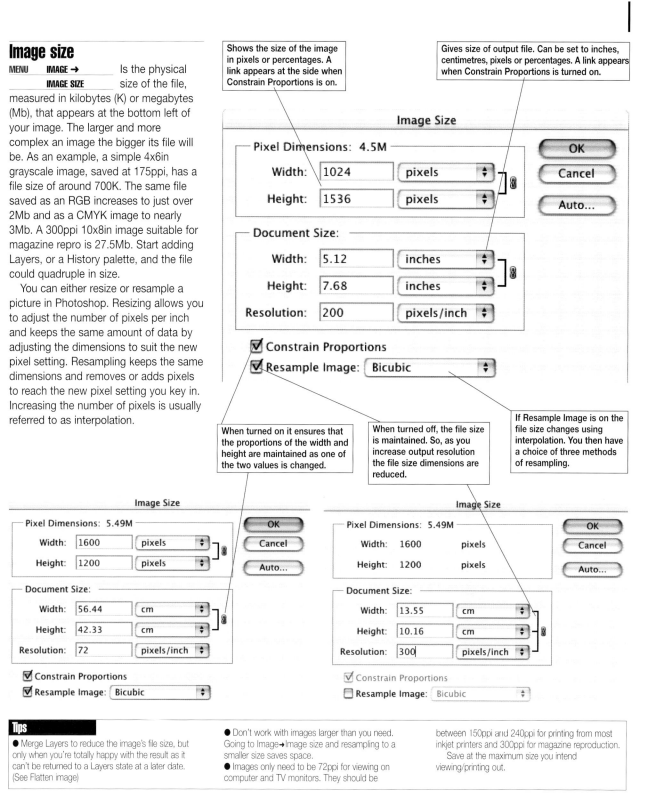

Shows the size of the image in pixels or percentages. A link appears at the side when Constrain Proportions is on.

Gives size of output file. Can be set to inches, centimetres, pixels or percentages. A link appears when Constrain Proportions is turned on.

When turned on it ensures that the proportions of the width and height are maintained as one of the two values is changed.

When turned off, the file size is maintained. So, as you increase output resolution the file size dimensions are reduced.

If Resample Image is on the file size changes using interpolation. You then have a choice of three methods of resampling.

Tips

● Merge Layers to reduce the image's file size, but only when you're totally happy with the result as it can't be returned to a Layers state at a later date. (See Flatten image)

● Don't work with images larger than you need. Going to Image→Image size and resampling to a smaller size saves space.
● Images only need to be 72ppi for viewing on computer and TV monitors. They should be

between 150ppi and 240ppi for printing from most inkjet printers and 300ppi for magazine reproduction.
 Save at the maximum size you intend viewing/printing out.

Indexed colors

MENU **IMAGE →** Color
 MODE → mode
 INDEXED COLORS used to

reduce the image to 8-bit to suit
viewing on older monitors or on
the Web to keep the file size
conveniently small.

Several color palettes can be
selected from the menu including
a Web palette with 256 colors that's
widely used by Web browsers so your
image will look the same whichever
computer platform or Internet explorer
the picture is viewed on.

Two pictures of the
flower A and B. A is
the original 16.7
million color image. B
is index color with
just 256 colors. At a
glance they look
similar. Enlarge just a
small portion of the
image and you'll see
the lack of smooth
gradation between
colored pixels.

256 colors is fine for
Web use, but when
making prints stick
with maximum color
depth.

Info palette

MENU **WINDOW →** Basic palette
 INFO that displays
a choice of RGB, LAB, Web, HSB
and CMYK information for the
image being worked on. Moving
any tool across the image will
change the value on screen as it
passes over each pixel. The
palette also shows X and Y co-ordinates and the width and
height of any box or rectangular section that you create.

Input

Loading pictures into your
computer can be done in a number
of ways. The fully digital route is to
use a digital camera, which can be
connected to the serial or USB
port; some have a docking station.

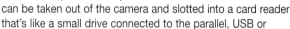

Alternatively the memory card
can be taken out of the camera and slotted into a card reader
that's like a small drive connected to the parallel, USB or

Firewire port. Some of
the latest cameras
even have infrared or
Bluetooth remote
transmission.

If you have a
traditional camera and
shoot negative film or
transparencies you can
buy a film scanner that
converts the film image into a digital file and connects to the
computer's SCSI, USB, parallel or Firewire port. A flatbed
scanner is like a mini photocopier, designed to scan flat artwork
such as prints. They're available to fit various computer ports.

Another option is to have the films
scanned by a lab. Many shops now
offer Kodak's Picture CD service
where the films are processed as
normal but you also get a CD with
the images. **(See Picture CD)**

Finally you could have a shop scan
your photos and place them on a
Web server that looks after your
images. You can then log on to the
site and download the pictures you
want to print.

Interpolation

If you change the size of a digital file your software either adds pixels when increasing the size or removes them when making the image smaller. This is known as interpolation and relies on Photoshop knowing which pixels to add or dump.

There are three methods of interpolation – Nearest Neighbour, Bilinear and Bicubic. One can be set as default by going to File→Preferences→General.

Nearest Neighbour offers the fastest method by copying the adjacent pixels, but results are often poor. Bilinear looks at pixels above and below plus left and right and averages out the result to give an intermediate pixel and a smooth blend. It's slower than Nearest Neighbour, but not as slow as Bicubic which looks at all the pixels surrounding each pixel and averages them all out to create the new ones. It then boosts contrast between each pixel to reduce softness.

Inverse

MENU SELECT →
 INVERSE

When the subject is difficult to draw round accurately, look at the background or surrounding pixels. Could Color Range be used, or the Magic Wand? If so, select the surrounding areas and then the Inverse command to swap to the subject.

Inverting

MENU IMAGE →
 ADJUSTMENTS →
 INVERT
QUICK KEYS CTRL+I

Changes a color negative image into a positive and vice versa.

This photo of an eye is 29 pixels wide by 29 pixels high. Increasing the image to create a 290x290 version requires a hefty interpolation job, and it's a good test for the various methods.
A: Near Neighbour,
B: Bilinear, and
C: Bicubic.

As a negative you can still apply other filter effects – this example is Find Edges followed by Fade Find Edges at 100% with Difference blend selected.

JPEG
Joiner

JPEG

Short for Joint Photographic Experts Group. The most popular method of image compression that's great for continuous tone photographs.

It supports CMYK, RGB and grayscale. It's a lossy compression method so information is discarded to save disk space, but when saved at a minimal compression level the image can be indistinguishable from the original.

The JPEG Options palette has a slider to adjust the compression level from 0 low quality/high compression to 10 high quality/low compression. Set 10+ for best printed results and around 6 for Web use, avoid lower settings where possible.

You also have three format options – Baseline Standard for normal use, Baseline Optimized, a higher compression method used for saving images for Web use, and Progressive, also for Web use. This option displays the image in stages so the viewer can skip by if the photo isn't interesting.

Warning

● Every time you close and reopen a JPEG file you compress and uncompress, and the effect can be cumulative so the image may gradually decrease in quality. Work in PSD format until you've done everything you want to the image then save to JPEG.

Joiner

A traditional photo technique is to take a series of pictures from the same position, each with a different viewpoint. Then the photographer mounts the images side by side to create a 'joiner', or panorama.

1 Select a series of pictures that have been taken for the panorama.

This can be done manually in Photoshop using gradient masks and the Clone stamp, but it's easier to use auto software such as PhotoStitch or PhotoVista, and Photoshop Elements also has a stitching feature.

2 Import them into a program such as PhotoStitch.

This image shows the effect of JPEG compression. The original uncompressed file has a file size of 5.5Mb. Watch what happens to the file size and the quality as higher compression is chosen.

JPEG, maximum quality, setting 12, file size 1.5Mb. It's hard to spot any difference with this and the uncompressed file.

JPEG, maximum quality, setting 9, file size 736K. It's hard to spot any difference with this and the uncompressed file either.

JPEG, high quality, setting 6, file size 448K. Very subtle changes in color of some pixels, but still very good.

JPEG, medium quality, setting 3, file size 260K. It's now starting to clump groups of pixels in blocks noticeable in the outlined area.

JPEG, low quality, setting 0, file size 172K. Low quality produces poor results and the recognizable problems of heavy compression.

You can use Photoshop to stitch pictures manually. Extend the canvas to the same length of the total length of the pictures you are joining. Paste them onto the canvas and position them. Reduce the opacity of the top one so you can see where it overlaps and adjust so they match. Use the gradient tool to get a good blend. Then use the Clone tool to help patch up bad bits. Repeat this on all the pictures. It's far easier to use an auto stitching program though.

3 Left and above: Let the software automatically stitch the photos together. You may then have to crop and clone in the blank spots.

4 The result is an impressive panorama.

Keyboard shortcuts

Shortcuts to commands and options using individual or groups of keys. Learn the ones you use regularly to speed up your work. When shortcuts are available they're listed in this book as Quick Keys and for the PC. Mac users have similar shortcuts. **(See Appendix C)**

Knockout

A mode from Blend Options palette selected from the Layer Style menu that allows you to be more creative with the ways layers react with other layers. It can be used with text and vector shapes to great effect. To illustrate how it works I've created a blue star layer on top that will be used as the Knockout layer. It's above four jigsaw piece layers and all five are placed in a layer set. The background is a photo of bananas and there's a yellow layer above that. **(See Layers and Layer Sets)**

If the star is set to Shallow Knockout with opacity at 0% it would cut through the layer underneath and reveal the next layer. As the jigsaw pieces are in a set it cuts through them too and reveals the yellow layer below.

If the star is set to Deep Knockout with opacity at 0% it cuts through all the layers and reveals the background layer.

By turning off channels and adjusting opacity you can gain infinite control of how a layer blends with any layer below. It's the most complex area of Photoshop and much experimentation is necessary to understand this fully.

Kodak Photo CD

Kodak were way ahead of their time launching Photo CD in 1992 as a product designed to view photos on a television. Unfortunately it didn't take off until around four years later.

The service is offered by photo finishers and pro bureaux. Your images are scanned at high resolution using drum scan quality and recorded onto disc as Pict files. When you open the disc you have a choice of five file sizes from 192x128ppi to 3072x2048ppi. The smaller sizes are for using as positionals or for TV and Web use and the larger files are for making prints allowing up to around 7x10in enlargements.

Kodak Picture CD

Similar principle to Photo CD, but with a magazine style interface and free software, produced in association with Adobe and Intel. The CD opens up with a contents page and a range of options. Various menus let you edit and enhance your

pictures, send them as e-mail postcards, catalogue them and print them. The service is available when you have a film processed and just requires a tick on the film processing envelope to ensure the lab produces a Picture CD of your film as well as a set of photos.

The interface is extremely friendly and easy to navigate. The first page that appears on screen is the contents page (above right). This has a menu of the items on the CD which can then be navigated using the linked buttons. You see your photos on the left and these can be edited using the basic software under the Picture Fixers heading (right). There are also tips and articles which change each time a new version of the CD is produced. At the time of writing it was Volume 4, Issue 2. Printing photos and sending them attached as e-mails is also made easy.

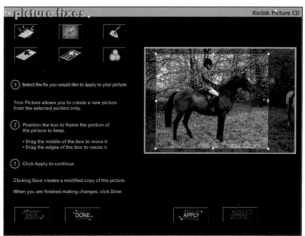

Lab Color

An international standard for color measurements developed by the Commission Internationale de L'Eclairage (CIE). It's capable of reproducing all the colors of RGB and CMYK and uses three channels – one for luminosity and the other two for RGB type color ranges.

Some users prefer to work in this mode as it's device independent and colors that fall into the CMYK gamut aren't changed when you convert to CMYK.

Lasso

QUICK KEY L There are three Lassos to pick from the toolbox. The two standard versions, Freehand and Polygon, have been joined by a Magnetic version.

Lasso Tool L
Polygonal Lasso Tool L
Magnetic Lasso Tool L

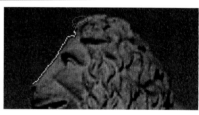

The Freehand Lasso is used in most programs and is used by accurately drawing round the subject. You can select a feather to be applied to the section and turn anti-aliasing on or off.

The Polygon Lasso is good for drawing round boxes and straight edged items as it creates a straight edge between the source and destination point.

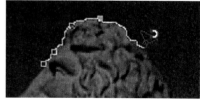

Magnetic Lasso is arguably the most useful Lasso. You draw roughly around the subject and the Lasso detects contrast changes and defines the edge. It then pulls the inaccurate drawing into line, often creating a very good selection.

Tip
● Don't worry too much about being spot on with your drawing. You can hold down the Shift key to add to the selection or the Alt key to take away from it.

Layers

One of the most useful features of Photoshop is Layers. Basically, using layers is like having several sheets of tracing paper, each holding part of the image. Laying the sheets on top of each other builds up the image and it's easy to remove any sheet to change the feel of the work. But, being digital, layers offer much more.

You can change how one layer reacts with another using the Blend modes (see individual entries). You can adjust the opacity so one layer is stronger than another, you can apply a filter effect to one layer and you can copy and paste from one layer to another.

Photoshop 6.0 has a few new Layer options on the palette. A selection of locks can be assigned to a layer to protect it from accidents later. The first is lock transparency. This used to be called Preserve Transparency and ensures that any areas that are transparent (indicated by the checked grid) will not be affected by paint or filter effects. Then we have lock paintbrush which, as the name implies, prevents you from using brushes. The third is a lock to stop you using the Move tool to move elements from this layer. All three can be individually selected or locked as a group.

Layers are like sheets of glass or tracing paper, each one placed on top of the other to produce a combined multi-layer image.

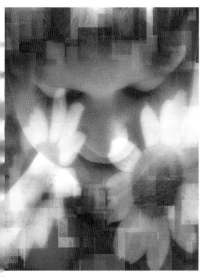

Three images of a boy, flowers and colored pattern were combined for this shot, each with a blend mode selected that would allow the layers to mix and become diffused by each other.

The three bottom layers of this five layer image were merged using Overlay and Screen blend modes while the top two layers were set to normal so that they stand out.

Layer Based Slice

This feature, introduced with version 6.0, lets you cut up, or slice, your picture into several pieces. When the image is used in a Web page each slice is saved as an independent file with html code and becomes a fully functional part. The html code contains color palette info and links, rollover effects, and animations can be added in ImageReady.

Slices help you gain faster download speeds and increased image quality. Apply a layer based slice on a layer with a selection and the slice will be positioned around it. This can then be moved and scaled using the Move tool.

A selection was made around the centre of the flower and this was copied and pasted onto a new layer. Now when you request a New Layer Slice it appears around the selection and can be set to be used as a hot link on a Web page.

Layer clipping path

MENU LAYER ➜ ADD LAYER CLIPPING PATH The Layer clipping path is a sharp edged shape around an object that can be edited using the Shape or Pen tools. The path can be converted into a layer mask by choosing Layer➜Rasterize➜Layer Clipping Path.

This Layer clipping path was a tick before I started to drag the points around.

I took this photo a few years ago for Sam, a drummer in a band, who wanted to create a promo card. It was shot on color negative film and scanned on, at the time, one of the better budget film scanners. This didn't have dust and scratch removal and grain was accentuated.

Sam was holding a potato (it seemed like a good idea at the time!) from which I originally had a lens flare spot appearing to make it look a little magical. This time I decided to replace it with a picture of a skull. And almost in the words of Shakespeare 'Alas, poor layer masks, I knew them well'.

With Layer masks you can edit each layer with ease, allowing areas of one layer to show through to the ones below. In this composite I have four layers: one with the skull, one with Sam the correct way round and the same image copied, flipped and enlarged to produce a ghost-like extra, plus a man-made background.

Layer Mask

MENU LAYER ➜ ADD LAYER MASK A layer mask controls how much of that particular layer appears in the overall image. Black masked areas don't show through and white areas do. You can use the vignette and graduate filters to good

effect using Layer Masks.

Masks can be turned off at any stage and any bits of the image that have been masked will show through on the overall image again.

Left: The skull has been very roughly cut from its background and pasted on the layer with Sam. It obviously looks like it has too! By adding a Layer Mask you can paint out areas of the skull layer using the Eraser. Above: Use a large Eraser brush to get rid of the surrounds and a small one for the detailed areas.

Above right: Now the second Sam layer was pasted, flipped and scaled up. Notice the rough selection around the shirt and hair. Eraser and Paint brush to the rescue.

Once complete I rearranged the pieces, added an adjustment layer and turned it sepia. I then flattened the layers and added grain and a green vignette on the background areas.

Layer properties

MENU **LAYER →**
 LAYER PROPERTIES

Opens up a small box where you name the layer and select a color for it.

Layer set

A great new feature introduced in version 6.0 that allows layers to be grouped and all the layer blend modes applied to the group. Alternatively the individual layers within the group can have their own set of blend modes that become active when you select Pass Through from the set's blend mode options.

Layer Style

MENU **LAYER →**
 LAYER STYLE →

Control how a layer looks by adjusting its style from a new palette. This offers advanced blending options that lets you adjust the way each color channel blends with the layer below and each element can be adjusted from the palette. Global light lets all the layers have the same angle and altitude.

Lens Flare

MENU **FILTER →**
 RENDER →
 LENS FLARE

Another one of those filters that will make lens manufacturers cringe. They spend millions on research to get a lens that you can point into the light without getting flare and then you go and stick some in using Photoshop! The truth is a touch of flare can sometimes add the extra bit that's needed to make the image work.

The palette offers a choice of three lens types and an adjustable brightness control, each can be seen in action in the series of pictures below. There's a preview window to check the result before you apply the effect to the main image.

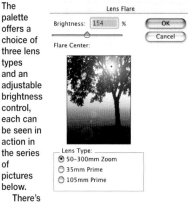

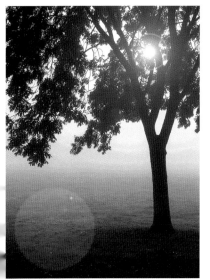

35mm prime

50-300mm zoom

105mm prime

Levels

MENU IMAGE →

ADJUSTMENTS →

LEVELS

QUICK KEYS CTRL+L

Used to adjust the black and white points of an image to change contrast. Auto levels does this automatically, but it can affect the color of the image.

When you're in this palette there's a window with the histogram and sliders to control the darkest and lightest points. The left-hand triangle controls the shadow area, the right one looks after highlights and the middle triangle adjusts midtones.

If you drag the black triangle to the right you'll see the image becomes darker. This is because you are changing the value of the darker pixels to appear black. Dragging this too far over would make shadow areas with detail become black. Similarly dragging the white triangle left affects highlights and dragging it too far left will make highlight areas completely white without any detail. This is known as clipping because you are basically cutting off the black and white areas of your photograph.

As the right-hand slider is moved inwards the white point shifts. Here the white triangle indicates the new white point and everything that was beyond that also becomes white. The result is a compressed range of colors with washed-out highlights.

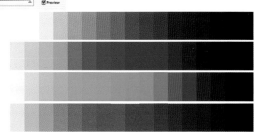

This test grid shows what happens when Levels are used. The original (left) displays a full range of gray tones in 5% increases from pure white to pure black. On the right are two versions showing what happens when levels are adjusted.

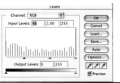

This time the left-hand black triangle was moved inward. Now the highlights stay the same but the shadows block up, so more black area exists and the color tonal range is reduced.

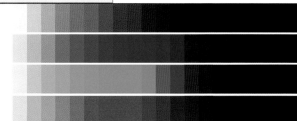

● To help you gauge the darkest and lightest points hold down the Alt key (Option on a Mac) while you click on the white or black triangle. This creates a posterized image showing the lightest point as white and the darkest point as black. As you drag the markers inwards you will see the white or black areas increase over the picture. This will give you an indication of how far to drag the sliders to make effective use of clipping the image. Use the values displayed as your highlight and shadow points.

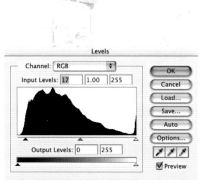

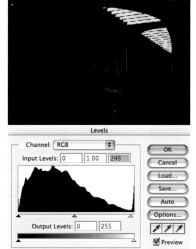

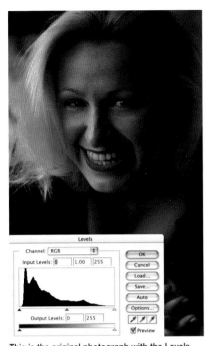

This is the original photograph with the Levels histogram showing a peak in the darker areas and a flat area where the highlights are.

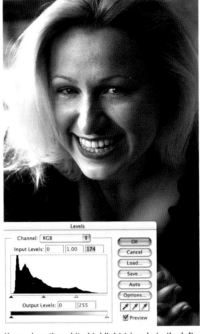

If you drag the white highlight triangle to the left the image lightens in the highlight areas. Take it too far, as I have done here, and the lighter areas that should have detail become pure white.

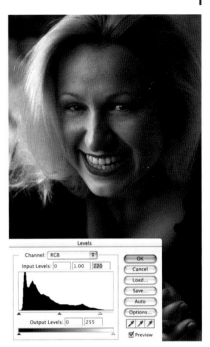

The trick is to move the highlight slider so that the image lightens but you still maintain detail in the highlights. This is usually around the end of the black graph.

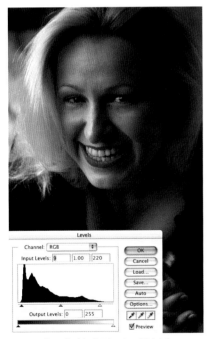

Now we drag the black triangle which takes care of the shadows. Again taking this just far enough to avoid the shadow area blocking up.

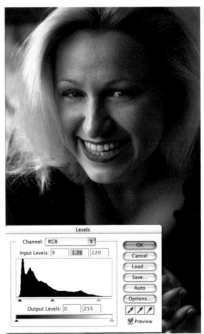

Finally drag the middle gray slider left or right to balance out the midtones. In this case slightly to the left towards the graph's peak.

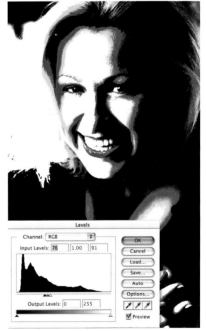

Pull all three triangles into a similar point on the histogram and you create a posterized effect with only a few tones.

Line art

An image that's drawn using one color on a background color with no midtones. Line art is a popular giveaway on royalty-free CDs, such as this example, taken from IMSI's Masterclips collection – should that be Lion Art!

Line tool

QUICK KEY U Used to place lines in the image. When you draw with the Line tool it uses the foreground color and whatever width is set in the palette. You can change the color, width and style of line from the Options palette. You can also stick on an arrowhead making the tool useful for creating pointers.

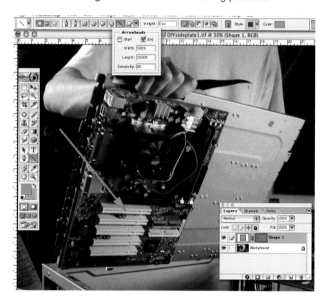

Lighten
(See Blending modes)

Lighting Effects
(See page 103)

Linear burn
(See Blending modes)

Linear dodge
(See Blending modes)

Linear light
(See Blending modes)

Liquify

MENU FILTER →
 LIQUIFY
QUICK KEYS SHIFT+CTRL+X

Someone at Adobe must have been playing around with Kai's Super Goo one weekend and decided Photoshop owners would want it. The truth is we probably don't but we will have plenty of fun deciding we don't! It first appeared in Photoshop 6.0 under the Image menu and has now moved to the Filter menu. It basically lets you smudge pixels to distort the image as if it was liquid and the most fun can be had by creating wacky portraits of people, or pets. You could use the Pucker tool to shrink the nose, the Bloat tool to make the eyes and teeth bulge, the Twirl tool to add an artificial curl to the hair and the Warp tool to pull up the edges of the mouth.

The Bloat tool was set to a low pressure and used to enlarge the eye slightly, making it appear a touch wider.

Tips

● Use the mesh grid to help show you the extent of the effect you've added and change its colour so it stands out from the picture you're working on.

Don't discard it so quickly, though, it does have practical uses. You could use the Bloat tool set to a low pressure and enlarge the eyes just a little to make them look wide open. Or maybe use the warp to turn the corners of the mouth to introduce more of a smile.

Liquify
(Cont.)

Eyes a popping!

Hours of Dali style fun can be had with flowers.

You can use the filter to stretch and warp the background too which, if done better than this, could be made to look like an oil painting.

Oh dear, this tool also gives you a licence to create all sorts of what's the point pictures.

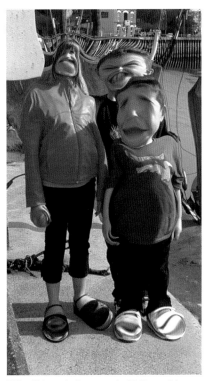

Kids will love playing around with these pictures, but it's good fun for adults too!

Luminosity blend
(See Blend modes)

LZW compression

A lossless method of compression used with with TIFF and GIF file formats to save space without affecting image quality. The disadvantage is it takes longer to open a compressed image than an uncompressed version.

Lighting Effects

MENU **FILTER** →
RENDER →
LIGHTING EFFECTS A superb range of filters that can be used to simulate various forms of light from spotlight to tungsten. There's plenty of choice so it's a case of picking a suitable image and sliding the controls to experiment. Remember to select undo (Ctrl+U) if you don't like the effect or click on a previous stage in the History palette.

The original was lit by a single studio flash head and softbox from the right. This has given it a fairly decent lighting effect but we can do all sorts of other things. Now where's the light!

The idea behind this version was to create a tungsten spotlight effect. The light type was set to spotlight with an intense but narrow, white beam and the ambient light was yellow with a positive ambience setting to create the warmth.

Omni light was selected with white light at a medium intensity. The point was positioned on the white flower to create a glowing effect. The ambient light was set to blue to contrast and give a wintery feel to the shot.

Omni lighting was used with gray and black colors so the background pixel colors have an effect on the lighting. The idea was to create a moonlight effect, and a quick tweak in color balance will sort it.

The original was lit using a snoot light for a low key effect. This placed emphasis on the rose petals. Digitally using an omni light source it's easy to bring back the underexposed areas and create a very different effect.

Almost any lighting effect is possible using this great filter. Here I've taken a drab winter scene – icy cold and foggy – and I've added an orange omni light to the top right which has created a lovely misty sunset effect.

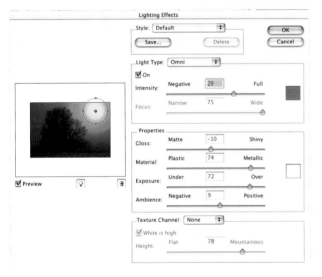

A spotlight effect with dark tones can be used to place emphasis on one area of the photograph. In this case, blue was used making the shot look like a dark and moody Blair Witch style forest.

m

Magic Eraser tool

QUICK KEY E Introduced on Photoshop 5.5, this tool, found in the Eraser compartment of the toolbox, is used to make pixels transparent. Click on the area you want to lose and the pixels disappear.

The palette has a number of options including the Opacity and Tolerance levels along with on/off options for anti-aliasing, Use all Layers and Contiguous modes.

Anti-aliasing makes some of the edge pixels semi-transparent to ensure edges of unremoved details are smooth for natural cutouts. Using All Layers mode makes pixels in every layer to be considered by the Eraser. Contiguous mode ensures just the pixels connected to the sampled color are selected. When turned off, any pixels with a similar value within the image are selected.

All this image needed was six clicks in various parts of the sky to completely remove it. When pasted onto another background it will show through in all the areas of transparency.

Turning Anti-aliasing on (right) ensures that edge pixels appear softer which, in turn, makes the cutout look more natural.

Magic Wand tool

QUICK KEY W Click on the image using this tool to select an area that has the same brightness. If for instance your subject has a blue background that you want to change to green, click anywhere on the blue and you'll see the Magic Wand create a selection around all the pixels that have a similar color and brightness level. Adjust the Tolerance setting to increase or decrease the range in the selection. You can also select from an individual channel which is sometimes easier.

Tip
● Holding down the Shift key as you click using the Magic Wand adds to the selection and holding down the Alt key removes from the selection.

Magnetic Pen
(See Pen tools)

Magnetic Lasso tool
(See Lasso tool)

Measure

QUICK KEY I The measure tool is an underused item that is used to give precise details about subject distance and angle. It can also be the perfect assistant when you need to straighten up a wonky horizon or leaning wall. Click on it and draw a line along the sloping object. Then go to Image→Rotate Canvas Arbitrary and the image will magically straighten up.

Median filter
(See Noise filter)

Magnification box

Appears at the bottom left of a picture and lets you enter a value manually to change the size of the image on screen.

Enlarging the image on screen helps when you need to edit small areas of detail, but this may appear as blocks of pixels so you should use the Zoom tool to nip backwards and forwards.
(See Zoom tool)

Above: Image viewed on screen at 25%. Right: Image viewed at maximum 100%.

Marquee tool

QUICK KEY M The marquee tool is used to make a rectangular, circular or single row selection from the subject. Then copy and paste can be used to pick up and drop the selection elsewhere.

Tip
● Use this to create lovely vignette effects by adding a large feather to the selection before you copy and paste to a blank document.

Masks

Used to protect parts of the image when you apply filter effects or change color. They can be added to channels or layers.
(See Apha Channels and Quick Mask mode)

Memory

Photoshop is one of the more hungry programs, especially when you have a large History palette and several unmerged layers. As a result if your computer doesn't have loads of RAM spare you could see the performance drop and you may find filters take much longer to apply.

Click on the arrow at the bottom of the window by the file size figures and select Scratch Sizes from the drop down menu. You'll see the figures change. The new left-hand figure represents the room required for the currently opened images and the right-hand one is the space available in RAM. If the first figure is bigger than the second you're treading on thin ground and could find your computer crashes more often.

The computer will borrow memory from the hard drive and will slow down as it accesses the info. Either work with just one image open at a time or upgrade your PC and buy some more RAM. **(See RAM)**

Merging Layers

QUICK KEYS CTRL+E When you've finished editing an image and are sure you don't need to keep it in layers you can flatten the layers to make the image's file size much smaller. There are several ways to do this – all found at the bottom of the Layers menu.

Merge Layers and Merge Down combine the selected layer and the one below it in the Layers palette. Merge Visible combines all layers with an eye icon in front of the layer's name in the Layers palette.

Merge Linked brings together all the layers that you've selected using the linking box (including the one you were last working on). Merge Group combines all the layers that you've previously grouped using the Layer→Group Linked command. Flatten Image merges all layers that are visible and discards all the others. It's the option to choose when all your image editing is complete.

Masks are lost when layers are merged so if you intend revisiting an image to make further adjustments save a copy with all the necessary layers.

Minimum

MENU FILTER →
OTHER →
MINIMUM

Quite an unusual filter, placed in the 'Other' area which suggests that Adobe didn't really know where to fit it. In most cases the filter doesn't do much good, but when there are quite marked changes in tone from one area to another it can be effective in a creative sort of way. In this example it's created some funky glowing edges. Use with care, though!

Mezzotint filter
(See Pixelating filters)

Moiré patterns

A mottled pattern caused when printed material is converted to digital using a scanner. Some scan software has a descreening feature that eliminates the pattern but this can soften the image.

You can also rotate the material to be scanned slightly in the scanner and straighten it up once scanned, which sometimes helps.
(See Noise filters)

Moiré patterns
(Cont.)

This scan of a peacock butterfly came from a 2x1in picture in a magazine. The Moiré pattern isn't obvious when the picture is small, but as soon as you enlarge it the criss-cross pattern becomes harsh. Use Photoshop's Median filter at a setting of around two to reduce the pattern.

Montage

A collection of images and text brought together on one canvas using features such as Layers, Blending modes and the Rubber Stamp tool to make seamless joins.

Motion Blur
(See Blur modes)

Move tool

QUICK KEY V Hardly the most exciting item in the Photoshop toolbox, yet still useful. It's used to drag the image around on screen and can also be used to move Selections and Layers across to other Photoshop images.

Double click on the tool to call up the Options palette and just two options, Pixel doubling and Auto Select Layer. Turn Pixel doubling on to increase the speed the tool moves the selected image in the preview. Auto Select Layer makes the tool automatically select your image's top layer.

If you have opened another command, say Levels, and you want to scroll an open image that's larger than the screen area, click on the space bar and the mouse which then allows you to drag the relevant part of the image into a suitable view.

Just to prove two heads are better than one! The better expression was borrowed and blended into the other image.

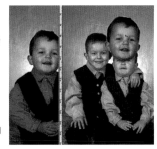

Multi-page PDF to PSD

MENU FILE →
AUTOMATE →
MULTI-PAGE
PDF TO PSD

New feature in Photoshop 5.5 that automatically converts Acrobat PDF files into Photoshop PSD. White backgrounds become transparent and images can be edited in Photoshop. Options are available to save at various resolutions in color or black & white, as seen here on Photoshop Tutorial PDF files.

Multiply
(See Blending modes)

n

Navigator palette

MENU WINDOW→ This palette shows a small preview of the
 NAVIGATOR image you're working on. The palette
preview can be made smaller or larger by dragging the bottom
right edge of the box. At the base of the preview window is a
zoom scale that you adjust to make the main image magnify or
reduce in size.

 The area that shows on screen appears as a frame in the
navigator's preview window which gets smaller as you increase
magnification. The frame can be moved around the preview to
select the area of the main image you want to work on.

New

MENU **FILE →** When opening a fresh file in Photoshop you
 NEW follow the usual path that most programs
QUICK KEYS **CTRL+N** offer, File>New. In Photoshop's past you
then keyed in the measurements required and a blank canvas
would appear.
Photoshop 7.0
brings new default
options with all the
popular preset sizes
to save you keying in
values. You can of
course still set any
size you want in the
custom fields.

Noise filter

MENU **FILTER →** Four filters used to add grain or remove
 NOISE... dust in an image to make it look natural.
Noise can also be used to reduce banding effects that are often
introduced by gradients.

To illustrate this I have created a color gradient which clearly
shows the lines between tones of the color gradient. Adding a
small amount of noise removes these, making the gradient
smoother and a little more natural. Adjust the slider and watch
the image. You can always undo (Ctrl+Z) if you are not happy
with the effect. I used a setting of 0.6%. Any more and the grain
became too noticeable.

ADD NOISE

When used in small amounts this filter can make a digital picture
with smoothed edges or an Illustrator file look more natural. Use
in larger amounts to recreate an effect you'd obtain using fast
film. Controls include an amount slider to vary from a very subtle
1 to an unbelievably gritty 999. Then you can choose between
Uniform or Gaussian distribution. Gaussian produces a stronger
effect. Finally turn Monochromatic on or off. When on, the Noise
filter works the same on all color channels, unlike off where the
effect is random on each channel.

Adding 30% of Gaussian distribution with Monochromatic selected produces
an image that's far too grainy for most images.

Adding 10% of Gaussian distribution with Monochromatic selected produces
a far more natural result.

Reducing to about 6% gives the best and more subtle effect.

Noise filter
(Cont.)

DESPECKLE
A subtle softening filter that helps reduce noise caused by poor scanning. When applied increase sharpness using the Unsharp Mask filter.

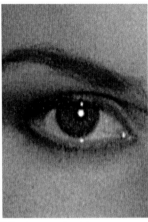

This close-up of a girl's eye was cropped from a 46Mb scan. The Despeckle filter helps reduce some of the problems of the scan, but does tend to soften the image slightly.

MEDIAN
Used to reduce noise, so it's quite effective with the Moiré patterns that are caused when scanning printed material. The downside is it tends to soften the image. Apply the Unsharp Mask filter to increase sharpness after this filter has been used.

Median has a dialogue box with a sliding adjuster giving more control over the effect. The Moiré pattern is easily removed but the result is softer and needs the Unsharp Mask applying.

DUST & SCRATCHES
The most useful of the Noise filter range is Dust & Scratches, especially when used on scanned films. No matter how well you try to keep the surface clean it will attract dust and result in scans with marks. This is a noise filter that detects dramatic changes in adjacent pixels and blurs the surrounding colors to smooth out the tones.

It's not always clever enough to know what is and what isn't dust so don't think this is the answer to your prayers. You're more likely to end up with a soft result than a rescued one!

Try various combinations of the two Radius and Threshold sliders and adjust the settings until the best result shows in the preview window. Dragging the Radius slider to the right increases the effect, unlike the Threshold slider which reduces it.

Be careful how far across you set the Radius. Even just a small setting of 4 pixels has destroyed all the detail in the example on the right. The dust has gone though! Below is a more sensible 1 pixel setting, but even here the image is still softened.

Here's a handy tip to help you use Dust & Scratches over a whole image without affecting quality.

1 First apply the filter to the whole image. Then click in the box to the left of the Dust & Scratches level in the History palette. This puts the History Brush icon in the box.

2 Now click on the previous history state, in our case the crop stage. The dust and scratches will return but you can now use the History brush to paint over all the bad areas with the Dust & Scratches filter applied to the size of the History brush.

3 That's it all done apart from the big chunk in the middle. Try the tip below or use the Patch tool. **(See Patch tool)**

The quickest way to get rid of big chunks, especially if there are only a few around your picture, is to use the Patch tool seen here doing a marvellous job with ease.

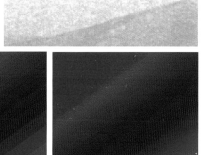

The Add Noise filter can be used to reduce banding when a gradient is produced.

Tip
● Draw a selection around the affected area, apply a feather and then use the Dust & Scratches filter.

Note
A new feature on version 6.0 that allows you to leave messages around the picture. These appear as little notes on the image which, when clicked open, reveal the message you've left. Useful if you're working with a designer who needs to do something with the picture before it goes to print.

Opacity

The opacity slider appears in many of the palettes and is adjusted by either dragging the arrow left or right or typing in a new percentage value. Use this mode to adjust the layer's appearance in the overall image or adjust strengths of paints and editing tools.

Here's one of the ways you can use opacity in a more complex layer structure. I created a background and cut out three seagulls which were then pasted onto the background creating four layers. I wanted two of the seagulls to appear to be in mist, but just changing the opacity would make the background show through so I created a neutral gray layer with a gradient mask and reduced the opacity of this to partly reveal the birds.

Opacity set to 20%.

Opacity set to 40%.

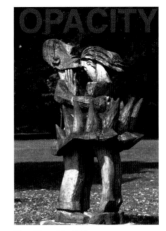

Opacity set to 60%.

Opacity set to 80%.

Opacity set to 100%.

Text displayed at various opacities.

Output levels

A slider at the base of the Levels palette is used to control the highlight and shadow detail of the image for printing. Dragging the left-hand marker right decreases shadows while dragging the right-hand marker left decreases highlights.

● If you get a bronzing effect on the blacks of your inkjet prints it's because too much black ink is being used. It occurs on some types of paper when they're not fully compatible with printers. Adjusting the shadow triangle from 0 to 5 or 10 reduces shadow density and helps avoid overinking the black.

Open

MENU FILE →
 OPEN

QUICK KEY O

Use this to open pictures from within Photoshop. It will point you to a folder or directory and you then go through the system to search for the picture. When you find the image double click it to open.

Open recent

MENU FILE →
 OPEN RECENT

First introduced on version 6.0, this feature shows a list of 10 recent images that you have had open in Photoshop and offers a shortcut path to find them. This saves you having to trawl through your entire system if you want to reopen an image you have previously worked on and forgot where you saved it.

Options palette

MENU WINDOW →
 OPTIONS

Double clicking on anything in the toolbox brings up the Options palette that usually has a range of settings, checkboxes and sometimes grayed out items that can only be accessed when you're in certain modes. Ones at the bottom with a stylus next to them need a graphics tablet attached to be functional. The arrow at the top right lets you reset the tools.

Overlay mode
(See Blending modes)

p

abcdefghijklmno**p**qrstuvwxyz

Page Setup

MENU	FILE →
	PAGE SETUP
QUICK KEYS	SHIFT+CTRL+P

This takes you to your printer's settings where you select the paper size and orientation.

The depth of settings you see depends on the Operating System and print driver software. On Mac OSX, advanced settings are found in the print menu, whereas users of older Mac OS versions and PC platforms can access advanced settings from this page setup menu.

The Lexmark Z65 has a generous number of paper sizes to choose from within the page setup window. Though I suspect only a few will ever be needed!

Paint bucket

QUICK KEY G Use this to flood the selected area with the foreground color.

The Tolerance setting determines how many pixels are affected by the flood. A small amount results in a patchy paint effect, while a

higher tolerance may color areas you don't want covered. The deckchair stripes, above, show the Tolerance at four settings. The left-hand one was set to 10, the second 20, the third 30 and the fourth 40.

Click on Anti-aliased to soften the edge of the paint fill. The stripes, left, show Anti-aliased turned on (left stripe) and off (right stripe).

Use all Layers uses pixels in all the layers to influence which ones are filled, but only fills the area on the active layer.

Paintbrush tool

QUICK KEY **B** One of three tools used to apply selected color to the image. The paintbrush can be used on full strength or less using the opacity setting to reduce the amount of color affecting the image. With lower opacity the original pixel color can still be seen. This effect is like adding a wash to the image and is really useful for hand-coloring black & white images.

■ 🖌 Brush Tool B
 ✏ Pencil Tool B

A paintbrush loaded with various colours was used to roughly handcolor this flower stall. The layer was duplicated and Gaussian Blur and Diffuse glow filters were applied to give the glowing effect.

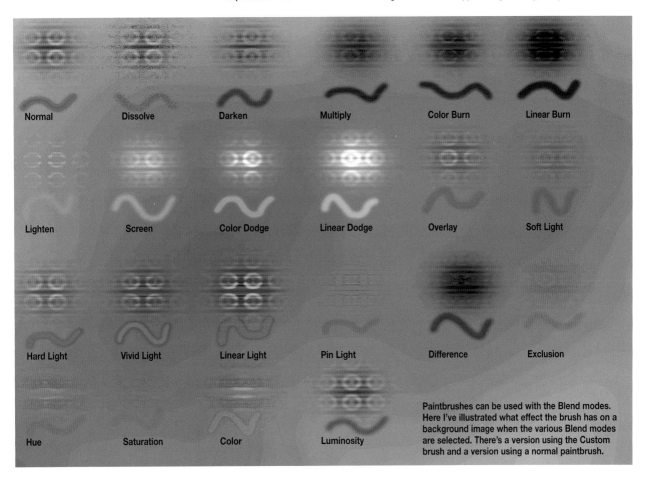

Normal Dissolve Darken Multiply Color Burn Linear Burn

Lighten Screen Color Dodge Linear Dodge Overlay Soft Light

Hard Light Vivid Light Linear Light Pin Light Difference Exclusion

Hue Saturation Color Luminosity

Paintbrushes can be used with the Blend modes. Here I've illustrated what effect the brush has on a background image when the various Blend modes are selected. There's a version using the Custom brush and a version using a normal paintbrush.

Palettes

The menu boxes that let you adjust settings of various tools.

Arrange them carefully on the desktop to avoid clutter. Many of them have shortcut keys to open and close the window, making it visible or invisible on the desktop.

Palettes can also be grouped to make the desktop even tidier.
(See Appendix C)

You can drag one palette onto another to combine them and save space on the desktop.

Palette Well

When several palettes are open your screen may become cluttered. Photoshop 7.0 makes it easy to arrange things by having a Dock to Palette Well mode that moves the palette to a position at the top of the page. The palette can then either be used as a drop down from the well or dragged back onto the screen.

Paste into

MENU	EDIT →
	PASTE INTO
QUICK KEYS	**SHIFT+CTRL+V**

Used to paste an image into part of another that's been previously selected. The new pasted image appears within the selection. The area around the selection becomes a Layer Mask and the icon appears by the pasted image by the layer thumbnail.

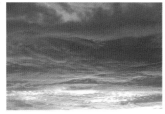

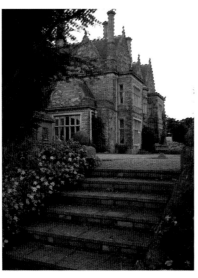

Here the sky area was selected and the more interesting sky was pasted into the selection. You then need to adjust the pasted image's position and size using the Move and Transform tools.

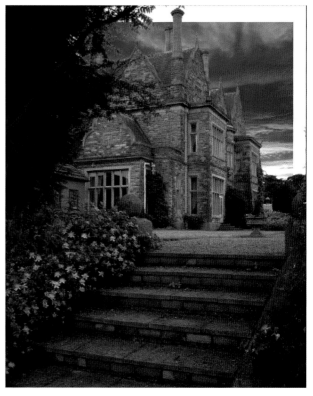

Patch: ⦿ Source ○ Destination Use Pattern

Patch tool

New to Photoshop 7.0 is this astounding tool and one feature that really makes the upgrade worthwhile. It does a similar job to the familiar Clone tool but makes a much better and faster job of repairs. You select an area that you want to repair. This could be wrinkles on portraits, blemishes on skin or fruit, dusts on scans, or even unwanted birds in a sky. You select either source or destination and draw a lasso around the area you want to use as the source (pixels that will be the sample) or Destination (area you want to repair). Then you drag the selection to the new spot and the job's done.

A few laughter lines, catchlights from the flash on the nose and chin and an odd crease here and there – put away the Nivea, we have a much better option!

Moving around the face and neck with the Patch tool took no longer than five minutes and you can't see where the repairs are. All you do is select nearby areas and drag to match up the photo. Alan's 10 years younger now.

Here's an old photo that was scanned on a flatbed scanner. I selected the area I want to repair, dragged it to the new sample point and let go. The Patch tool selection automatically returns to base and the sampled pixels are blended.

Path component selection tool

QUICK KEY A

This tool is used to select a whole path
shape and move it on screen. Unlike the
direct selection tool which lets you click
on an anchor point and drag to distort
the path's shape.

Paths

Paths are outlines created by
drawing with one of the Pen
tools. They are vector based
so don't contain pixels and
appear separate from a
normal bitmap image.

A thumbnail of the path can
be viewed in the Paths palette, and from here you
can select a number of options to apply to the
active layer from a row of icons along the base or
from the arrow's drop down menu. These options
include: Filling the path
with the foreground color;
producing a Stroke to
add the foreground color
along the selected path and making a Selection
from the path.

A path can be moved to a new image by
dragging the original path icon from the palette
and pulling it over a new image. You can also copy
paths from one location and paste them into
another using the normal copy & paste option.
Paths can be converted quickly into selections and
selections can be turned into paths.

Paths are also used by designers who turn the
selection into a clipping path and import it into a
page layout. The clipping path ensures everything
outside the frame appears as transparent on the layout. This
ensures text wraps around the subject and the subject blends
well with the layout. **(See Pen tools)**

Use the Quick Mask mode to paint a mask around the subject.
Magnify an area and use the Eraser and Airbrush to remove or add to the
mask, then convert the masked selection into a path.

Once a path is drawn you can turn it into a selection, fill it or produce a
colored outline using the Stroke Path option.

Once you have a
path you can
turn it into a
selection and
then cut and
paste the
selected object.
In this case the
bottle was
flipped and
colored using the
Hue/ Saturation
command.

Here the
path was
filled with a
pattern
and then
faded with
the
Difference
Blend
mode
selected.

Pattern Stamp tool

QUICK KEY S Like the Clone Stamp, but it takes the sample from a preselected area that you've defined. To use this select an area you want to clone using the

Rectangular Marquee and use this to create the pattern. Then select Edit→Define Pattern.

Now when you use the Pattern Stamp tool the defined area will be repeated as you draw across the canvas. If the Align box is checked the pattern will be repeated in uniform tiles in the shape of the selection. If you uncheck the Align box a tile appears wherever you draw. Blend tools are also available in this mode.

A selection from a mushroom, painted in using the aligned turned off for the top version and turned on for the bottom version.
Right is the same brush with the Impressionist option turned on and changed to purple.

First make a selection of an area that you think will suit the Pattern Stamp tool. Then go to the Edit→Define Pattern and the new pattern will appear in the Patterns Presets box.

Normal blend

Dissolve blend

Difference blend

Luminosity blend

Hard Light blend

Then you can paint a pattern using the pattern stamp and it will repeat whatever pattern you select. As illustrated here you can also use Blend modes to change the way the pattern appears on the page.

Tip

● Make your own mini gift wrapping paper by selecting a part of a subject that would look good repeated and use the Pattern Stamp tool in aligned mode to cover an A4 or A3 sheet.

p

Pen tool

QUICK KEY P With an icon like the nib of an ink pen this tool is used to create a path that can be turned into a selection. It's unusual to use at first, but spend some time getting familiar with it and your drawing and selection skills will improve tenfold.

The Pen tool icon on the toolbar has several options. The first is Pen tool which you use to add points, known as anchor points, around the subject.

The points are automatically linked to make the path. This is ideal when you want to draw straight lines and smooth curves. You can have as many anchor points as you like and they can be removed by clicking on them.

To draw a straight line, click at a start point then move to the finish point and click again. To complete a straight path click the Pen tool icon in the toolbox when you reach the end. To complete a round path click on the original starting point to complete the shape.

The Freeform Pen tool is like the normal Lasso and creates a path wherever you draw. It's like using a normal pen and is very accurate, providing you are! Anchor points are added along the path, and their positions can be changed when the path is complete. The Magnetic Pen tool works like the Magnetic Lasso and automatically locates high contrast differences between pixels and lays the path along the edge. This used to be selected from the toolbar but can now be found on the options bar at the top of the screen. Use this if you're a little unsteady at drawing.

Tips

● When using the Magnetic Pen tool go slowly so the Pen locates the edge you're drawing along to ensure it picks up what you expect it to.
● Hold down the Shift key to create a straight line running at a 45° angle.
● Click the Rubber Band box in the Options palette to see the curve of the path you're about to create as you move the Pen tool.

PDF

Short for Portable Document Format, this file format is used to convert Quark documents that contain words and pictures into a format that any one can view using the free Adobe Acrobat reader. Pictures that have been edited in Photoshop can also be saved in this format. Photoshop 7.0 now has an option to password protect the PDFs too.

Pencil tool

QUICK KEY B Produces a hard-edged line and is more useful for drawing than retouching images. The Options palette has a fade feature that gradually reduces the pencil color opacity to zero giving a gradual fading effect. There's also an Auto erase that replaces the image with the back-ground color as you draw.

Perspective

MENU EDIT →
 TRANSFORM →
 PERSPECTIVE

Use this to either reduce converging verticals or exaggerate them. Drag the handles at the edges of the selection to pull in or pull out the canvas. A tall building that's been taken from a low angle with a wide-angle lens will appear narrower at the top. Stretch the canvas outward to make the walls upright.

Alternatively a road going off into the distance can be made to reach a pinpoint at the horizon by pulling the canvas in at the top.

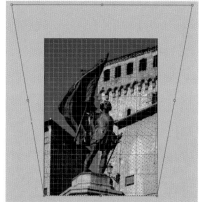

Tip

● Use View→Show Grid to help get uprights vertical.

Whoops!

● If the Transform option is grayed out go back to the picture and select the area you want to transform. Select All if it's the whole picture you're changing.

Pub signs are something that rarely appear square, and that's not because of the few you've just had indoors! The distort tool is a better option to use.

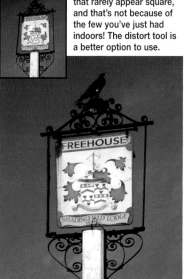

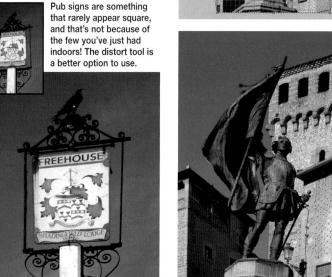

Picture Package

MENU FILE ➔
AUTOMATE ➔
PICTURE PACKAGE An auto mode that resizes a selected picture to a specified resolution and fits a variety of sizes on an A4 page, ranging from one to 16 pictures.

First you choose the source image which then opens into one of the templates. You can change the size of the page and the number of pictures displayed in the layout. The source image appears in each of the picture frame areas on the layout and then you either print that or click on individual boxes in the layout to change pictures into a multiple print page.

CHOOSE YOUR TEMPLATE
Picture Package has a range of layouts you can choose from. This is a great automated tool to help you print multiple photos from one or several images on a sheet of A4 paper.

Pin light
(See Blending modes)

PICT file

Is widely used by Mac operators for use in graphics and page layout programs, and is ideal for transferring between the two. It supports RGB and allows a single Alpha channel, Index colors and Grayscale.

Pixel dimensions

Number of pixels measured along the width and height of an image, quoted as 640x480ppi on basic digital cameras and 1280x960 on megapixel models.

Pixelating filters

MENU FILTER ➔
PIXELATE ➔ A range of seemingly pointless filters that convert the selected area into varying patterns of clumped pixels.

COLOR HALFTONE
Divides the image into rectangles and replaces them with circles to create an enlarged halftone effect. The menu lets you select the radius of the halftone dot, with pixel values from 4 to 127, and you can enter screen-angle values for each channel. It can take ages to apply and you'll wonder why you bothered!

FRAGMENT
Duplicates pixels and offsets them to create an effect that you'd normally only see after a few too many drinks!

CRYSTALLIZE
Takes pixels into lumps and converts them into a polygon shape of solid color. The size of polygon can be varied between 3 and 300 pixels, although anything past 3 starts to look ridiculous.

POINTILLIZE
Makes the image look like a pointillist painting. Yuk!

MEZZOTINT
Brings up a dialogue box that has nine options – each scrambling the picture to look as though it's a badly tuned television picture. One to avoid, unless, of course, you like looking at badly tuned images!

MOSAIC
Clumps pixels into square blocks and makes them the same color. The effect is like a very low resolution image and another one we'll avoid.

FACET
One of the better pixelating filters, changes clumps of similar colored pixels into blocks of the same color pixels to make images look like they're paintings.

Plastic Wrap filter
(See Artistic filters)

Plug-in filters

A filter that offers additional features to the standard program. Photoshop supports third party filters that can be added to Photoshop's plug-ins folder to increase the program's flexibility. The files have .8bf as their description. Many of the current supplied range used to be third party options.
(See Appendix E)

Above are just a few of the interfaces of plug-ins that are available for Photoshop. Many more plug-ins are available as free downloads from Web sites, a couple of the best being PC Resources for Photoshop at <*www.netins.net/ showcase/wolf359/plugins.htm*> and The Plug-in Site at <*http://thepluginsite.com*>

Polygonal Lasso tool
(See Lasso tool)

Posterization

MENU	IMAGE →
	ADJUSTMENTS →
	POSTERIZE

Converts the image into a number of brightness levels between 2 and 255 to produce a graphic effect. 2 is too harsh, 255 too subtle. A good balance is between four and eight.

This shows the result of varying levels of Posterization on a color image running from the left: 2 levels, 4 levels, 8 levels, 12 levels and 16 levels .

Posterization set to 2 levels.

Posterization set to 4 levels.

Posterization set to 6 levels.

Preferences
(See Appendix D)

Preserve luminosity
(See Color balance)

Posterization set to 8 levels.

Posterization set to 10 levels.

Preset manager

MENU EDIT → Brings all the
 PRESET MANAGER preset palettes
into one box so you can create new
ones, load and edit existing ones or
delete unwanted ones. These categories
include Brushes, Swatches, Gradients,
Styles, Patterns, Contours, Custom
Shapes and Tools, each with its own set
of presets. Tools, for instance, contains
Art History, Brushes, Crop & Marquee
and Text presets that can be loaded or
new ones saved.

Preserve Transparency
When this box is ticked in the Layers
palette the areas of transparency are
protected from brush strokes or other
changes made to that layer.

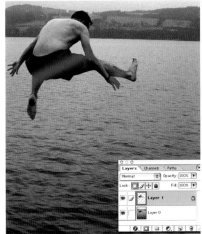

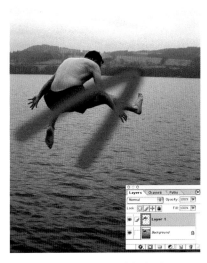

To show the effect I cut around the leaping
bather and pasted him onto a new layer. Then I
painted over him using Preserve Transparency
turned on (left) and off (above).

Print Options

MENU **FILE →**
PRINT WITH PREVIEW
QUICK KEY **P**

Adobe created this sensible printing system on version 6.0 and now in 7.0 it's the standard mode that appears when you select print. You can choose Scale to fit Media which automatically adjusts the image to suit the paper you're using in your printer. Before we had this option we had to put up with a message saying 'image too big, do you wish to proceed'.

You can also adjust the size and position of the image so it prints in a certain part of the paper. Show bounding box lets you adjust by dragging the corner boxes or you could manually adjust size and position by keying in known measurements. All done with minimal loss of brain cells!

Above: The preview window shows the default setting and how the print will appear on an A4 sheet, in this case it's too big and will be heavily cropped.

Left: Click Scale to fit media to get a full image inside the preview window and a useful print.

Below left: Uncheck 'centre' and key in a size to print a custom size and position anywhere on the page.

Above right: The new print options window in version 7.0 has many other choices you can make. To show you a few in this example I've changed the background color to green, selected crop marks which help when you want to trim the print. I've also selected registration marks. Below: Click on output and select Color management to set the source (image) and print space (output) profiles. This ensures that Photoshop works with the inkjet printer to deliver a good quality result.

Print resolution

The number of dots along the length and width of a print, measured in dots per inch. Generally the more dots per inch the higher the resolution. Most inkjet printers print out at between 600dpi and 1440dpi, but these are slightly misleading as the figures allow for between three and six ink color droplets which are used to make up each dot.

A 1440dpi printer that uses six individual ink colors actually means the print resolution is more like 240dpi. The highest true resolution is around 400dpi for dye-sub printers and most books and magazines print at around 300dpi.

This close-up of the tip of a peacock butterfly's wing shows how the dots make up the image. This is the equivalent of a 1/4in area printed out at 300dpi, so it shows the formation of around 75 dots across the length.

Proof Setup

MENU VIEW →
 PROOF SETUP →

Lets you view the image on the monitor as it will appear when reproduced on a specific output device. This is known as soft-proofing and saves you printing a hard copy of your document to preview how the colors will look. It is only any use when you have calibrated your monitor.

PSD

Photoshop's native format. Use this to save photos when you want to keep individual layers.

Progressive JPEG

A file format used on the Web for quicker downloads. The image opens up progressively so you can get a rough idea what it looks like and either wait until it is at its highest resolution or click off and go elsewhere.

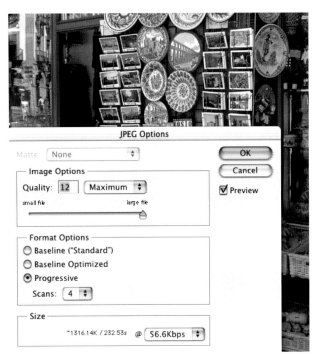

Purge command

MENU EDIT →
 PURGE

This clears stuff out of the computer's memory such as the pattern held in the buffer ready for use by the Pattern Stamp tool.

You'd use the Purge command when the computer is starting to run slowly or can't finish an action due to a lack of memory. Several options are available from the Purge drop down menu including Undo, Clipboard, Patterns, History.

q

Quadtones
Quick Mask mode

Quadtones

MENU IMAGE →
 MODE →
 DUOTONES

Quadtones, like Duotones and Tritones, are grayscale images that use process or Pantone colors to give a subtle color tone, almost like the sepia, blue and gold toning of the conventional darkroom but with much more control and repeatability. Photoshop has a selection of preset Quadtones in the Duotone folder found in the Preset folder.
(See Duotones and Tritones)

From the preset selection, this adjusts the grayscale without adding a colour hue and is used to ensure better printing in high quality books.

Another preset using P antone colours to give a subtle green hue. This would be effective on still life shots but less so on a portrait.

129

One of the Pantone presets that gives a slight sepia style glow.

A process color preset that may work well with a vintage portrait.

Blue colors like this, created using the process color preset, can work well with glamour images.

Playing around with the Quadtones colors can be very rewarding when you stumble, by chance, on a pleasing tone as a result of mixing colors.

Quick Mask mode

QUICK KEY Q Enter this mode by clicking on the icon near the bottom of the toolbar. It's a quick way to create a mask around a section. The mask can be increased using one of the Painting tools or decreased using the Eraser.

When you've made all your adjustments to the mask, click the off icon at the base of the toolbar and a selection will appear on the edges where the mask meets the unmasked area. Use the Paint or Erase tool set to a small brush size to clean up rough areas.

r

RAM
Raster image
Rectangle tool
Replace Color
Resample Image
RGB
Rotate Canvas

Radial Blur
(See Blur modes)

Radial Fill
(See Gradient tool)

RAM

Short for Random Access Memory – the part of the computer that's used to run programs. Photoshop needs a minimum of 128Mb to run, 192Mb for anything more than basic manipulation and as much as you can stick in to do complex multi-layer picture editing of large files.

Most computers can be upgraded and RAM, while fragile, is easy to install. You just take off the computer's side, back or lid, locate the memory slots and clip a stick of RAM into the hole. RAM used to be very expensive – a 32Mb chip cost around £900 a few years ago – now it's around 25p per megabyte.

Raster image

Another name for a bitmap – an image made up of a grid of pixels.

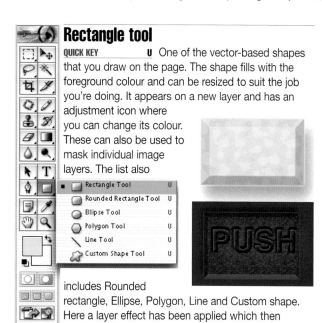

Rectangle tool

QUICK KEY **U** One of the vector-based shapes that you draw on the page. The shape fills with the foreground colour and can be resized to suit the job you're doing. It appears on a new layer and has an adjustment icon where you can change its colour. These can also be used to mask individual image layers. The list also

Rectangle Tool	U
Rounded Rectangle Tool	U
Ellipse Tool	U
Polygon Tool	U
Line Tool	U
Custom Shape Tool	U

includes Rounded rectangle, Ellipse, Polygon, Line and Custom shape. Here a layer effect has been applied which then affects any shape that's added to the canvas.

Rectangular Marquee tool
(See Marquee tools)

Replace Color

MENU **IMAGE →**
 ADJUSTMENTS →
 REPLACE COLOR

Use this mode to select and change the color of your subject. The palette that appears has a fuzziness scale that works like the tolerance setting – the higher it's set the more pixels are selected around

the original color. This mode is useful when the subject you want to change has a strong color dominance as it's easier to select the area you want. Set the preview window to Selection and click on either the preview image or the main image using the Eyedropper tool to select the color you want to change.

The preview image shows the color selected as white and the

surrounding areas as black. You can then adjust the Hue, Saturation and Lightness. Use the +/- Eyedroppers to add to, or remove from, the color selected.

Resolution
(See Image Resolution)

RGB

Mode used to display colors on a computer monitor – R being Red, G green and B blue. The colors are mixed together in various proportions and intensities to create most of the visible spectrum with over 16.7 million colors.

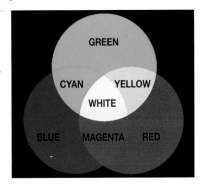

Photoshop assigns an intensity value to each pixel ranging from 0 (black) to 255 (white) for each of the RGB colors. Cyan, Magenta and Yellow are produced when different proportions of color overlap, for example R and G values of 255 mixed with a B value of 0 result in 100% Cyan.

Gray is created when there's an equal amount of R, G and B. When all the values are 255, the result is pure white and when the values are 0, pure black. This is known as additive color.

Ripple filter
(See Distort filters)

Resample Image

MENU **IMAGE →**
 IMAGE SIZE

If you want to make a picture smaller for use on a Web page, or bigger to enlarge for the wall, you have to take away or add pixels – known as resampling. The Image Size palette lets you change the image using the pixel dimension or measurements. Make sure Resample Image is checked.
(See Image size and Interpolation)

Rotate Canvas

MENU **IMAGE →**
 ROTATE CANVAS →

Scanned images can often appear the wrong way up or back to front. This option lets you rotate the canvas by 90° clockwise or anti-clockwise, 180° or flip horizontally or vertically.

If you take a photo with a wonky horizon you can adjust by slightly rotating the whole picture. Select Arbitrary from the Rotate Canvas menu and key in the amount of rotation required in degrees.

You can also use the Transform option Edit→Transform→Rotate to rotate a selection or whole selected layer. Use the Grid option View→Show Grid to help align the horizontal or vertical elements.

Tip
● Draw a line, using the measure tool, along a sloping object that you want straight, then go to Image→Rotate Canvas Arbitrary and the image will magically straighten.

S

Saturation

MENU	IMAGE ➜
	ADJUST ➜
	HUE/SATURATION
QUICK KEYS	CTRL+U

A slider control to adjust the colors in the image from –100 to +100. Dragging the slider to the left decreases the color in the image which is useful if you want a pastel effect or black & white.

Dragging to the right is the recipe for vivid colors – go too far and the image will look unnatural.

The Sponge tool can also be used to apply the effect on smaller areas. **(See Sponge tool)**

Saturation reduced to –100 knocks out all the color.

Increase to +100 and the colors become unreal.

Save

MENU	FILE →
	SAVE
QUICK KEYS	CTRL+S

Save changes to the Adobe Photoshop document "doortwo.tif" before closing?

Don't Save Cancel Save

When you click on the close box to close a photograph a message box will appear asking you if you want to Save, Cancel or Don't Save which may seem like a silly message if you've clicked on the picture to close it. This is your chance to save changes before closing. If you click Save, the latest version will be saved. If you click cancel you can go back and make a final adjustment that you may have forgot as you clicked on close. If you click on Don't Save it will save the file as the last saved version so any corrections or editing you have done will be lost. This is a useful option if you've opened a picture to try out an effect that you don't want to apply. (**See Save As)**

Save As

MENU	FILE →
	SAVE AS
QUICK KEYS	SHIFT+CTRL+S

If you prefer to keep the original and have a different file for the new edited image, select this option and change the name. To make things easy just add 2 at the end of the current name so you know it's version two. It also lets you change file format. (**See individual file format entries)**

Save for Web

MENU	FILE →
	SAVE FOR WEB
QUICK KEYS	CTRL+SHIFT+ALT+S

One for Web designers which was introduced in version 5.5. Open a picture you want to convert for the Web and when you've done all your retouching or enhancing go to Save for Web. This brings up a palette to the side of your picture with a range of options to reduce the file size by resampling, file change and color reduction.

If you're not sure what effect various options will have on your image you can split the screen into two or four versions and apply a different setting to each.

The base of each picture has details of the new reduced file size and, very important for Web, the download time on a modem.

Spend time with this mode and your Web images will fly!

Scale command

(See Transform)

Scratch disk

When your computer lacks the RAM needed to perform a complicated Photoshop task, the program uses its own virtual memory system known as a Scratch disk. The Scratch disk is best assigned to the hard drive – removable drives are not recommended for this type of use. If you have partitioned your hard drive use a separate partition to hold the Scratch disk to the one that's running Photoshop for the best performance.

Screen mode

(See Blending modes)

Selecting

When you want to edit part of an image it has to be selected. A selection can be made using several Photoshop tools such as the Lasso and Pen tools, Pens, Marquees, Magic Wand and Color Range. These are all explained in their relevant sections. The selection appears with a moving dotted line border that's often described as marching ants. Select→All puts the marching ants around the whole image.

S

Selective color

MENU **IMAGE →**
 ADJUSTMENTS →
 SELECTIVE COLOR

Use this color correction mode to remove a color cast or add creative color. The palette has a drop down menu of the six additive and subtractive primary colors along with blacks, neutrals and whites. Select which you want to modify and then adjust the Cyan, Magenta, Yellow or Black content.

Adjusting the cyan slider in the red does not affect the cyan in any of the other areas. For color casts it's often just a case of nipping into the Neutral colors and adjusting the four sliders until the image looks balanced on screen.

You also need to choose between Relative and Absolute adjustment methods. With Relative selected you adjust the cyan, magenta, yellow and black sliders by a percentage of the total. A 25% magenta pixel becomes 30% when you add 20% (20% of 25% = 5%). Add 20% using the Absolute method and a 25% magenta becomes 45% magenta.

Playing around with the color sliders can produce some creative color effects.

Sharpen

Filters used to give an apparent sharpening effect by increase contrast between light and dark pixels. Three of the Sharpening filters perform automatic operation. You have much more control using the last option, Unsharp Mask. **(See Unsharp Mask)**

Single Column Marquee tool
(See Marquee tools)

Single Row Marquee tool
(See Marquee tools)

Sketch filters

MENU **FILTER →** A selection of filters that add hand-drawn
 SKETCH → texture to your images using the foreground
and background colors.

The image becomes two tone but you could always use the
History Brush to bring some more color back.

BAS RELIEF

Changes dark areas to the foreground color and light areas to the
background color. Two sliders control the detail and smoothness of the
effect. Here the foreground color was set to green.

Tip
● Set Detail at maximum and Smoothness at
minimum for the kind of bas relief you'd create in a
darkroom, especially when foreground and
background colours are set to black & white.

CHARCOAL

Similar effect to Chalk &
Charcoal. The
foreground color, in this
case blue, is sketched on
top of the background
color.

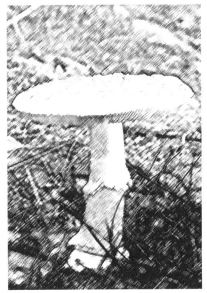

CHALK & CHARCOAL

Recreates the image with solid mid-gray highlights and midtones. The
background becomes coarse chalk using the foreground color, and shadow
areas are replaced with diagonal charcoal lines using the background color.
Sliders control the balance of Chalk and Charcoal and the Stroke length.

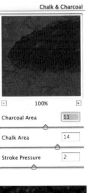

Tip
● Go to Edit→Fade Charcoal and set Difference
mode with an opacity of 100% for a colorful, truly
magical mushroom style effect.

CHROME

Produces an image with smooth edges and a variety of gray tones, making it
look like highly reflective chrome. The small inset picture is the result of fade
with multiply blend mode set at 60%. Here the chrome looks like waterdrops.

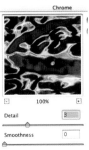

Tips
● Images can look dull when this filter has been
used. Adjust Levels to add contrast to the image.
● Doesn't work well with all subjects – go for bigger
subjects with less detail.

S

Sketch filters
(Cont.)

CONTÉ CRAYON
Uses the foreground color for dark areas and the background color for light areas to supposedly recreate the effect of a Conté Crayon drawing – it's more like a tapestry effect. Sliding controls let you adjust the strength of the foreground and background colors along with the Texture, Scaling, Relief and Light direction of the effect. Here orange was selected as the foreground color and then the result was faded using the Difference blend mode set at 100%.

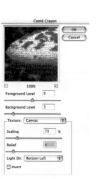

GRAPHIC PEN
Changes the image to a series of fine ink strokes which ensures detail of the original is still present. The foreground color is used for the pen's ink and the canvas becomes the background color. Controls allow stroke length and direction to be adjusted along with the pen and paper color balance.

PHOTOCOPY
Another pointless effect that is supposed to turn the image into a photocopied effect. One of the filter's creators is obviously using a vintage photocopier! The inset picture is slightly more interesting, using Fade and Overlay blend mode at 100%.

PLASTER
Creates a slight 3D effect that looks like spilt fluid on a glass sheet. Dark areas are raised and light areas sink, unless you select Invert to reverse the effect.

HALFTONE PATTERN

Produces a circle, dot or line pattern using the foreground and background colors. In this example I have used blue as the foreground color and the line pattern. The smaller photo is the result of applying the fade filter in overlay mode, which has given a 'photograph of a TV screen' appearance.

NOTE PAPER

I can't see the point of this one! Controls let you adjust the proportions of the foreground and background colors, add grain and adjust the relief of the texture. Try a few settings then give up!

RETICULATION

Use the Density, Black and White sliders to control the reticulation effect that you'd normally only achieve by accident in the darkroom.

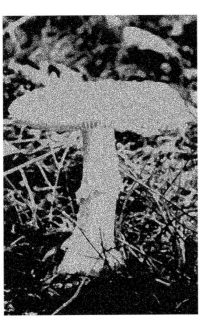

STAMP

Lightness/darkness and smoothness controls are all that are available for use with this potato-printing filter. Another one to avoid!

S

Sketch filters
(Cont.)

TORN EDGES
Normally one of the more interesting Sketch filters that simulates a ragged paper effect. You need to spend time adjusting settings to get the best effect. This image didn't take kindly to it. The inset picture has a Fade with Hardlight to put some detail back in the mushroom cap.

Slice tool

QUICK KEY K The Slice tool lets you cut a picture up ready for use on the Web. The overall picture will still appear seamless but each slice has its own Web code and can be adjusted so that it appears to change color, dim down, glow or whatever other effect you apply when the cursor goes over it. Each area is designated with a number.

Smart Blur
(See Blur modes)

WATER PAPER
Makes the foreground and background colors flow into the image just as watercolor paint or ink would when applied to blotting paper.

Tip
● Use the Edit→Fade… and experiment with the Blend modes and different opacities. Here the Water Paper fade has been blended using Overlay mode to create an effect that looks like a cheap color photocopier print.

Snapshot
Lets you make a Snapshot (temporary copy) at any stage in the editing process. The snapshot appears in a list at the top of the History palette and can be recalled by clicking on the Snapshot you want to return to.

You can make as many snapshots as you need to compare editing stages, return to certain states or compare two or more final techniques.

Tips
● Select the Allow Non-linear History option from the triangle drop down menu in the Options palette. Then you won't lose the current History state when you return to an earlier History palette.
● Snapshots are not saved with the image so when you quit snapshots are lost.

Smudge tool

QUICK KEY **R** Click on the finger icon that's shared by the Sharpen & Blur tools in the toolbox and use it to push or smudge color from pixels into neighbouring pixels. It creates an effect like rubbing your finger through wet paint and, as with all paint tools, you can select the size of your fingertip.

The Smudge tool can also be used to remove blemishes and spots by rubbing around the area to blend the dust spot with its surroundings.

The tool's Options palette allows the Blending mode and pressure to be adjusted and it picks up the color under the pointer to paint, unless you select the Finger Painting option which uses the foreground color. Change to Finger Painting by pressing Alt (Windows) or Option (Mac OS) as you drag with the Smudge tool.

Selecting All Layers makes the Smudge tool use color from all the visible layers. When deselected it uses colors from just the active layer. You can also choose Size or Pressure when a pressure-sensitive drawing tablet is connected. These are grayed out when not available.

The Smudge tool can also be used to blur objects by rubbing over the surface in all directions. The effect can look like water's dripped onto a watercolor painting.

Soft light mode
(See Blending modes)

Solarizing
(See Stylize filter)

Spherize filter
(See Distort filters)

Sponge tool

QUICK KEY **O**

Shares a place with the Dodge & Burn tools in the toolbox. The icon looks like a sponge and when dragged over the image

The Sponge tool does locally what the saturation option does for a whole selection.

surface either increases localized saturation or decreases saturation depending on which you selected from the Options palette.

Tip

● Use the view Gamut Warning option with a bright color to see where the sponge could be used and the effect it has.

Spot Color channels

Allows you to add and print a color that would normally not be possible from the normal CMYK gamut. You select the color using Pantone reference in a special Spot Color channel.

Select New Spot Channel from the Channels drop down menu and click on the color square to call up the color picker. Ignore the Out of Gamut warning and pick that lush fluro green or pink for the vivid heading or background. Selecting 100% solidity simulates a metallic color while 0% is more like a clear varnish effect.

Tip

● The Spot Color option works best when you have the image printed with a fifth color ink. Desktop printers use CMYK so you need to add the color to the normal channel's Merge Spot Channel. The printer will then simulate the color using CMYK, but it may not be as vivid.

S

Stroke

MENU EDIT → Used to place a border around
STROKE a selection using either fore-
ground or background color pixels. You can
choose the width of the border, the position
from the selection, Blend mode and opacity.
version 6.0 brought the color selector within
the palette rather than you having to go to
the toolbar foreground color to choose it.

Tips

● As with all border creating
methods, avoid colors that
clash and distract from the
subject.
● Use the Stroke command
when you want to highlight
part of a picture. Draw a
circle round it using the
Circular Marquee and apply
a two or three pixel stroke in
an eye-catching color.

Stylize filter

MENU FILTER → Use these filters to create impressionist
STYLIZE → effects.

DIFFUSE

Shuffles pixels around randomly to create a soft,
ragged looking image. Darken Only replaces light
pixels with darker pixels. Lighten Only replaces
dark pixels with lighter pixels.

EMBOSS

Locates high contrast edges and adds light and dark pixels to emphasize these edges. The strength of relief is increased using the Amount slider and the Height slider increases the 3D

effect by making the image appear raised from its background. You can also adjust the angle that the embossing takes effect through 360°.

EXTRUDE

Produces a 3D building block or pyramid effect. The height and size of blocks can be adjusted.

Tip

● Select Solid Front Faces to fill the front of each block with the average color. Keep it deselected to fill the front with the image.

Tip

● Try applying the Pyramid Extrude after the block. Use small pixel values for the most detailed effect.

S

Stylize filter
(cont.)

FIND EDGES
Emphasizes edges of a subject by detecting areas with high contrast edges and turning them black, while areas with low contrast appear white and medium contrast go gray.

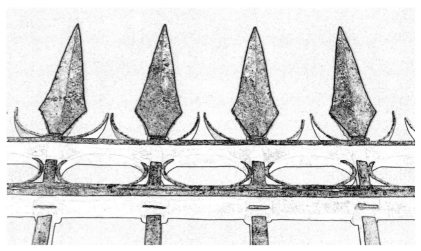

Tip

● Selecting Image→ Adjust→Invert makes Glowing Edges look like Find Edges and vice versa.

GLOWING EDGES
Opposite effect of Find Edges which makes the white edges that replace high contrast areas appear with a neon glow.

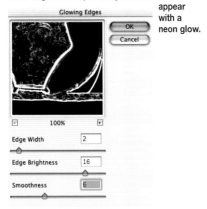

SOLARIZE
Produces an image like the photographic technique popularized by the likes of surrealist Man Ray where a print was exposed briefly to light during development to fog and turn highlights to black. Yuk!

TILES

Makes the image break up into a series of tiles. You can select tile size, gaps between the tiles and the color of gaps between the tiles.

● Reapply the tile filter on an already tiled photo and select a larger maximum offset, then go to Edit>Fade and select overlay blend mode set to about 50% for a crazy effect.

TRACE CONTOUR

Creates thin outlines that vary in color around high contrast edges.

WIND

Imitates an unrealistic wind effect by producing streaks from the pixels. Three options include Wind, Blast and Stagger which can be applied coming either from the left or right.

t

Texture filters

MENU FILTER →

 TEXTURE →

A series of filters that gives the image a textured appearance as though it has been ironed onto a textured surface.

CRAQUELURE
Produces a fine patch of cracks that looks a little like flaking paint. Choose your image carefully!

GRAIN
Adds grain to an image making it look more like a traditional photograph. This is a useful mode to apply to make a digital camera image blend with a traditional shot and look more natural when combined. There's a choice of grain types and the intensity and contrast can be controlled.

MOSAIC TILES

Breaks the image up into tiles separated by grout. The size of tiles can be adjusted along with the width and contrast of the grout.

PATCHWORK

Changes the image into a grid of colored squares. The colors produced are an average of all the enclosed pixels of each particular square. The size of grid can be changed and appears in varying depths to simulate a very realistic looking patchwork.

STAINED GLASS

Draws a series of irregular shaped cells over the image, outlined by the foreground color, and fills them with an average of the contained pixels. The cell and border size can be changed.

TEXTURIZER

Adds a texture to the image making it look like it's printed on canvas.

TIFF format (Tagged-Image File Format)

A versatile format that can easily be read by Macs and PCs using a variety of software programs. It supports CMYK, RGB, and grayscale files with Alpha channels plus Lab, indexed-color and Bitmaps without Alpha channels. TIFF files can be compressed, without any loss in quality, using the LZW method to gain storage space, but they'll be slower to open and save.

Tiles filter
(See Stylize filters)

Tolerance settings
(See Magic Wand)

t

Threshold mode

MENU IMAGE →

ADJUSTMENTS →

THRESHOLD

Makes a normal grayscale or color image appear like a high contrast lith image by discarding all tones including grays and leaving just black and white.

You can control where the black and white crossover points are using a slider on the Histogram.

Tip

● Create a silhouette using the Threshold mode then go to Hue/Saturation and with Colorize selected make a color. This gives effects similar to those using graphic art papers in the darkroom such as Kentmere Kentona papers or bleach etch effects.

Tolerance setting

Found in the Magic Wand options. It's used to adjust the number of pixel color variations selected from the one the magic wand touches. If the tolerance setting is high more pixel colors will be selected. If it's low fewer will be selected. Trial and error will help you determine what to set this to.

Tip

● Start small and work up or start big and work down until the wand is selecting more or less the area you want it to. Then adjust the tolerance to minimal setting and pick up wanted areas using the wand with the Alt key held down or remove parts of the selection with the wand and the Command key held down.

Toolbox

The area on the desktop where all the tools are located. Ones with arrows have pull-out sections with a choice of alternative tools.

Most of the toolbox icons can be double clicked to bring up the palette options box.

The bottom two icons are new to Photoshop and allow easy transfer from Photoshop 5.5 to ImageReady.

Shortcut keys are given throughout this book on the separate entries for toolbar contents.

(See Appendix C)

Tip

● The tab key hides all the desktop palettes, including the toolbar. Hold down the Shift key while clicking on the Tab key to keep the toolbar on view, while you hide palettes.

Tool presets

Store your favourite settings for Brushes, Crops and text styles to access them with ease from the preset menu.

(See Brushes)

Transform

MENU EDIT →
TRANSFORM →

A series of options that lets you change the size, shape, and perspective of a selection as well as rotate and flip it either manually or numerically.

The selection appears with squares, or handles, in the corners that you drag to change the dimensions. It's ideal for resizing an object when it's copied and pasted into another image. You can also use it to stretch landscapes and give them a panoramic feel.

The area you want to change must be selected before you can use these modes.

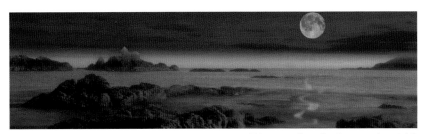

Take any ordinary landscape and stretch it using Transform→Scale to create a panoramic print.

Copy and resize your subject using Transform→ Scale to create a more realistic looking perspective.

Studio photographers can't always shoot from an angle that will ensure uprights are parallel. For this reason many commercial photographers use large format that allows perspective control. You can of course sort it out in Photoshop like this, using Transform→Distort.

Transform Again

Remembers that last Transform that you applied and repeats the action. This is a useful option if you're creating a composite picture and are pasting in and adjusting several elements.

t

Transparent layer

A layer with areas that contain no pixels, such as a new Layer, appears with a chequered pattern. Any subsequent layers that are merged will only be affected by the non-transparent areas. These are available in Photoshop's PSD format and the TIFF format, but need to be merged if saved as JPEGs. Transparent areas are then replaced by white. Cutouts can be saved by converting to clipping paths which prevent the white background appearing on the document.

Transparency masks

Use the Gradient Editor with the Transparency option selected to create a transparency mask. This can be used to help blend two layers or add a graduated filter effect to an image.

The original on the left was shot on an overcast day and could quite easily do with a lift. I copied the statue and pasted her on a new layer and then added a transparency mask as a new middle layer. A blue fill was added and the blue only shows through where the mask is clear.

Tritones

(See page 151)

Trapping

MENU **IMAGE →** Produces an overlap
 TRAP on colors by the
amount of pixels you key in. The overlap prevents gaps appearing between CMYK colors if there's a slight misalignment or movement of the printing plates. This technique is known as trapping and your printer will tell you if it's needed and what values to enter in the Trap dialogue box.

TWAIN

Believe it or not, TWAIN is short for Technology Without An Interesting Name! It's a file that comes with scanners that you place in the Mac's Preferences folder or the TWAIN folder of the PC's Windows Directory. When you want to scan from within Photoshop you go to File→Import→ TWAIN Acquire. If you have more than one scanner installed first select the one you want, File→Import→Select TWAIN Source.

You can keep within Photoshop while scanning pictures. Once scanned the image appears in a new Photoshop document named Untitled. Save this straightaway, because if the computer crashes you'll lose the file and will have to scan again.

Type tool

Photoshop 6.0's Type tool continues to improve making it even easier for designers to create stunning text treatments. As well as being able to call from the system's usual font size, color and styles you can create type with selection borders using the Type Mask tool and fill with

images or textures. Version 6.0 offers vector-based type that you can increase in size without any jaggedness. This also offers more control so you can distort and bend the text alone or around objects.

Photoshop 5.5 and 6.0 offered four Anti-alias options (None (off), Crisp, Strong and Smooth) rather than just on or off that you had in Photoshop 5.0's palette. The options have been joined by Sharp in version 7.0 and all five are accessed from the pull down menu. To indicate what difference you would see on a text curve I've magnified the top right of an elongated letter S. Left to right: None, Sharp, Crisp, Strong and Smooth.

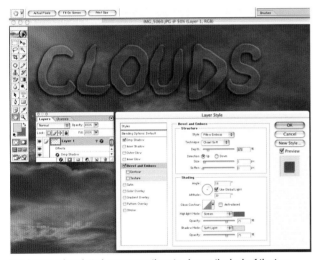

The Layer style palette has many options to change the look of the type. Here I've selected pillar Emboss using yellow and blue shading.

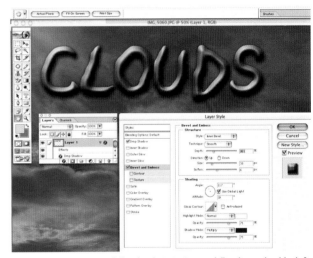

Inner bevel gives a more defined style to text, especially when using black & white shading.

Type can be bent and shaped in any direction. First select a style and then drag the sliders to warp the text. Here I've illustrated Flag (left) and Arch (middle). You can then add a style (right).

If you are using the Type tool to add a paragraph of text use the Bounding box option. With the Type tool selected click on the point where you want the text to start, hold the mouse down and drag. This creates a box that can be formatted to ensure the text appears as you prefer. You can change Character and Paragraph formatting.

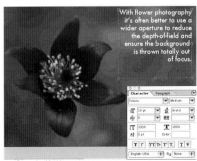

With flower photography it's often better to use a wider aperture to reduce the depth-of-field and ensure the background is thrown totally out of focus.

Tritones

MENU **IMAGE →** Part of the Duotones series using various
 MODE → color schemes from the presets folder in
 DUOTONE the Photoshop folder. The image first needs
to be in grayscale before it can be converted to a Duotone.
Here are a few examples of an image that started life as a color
photo taken on a Coolpix 995 digital camera. The image was
layered with a diffuse glow version, flattened and converted to
grayscale before it became a duotone/tritone.
(See Duotones and Quadtones)

t

u

abcdefghijklmnopqrst**u**vwxyz

Undo
Use all Layers
Unsharp Mask

Undo

MENU	**EDIT →**
	UNDO
QUICK KEYS	**CTRL+Z**

If you don't like the effect of a filter you've just applied, or you've gone wrong with a brushstroke you can use Undo to take you back one step. Edit→Step Forward/Step Backwards makes life even easier. It's like the History palette but uses shortcut keys to speed things up. Whatever you do can be simply undone. **(For multiple undos see History palette)**

Tip

● Use Undo to revert to a previous setting when making adjustments to palette settings that have several options.

Use all Layers

Select this mode in the Rubber Stamp, Paint bucket or Sharpness/Blur/Smudge palettes to ensure the color of all layers are merged to affect the active layer when the effect is applied. When Use all Layers is not selected only the colors in the active layer are sampled, cloned or smudged.

Here's a sort of space age pic, well that's what I'll pass it off as. It's just two bits of metal with a close-up of a light bulb thrown together for the purpose of this illustration. A Clone sample was taken from the bottom left of the light bulb and I cloned across the image to the left and above the light bulb using the Vivid Light

Blend mode. Left is a result of just the one layer cloned. Doing the same with the Use all Layers box checked shows it picks up the background bulb layer and repeats that too.

Unsharp Mask

MENU	FILTER →
	SHARPEN →
	UNSHARP MASK

A filter used to sharpen edges in an image and reduce blurring caused at the photographic, scanning, resampling, or printing stage. Unsharp Mask locates pixels that differ from neighbouring pixels and increases their contrast. It's perfect for sharpening pictures that are taken with digital cameras and scanned images that often have a slightly soft edge sharpness.

The dialogue box has Amount, Radius and Threshold settings that are adjusted by dragging sliders or manually entering values.

Amount changes the pixel contrast by the amount you set. When producing images for on-screen viewing you can judge the effect quite accurately and a setting of 50-100% is fine, but for printed output it's not as easy. Try a setting of 150% to 200%.

Radius controls the number of pixels surrounding the edge pixels that will be affected by sharpening. A lower value sharpens just edge pixels while a higher value sharpens a wider band of pixels. The amount you set also depends on the size of the image – use a smaller number for a lower resolution image and increase the number for a higher resolution image. Go too high and the edges become too contrasty.

Threshold, set at a default of 0, sharpens all the pixels. Moving the slider upwards prevents the filter from affecting pixels that are similar to neighbouring pixels. A value of between 2 and 20 is a good starting point. The higher you go the less effect Unsharp Mask will have on the image.

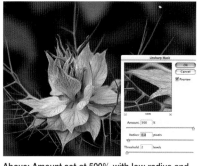

Above: Amount set at 500% with low radius and threshold values is acceptable.

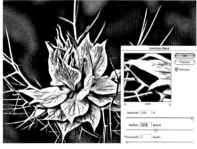

Above: Increase the radius and the result is too harsh with extreme contrast on all edges.

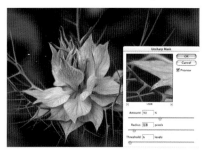

Above: Reducing the Amount and Radius and increasing threshold produces a better result. Below: Applying Unsharp mask to the lightness layer of the image in Lab color mode is best.

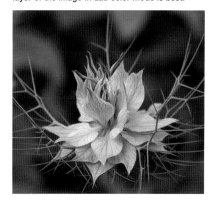

Above left: Magnified section of original shot on a Nikon Coolpix 995. Above right: Same shot with Unsharp Mask applied in Lab color's lightness channel.

Tips

● Bright colors can become overly saturated when Unsharp Mask has been applied and dust marks are easily enhanced. Try converting the image to Lab mode and apply the filter to the Lightness channel only to sharpen the image without affecting the color.
● Run Unsharp Mask twice at half the single settings for a more subtle effect.
● Hold down the Shift key and click within the preview window to show the original unfiltered version.

V–Z

Variations

MENU **IMAGE →**

 ADJUSTMENTS →

 VARIATIONS

This color balance control, which also lets you adjust image contrast and brightness, is the most colorful window of all the Photoshop dialogue boxes with its series of preview images.

The original selection and the adjusted selection appear at the top.

The menu appears at their side and from here you select Shadows, Midtones, or Highlights to adjust dark, middle or light areas.

Set the Fine/Coarse slider to control the amount of adjustment.

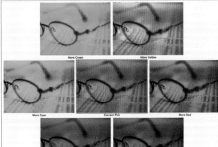 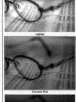

Seven pictures appear with the current example in the centre and the color options around the edges.
 To add a color to the image, click the appropriate color image and to subtract a color, click the image on the opposite side.

These three preview images are used to adjust image brightness. The centre is the current version, the one above makes the centre lighter and the one below makes it darker.

Vivid light
(See Blending modes)

Watercolor filter
(See Artistic filters)

Whoops

● If the Variations command is missing from the Adjust submenu check that the Variations plug-in module has been installed.

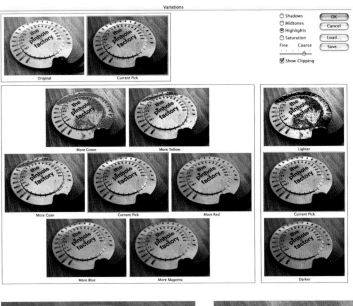

Turn Show Clipping on to display a preview of channels that have been clipped as a result of your adjustment. The neon color indicates the affected channel or channels. In this example if you clicked on darker the clipping would disappear.

Watermarks

MENU FILTER →
 DIGIMARC →
 EMBED WATERMARK

Adding a watermark to your image is a safe way of protecting the copyright. Digimarc embeds a digital watermark to the image. It's imperceptible to the human eye but is durable in digital and printed forms and will survive typical image edits and file format conversions. A © symbol appears by the title to warn any viewers that the copyright should be respected. To use this feature you have to register with Digimarc and receive a special ID number.

© Greysquirrel.JPG @ 50% (RGB)

Left: The original photograph of a brass calculator dial was photographed using window light and lost the lovely yellow color. Variations enabled me to bring this back to something like the original item. It's easy to use and you can see instantly which way to go to ensure better results. By careful control of lighten and darken I could ensure that the highlights didn't get clipped while adjusting color.

Web colors

When using pictures on the Web there are a limited number of colors that can be selected when writing HTML code. Photoshop versions back to 5.5 let you select the Web palette from the Color Picker and when you pick a color, the HTML reference code appears for the selected color. The bright red color I picked here has an HTML code of FF0066.

Wet edges

An option in the Brush palette that produces a brushstroke with a build-up of color on the edges to simulate a watercolor paintbrush effect.

Web Photo Gallery

MENU FILE →
 AUTOMATE →
 WEB PHOTO GALLERY

It's never been easier to get your pictures on-line with this new feature, introduced first in Photoshop version 5.5. This auto mode converts your pictures into Web manageable sizes, then writes some HTML code so that they appear as thumbnails on an opening index page. Clicking on an individual picture brings up a full screen version. The code includes arrows to navigate backwards or forwards through the gallery.

All the HTML pages, pictures and thumbnails are stored in the destination folder.

Various menu options let you set up this feature so that it creates the ideal Web page and style for you. You can select the number of images shown per page, the layout, text colour and size, along with image quality, destination folder and even add links.

Opening up the main page in this basic design template gives a thumbnail index of all the pictures on the site. Click on the arrow at the top of the page to navigate backwards and forwards through the pages.

The palette has options to generate the pictures at various sizes. The site will work quicker when small files are selected, but image quality will be poorer.

In this design the thumbnails disappear when you click on one to bring up a larger version.

Click on a thumbnail on the left to bring up a single image on a page. If you have a Web editing program you can customize the text and position.

And in this version the thumbnails stay on the bottom strip when a larger version is displayed.

Workgroup

New to version 7.0 and more for design agencies and project groups working remotely than individuals using a home computer. By using a secure server on the Internet you access your stored files and download and upload from there. A user can lock the file when he takes it to prevent two working on the same file at once.

Workspace

Great new feature with version 7.0 that lets you save the screen position of the Toolbar and palettes for a tidier desktop.

ZigZag filter
(See Distort filters)

Zoom tool

QUICK KEYS SHIFT+Z

Used to magnify or reduce the image on screen. The zoom options palette has one choice – resize windows to fit. When selected the window grows or contracts with the image.

When PC users click on the right-hand mouse key with the Zoom tool selected you're greeted with a new menu to fit to screen, view at 100% or print size. You can also select zoom in and zoom out from here. If you hold the Alt key down and click on the mouse the image will zoom out. **(See Navigator palette)**

Zoom set to 100%.

Zoom set to maximum 1600%.

● You don't have to call up the Zoom tool to change magnification. Go to the image size box in the bottom left corner of your picture and manually key in a percentage to change the size.
● Click and hold down the mouse at the top left of the area you want to magnify and drag to the bottom right. The image will then magnify to include just the selected area.

ZoomView

MENU FILE →
 EXPORT →
 ZOOM VIEW

Version 7.0 shows Adobe teaming up with Viewpoint to offer direct connection to the ZoomView Portal to help you display high resolution images on the Web.

ZoomView is a technology that overcomes bandwidth constraints by dividing high resolution images into bite-size tiles. As a viewer zooms into the image, more and more detailed tiles are transmitted and displayed. This allows your viewer to zoom in on detail at high resolutions using the free Viewpoint Media Player.

To publish ZoomView on a Web site you need a Viewpoint Licence Agreement which removes a VIEWPOINT watermark that is displayed in front of all non-licensed images that are displayed with the Viewpoint Media Player.

Registered Photoshop users are entitled to a free Viewpoint licence for non-commercial hobbyist purposes, such as showcasing a portfolio.

Index

Index

Appendix A: Photoshop versions compared

Every time Adobe update Photoshop, users ask whether it's worth upgrading. Often there are only a few changes, but they're usually 'must haves', making it hard not to want to upgrade. Throughout this book I've illustrated features that come with Photoshop 7.0, but many of these came with previous versions. If you have an earlier version or a light edition (LE), use this chart to see whether the feature is available on your copy.

I've also included the recent addition to Adobe's portfolio, Elements (Ele), which is like a light version of Photoshop, with some new, easier, automated modes, making it more accessible for beginners.

Photoshop feature changes	v3.0	v4.0	v5.0	LE	v5.5	v6.0	Ele	v7.0
Tools								
Annotation tools						☺		☺
Art History Brush					☺	☺		☺
Background & Magic Eraser					☺	☺	☺	☺
Crop tool with transform feature						☺		☺
Healing brush								☺
Measuring tool			☺		☺	☺		☺
Magnetic Lasso			☺	☺	☺	☺	☺	☺
Magnetic Pen			☺		☺	☺		☺
Painting tools	☺	☺	☺	☺	☺	☺	☺	☺
Patch tool								☺
Retouching tools	☺	☺	☺	☺	☺	☺	☺	☺
Text tools	☺	☺	☺	☺	☺	☺	☺	☺
Vector shape and text support						☺		☺
Web support								
Import/export GIF, JPEG and PNG files				☺	☺	☺	☺	☺
ImageReady					v2.0	v3.0		v7.0
Image slicing						☺		☺
Save for Web						☺	☺	☺
Web palette		☺	☺	☺	☺	☺	☺	☺
Export to ZoomView								☺

Photoshop feature changes	v3.0	v4.0	v5.0	LE	v5.5	v6.0	Ele	v7.0
Creative features								
3D Transform plug-in			☺		☺	☺	☺	☺
Adjustment Layers		☺	☺		☺	☺	☺	☺
Auto Shadow, Bevel, Glow			☺		☺	☺	☺	☺
Channel editing			☺		☺	☺		☺
Color correction controls	☺	☺	☺	☺	☺	☺	ltd.	☺
Color Range command	☺	☺	☺		☺	☺		☺
Extract Image command					☺	☺		☺
Layers	☺	☺	☺	☺	☺	☺	☺	☺
Layer alignment and layer effects			☺		☺	☺		☺
Layer sets						☺		☺
Layer styles						☺	☺	☺
Liquify						☺	☺	☺
Number of special effects filters	42+	90+		95+	95+	95+	99+	95+
Paths	☺	☺	☺		☺	☺		☺
Pattern maker								☺
Functionality								
Auto editing using the Actions palette		☺	☺		☺	☺		☺
Batch processing		☺	☺		☺	☺	ltd.	☺
Contact sheet			☺		☺	☺	☺	☺
Digital Watermark		☺	☺		☺	☺		☺
File browser							☺	☺
Guides & Grids for precise alignment		☺	☺		☺	☺	☺	☺
History palette for multiple undo			☺		☺	☺	☺	☺
Navigator		☺	☺	☺	☺	☺		☺
Open recent						☺	☺	☺
Palette well							☺	☺
Picture package						☺	☺	☺
Preset manager						☺	☺	☺
Spot color channels			☺		☺	☺		☺
Color support								
CMYK, Lab, Duotone and Multichannel	☺	☺	☺		☺	☺		☺
Color management and color sample			☺		☺	☺	☺	☺
Color separations	☺	☺	☺		☺	☺		☺
RGB, Indexed Color and Grayscale	☺	☺	☺	☺	☺	☺	☺	☺
Compatibility								
CMYK, Illustrator, PostScript and Acrobat Import	☺	☺	☺		☺	☺		☺
Exports paths to Illustrator	☺	☺	☺		☺	☺		☺
Print preview and soft proofing						☺		☺
Enhanced Tiff								☺

Appendix B: Typefaces

Your computer will, no doubt, come preloaded with a selection of typefaces, known as fonts. These can be accessed from Photoshop's Type tool and used in many ways with your images.

One option is to make postcards or greetings cards and use the type as the main message. You could also use the type to caption pictures, or as a supplement to a creative image, faded back as a layer.

The main thing to consider is the font you use. A modern face used on a sepia toned collage will look out of place. This book is created using Helvetica Neue and here's a selection of other fonts that you're likely to have access to. They are all set in 12 point. Select with care!

Two of the safest fonts to use on the Web are Arial and Verdana because all PC and Mac computers will have these two installed which means your viewers will see what you intended. If you use a font that your viewer doesn't have installed on their computer, it will select a substitute and your page may then look badly designed.

Before we look at the sets. Here's some you can use to add impact to your pages. Webdings and Zapf Dingbats create icons instead of letters. A to N are displayed here:

Photoshop A to Z in Abadi Condensed

Photoshop A to Z in Apple Chancery

Photoshop A to Z in Arial

PHOTOSHOP A TO Z IN BALLOON D

Photoshop A to Z in Basilia Regular

Photoshop A to Z in Baskerville

Photoshop A to Z in Bauhaus 93

Photoshop A to Z in Bell MT

PHOTOSHOP A TO Z IN BERMUDA

Photoshop A to Z in Bernard Condensed

Photoshop A to Z in Blacklight

Photoshop A to Z in Book Antiqua

Photoshop A to Z in Bookman Old

Photoshop A to Z in Britannic Bold

Photoshop A to Z in Brush Script MT

Photoshop A to Z in Calisto MT

PHOTOSHOP A TO Z IN CAPITAL REG

Photoshop A to Z in Century Gothic

Photoshop A to Z in Century Schoolbook

Photoshop A to Z in Charcoal

Photoshop A to Z in Chicago

Photoshop A to Z in Comic Sans

Photoshop A to Z in Cooper Black

PHOTOSHOP A TO Z IN COPPER PLATE

PHOTOSHOP A TO Z IN CUTOUT

Photoshop A to Z in Courier

PHOTOSHOP A TO Z IN DESDEMONA

Photoshop A to Z in Edwardian Script

Photoshop A to Z in Eurostile

Photoshop A to Z in Folio T

Photoshop A to Z in Footlight

Photoshop A to Z in Futura Bold

Photoshop A to Z in Futura Light

Photoshop A to Z in Gadget Regular

Photoshop A to Z in Garamond

Photoshop A to Z in Geneva

Photoshop A to Z in Georgia

Photoshop A to Z in Giddyup

Photoshop A to Z in Gill Sans

Photoshop A to Z in Gloucester

Photoshop A to Z in Goudy Old Style

Photoshop A to Z in Harrington

Photoshop A to Z in Helvetica

Photoshop A to Z in Helvetica Neue 65

Photoshop A to Z in Impact

Photoshop A to Z in Imprint

Photoshop A to Z in Kino MT

Photoshop A to Z in Letter Gothic

Photoshop A to Z in Lucinda Blackletter

Photoshop A to Z in Lucinda Bright

Photoshop A to Z in Matura Script

Photoshop A to Z in Metropolis

Photoshop A to Z in Micrograma

Photoshop A to Z in Minion Web

Photoshop A to Z in Mistral

Photoshop A to Z in Modern

PHOTOSHOP A TO Z IN MOJO

Photoshop A to Z in Monaco

Photoshop A to Z in Mono Corsiva

Photoshop A to Z in Myriad

Photoshop A to Z in New York

Photoshop A to Z in News Gothic

PHOTOSHOP A TO Z IN NYX

Photoshop A to Z in Onyx

PHOTOSHOP A TO Z IN OUCH

Photoshop A to Z in Palatino

Photoshop A to Z in Playbill

Photoshop A to Z in Pompeia

Photoshop A to Z in Postino

PHOTOSHOP A TO Z IN PERPETUA

Photoshop A to Z in Rockwell

Photoshop A to Z in Sand Regular

Photoshop A to Z in Shuriken Boy

Photoshop A to Z in Springfield

Photoshop A to Z in Spumoni

PHOTOSHOP A TO Z IN STENCIL

Photoshop A to Z in Tahoma

Photoshop A to Z in Textile

Photoshop A to Z in Times

Photoshop A to Z in Trade Gothic

Photoshop A to Z in Trebuchet MS

Photoshop A to Z in Verdana

Photoshop A to Z in Vladimir Serol

Photoshop A to Z in Windsor Regular

Photoshop A to Z in Xerox Sans Serif Narrow

Appendix C: Useful shortcuts

TOOLBAR
All of the tools in Photoshop's toolbar can be accessed using shortcut keys. Hold down the Alt + shortcut key to scroll through multiple options.

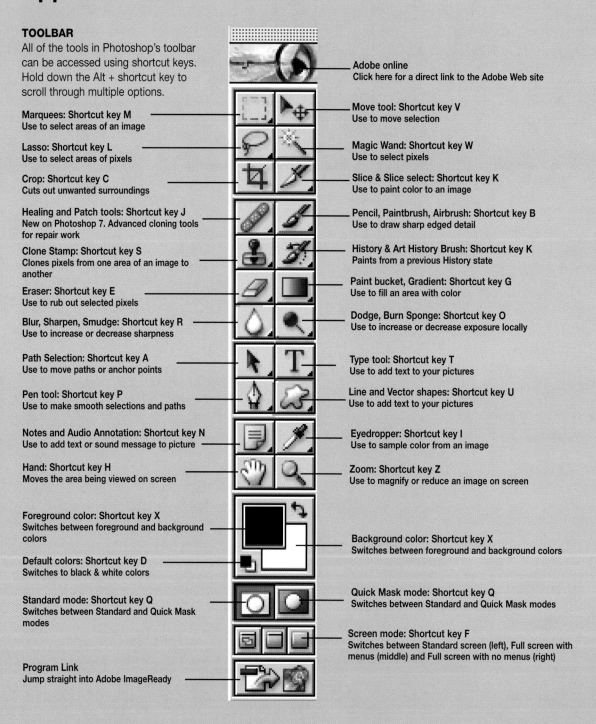

Adobe online
Click here for a direct link to the Adobe Web site

Marquees: Shortcut key M
Use to select areas of an image

Move tool: Shortcut key V
Use to move selection

Lasso: Shortcut key L
Use to select areas of pixels

Magic Wand: Shortcut key W
Use to select pixels

Crop: Shortcut key C
Cuts out unwanted surroundings

Slice & Slice select: Shortcut key K
Use to paint color to an image

Healing and Patch tools: Shortcut key J
New on Photoshop 7. Advanced cloning tools for repair work

Pencil, Paintbrush, Airbrush: Shortcut key B
Use to draw sharp edged detail

Clone Stamp: Shortcut key S
Clones pixels from one area of an image to another

History & Art History Brush: Shortcut key K
Paints from a previous History state

Eraser: Shortcut key E
Use to rub out selected pixels

Paint bucket, Gradient: Shortcut key G
Use to fill an area with color

Blur, Sharpen, Smudge: Shortcut key R
Use to increase or decrease sharpness

Dodge, Burn Sponge: Shortcut key O
Use to increase or decrease exposure locally

Path Selection: Shortcut key A
Use to move paths or anchor points

Type tool: Shortcut key T
Use to add text to your pictures

Pen tool: Shortcut key P
Use to make smooth selections and paths

Line and Vector shapes: Shortcut key U
Use to add text to your pictures

Notes and Audio Annotation: Shortcut key N
Use to add text or sound message to picture

Eyedropper: Shortcut key I
Use to sample color from an image

Hand: Shortcut key H
Moves the area being viewed on screen

Zoom: Shortcut key Z
Use to magnify or reduce an image on screen

Foreground color: Shortcut key X
Switches between foreground and background colors

Background color: Shortcut key X
Switches between foreground and background colors

Default colors: Shortcut key D
Switches to black & white colors

Standard mode: Shortcut key Q
Switches between Standard and Quick Mask modes

Quick Mask mode: Shortcut key Q
Switches between Standard and Quick Mask modes

Screen mode: Shortcut key F
Switches between Standard screen (left), Full screen with menus (middle) and Full screen with no menus (right)

Program Link
Jump straight into Adobe ImageReady

BLEND MODES

All the Blend modes have shortcuts. Hold down the Shift key + Alt with the corresponding letters below. Items in red are new to Photoshop 7.0.

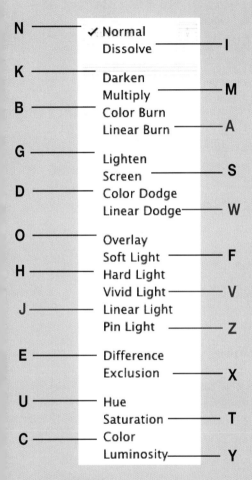

- N — ✓ Normal
- Dissolve — I
- K — Darken
- Multiply — M
- B — Color Burn
- Linear Burn — A
- G — Lighten
- Screen — S
- D — Color Dodge
- Linear Dodge — W
- O — Overlay
- Soft Light — F
- H — Hard Light
- Vivid Light — V
- J — Linear Light
- Pin Light — Z
- E — Difference
- Exclusion — X
- U — Hue
- Saturation — T
- C — Color
- Luminosity — Y

PALETTE VIEWS

The Tab key shows or hides all palettes.

Shift + Tab keys show or hide all but the toolbox.

PALETTES

Keeping your desktop clear of junk is essential for clean working, especially if you have a smaller monitor. Palettes are one of the biggest culprits for clogging up space. Fortunately F keys will open and close palettes with ease.

F5 shows or hides **Brush palette** on version 5.5 and before. Shows brush presets on version 7.0.

Color palette
F6 shows or hides it.

Layers palette
F7 shows or hides it.

Info palette
F8 shows or hides it.

Actions palette
F9 shows or hides it.

IMAGE HANDLING

Open Image: Command(Mac)/Ctrl(PC)+O
Browse: Command(Mac)/Ctrl(PC)+Shift+O
New Canvas: Command(Mac)/Ctrl(PC)+N
Save Image: Command(Mac)/Ctrl(PC)+S
Save As: Command(Mac)/Ctrl(PC)+Shift+S
Close Image: Command(Mac)/Ctrl(PC)+W

Print with preview: Command(Mac)/Ctrl(PC)+P

Undo: Command(Mac)/Ctrl(PC)+Z
Cut: Command(Mac)/Ctrl(PC)+X
Copy: Command(Mac)/Ctrl(PC)+C
Paste: Command(Mac)/Ctrl(PC)+V

MOVING SELECTIONS

Use the Move tool and the up, down, left and right arrows to move the selection one pixel at a time.

Hold down the Shift key when using the arrows to move the selection 10 pixels at a time.

EXTRACT MODE

The Extract toolbox of Photoshop 7.0 has the following quick keys.

- B
- G
- E
- I
- C
- T
- Z
- H

COMMON KEYBOARD SYMBOLS

Several keys are mentioned regularly in this book to use as shortcuts and as most readers will be PC owners I've mentioned the PC versions. Below are Mac equivalents with symbols to help you identify these on the keyboard.

⇧ Shift key is same on both systems

PC Enter key is Return key on a Mac

PC Ctrl key is Command key on Mac or ⌥

PC Alt key is Option key on Mac or ⌘

Appendix D: Preferences

Use these for setting up Photoshop to run just as you want it. The palette has several submenus that can be scrolled down by using the up and down arrows. Before you first use Photoshop it's worth becoming familiar with the options and setting up the program to run smoother by turning off options you won't need. Go to the Edit menu and then Preferences and choose General to see the palette below. Mac OSX users will find the item under the Photoshop menu, not the Edit menu.

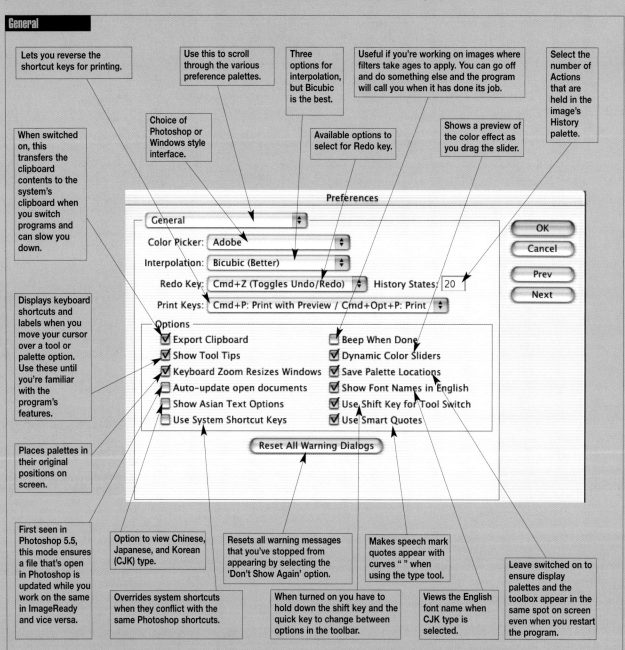

General

Lets you reverse the shortcut keys for printing.

Use this to scroll through the various preference palettes.

Three options for interpolation, but Bicubic is the best.

Useful if you're working on images where filters take ages to apply. You can go off and do something else and the program will call you when it has done its job.

Select the number of Actions that are held in the image's History palette.

Choice of Photoshop or Windows style interface.

Available options to select for Redo key.

Shows a preview of the color effect as you drag the slider.

When switched on, this transfers the clipboard contents to the system's clipboard when you switch programs and can slow you down.

Displays keyboard shortcuts and labels when you move your cursor over a tool or palette option. Use these until you're familiar with the program's features.

Places palettes in their original positions on screen.

First seen in Photoshop 5.5, this mode ensures a file that's open in Photoshop is updated while you work on the same in ImageReady and vice versa.

Option to view Chinese, Japanese, and Korean (CJK) type.

Overrides system shortcuts when they conflict with the same Photoshop shortcuts.

Resets all warning messages that you've stopped from appearing by selecting the 'Don't Show Again' option.

When turned on you have to hold down the shift key and the quick key to change between options in the toolbar.

Makes speech mark quotes appear with curves " " when using the type tool.

Views the English font name when CJK type is selected.

Leave switched on to ensure display palettes and the toolbox appear in the same spot on screen even when you restart the program.

Preferences

General

Color Picker: Adobe

Interpolation: Bicubic (Better)

Redo Key: Cmd+Z (Toggles Undo/Redo) History States: 20

Print Keys: Cmd+P: Print with Preview / Cmd+Opt+P: Print

Options

☑ Export Clipboard
☑ Show Tool Tips
☑ Keyboard Zoom Resizes Windows
☐ Auto-update open documents
☐ Show Asian Text Options
☐ Use System Shortcut Keys

☐ Beep When Done
☑ Dynamic Color Sliders
☑ Save Palette Locations
☑ Show Font Names in English
☑ Use Shift Key for Tool Switch
☑ Use Smart Quotes

Reset All Warning Dialogs

OK
Cancel
Prev
Next

File Handling

Never save: Saves files without previews. **Always save:** Saves files with previews. **Ask when saving:** Saves previews on individual file basis.

Automatically adds a three letter file description to the end of newly saved files so they can be read by Windows programs on a PC.

Ensures the file is fully compatible with earlier versions of Photoshop but it makes the file size larger.

Lists specified number of images previously worked on for quick recall from File→Open recent.

Use Lower Case adds a file extension using lower case characters (.jpg). When unchecked it adds one using upper case characters (.JPG).

New feature on version 7.0 that allows other network users, or workgroups, to access files from a server (central shared computer).

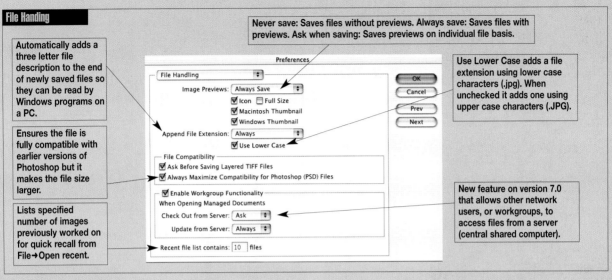

Preferences

File Handling

Image Previews: Always Save
- ☑ Icon ☐ Full Size
- ☑ Macintosh Thumbnail
- ☑ Windows Thumbnail

Append File Extension: Always
- ☑ Use Lower Case

File Compatibility
- ☑ Ask Before Saving Layered TIFF Files
- ☑ Always Maximize Compatibility for Photoshop (PSD) Files

☑ Enable Workgroup Functionality
When Opening Managed Documents
Check Out from Server: Ask
Update from Server: Always

Recent file list contains: 10 files

OK / Cancel / Prev / Next

Memory & Image Cache

Increases the speed that a histogram appears by producing it from the cached sample. The preview won't be as good, though.

Increase this to work faster on large files, providing you have enough RAM available for it to run smoothly.

Lets you preset how much RAM Photoshop can access from your computer's available memory.

Preferences

Memory & Image Cache

Cache Settings
Cache Levels: 4
☐ Use cache for histograms

Memory Usage
Available RAM: 223MB
Maximum Used by Photoshop: 50 % = 111MB

Note: Changes will take effect the next time you start Photoshop.

OK / Cancel / Prev / Next

Units & Rulers

Change the measurement scale used on the ruler from this box.

Size images up to fit in the columns of a newspaper or magazine.

Change the type measurements from points to pixels to mm.

Preset values of resolution that will appear when you create a new document. Setting 300ppi for print and 72ppi for screen resolution will produce suitable ppi files.

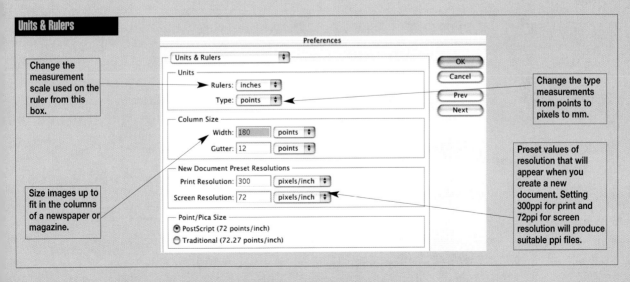

Preferences

Units & Rulers

Units
Rulers: inches
Type: points

Column Size
Width: 180 points
Gutter: 12 points

New Document Preset Resolutions
Print Resolution: 300 pixels/inch
Screen Resolution: 72 pixels/inch

Point/Pica Size
◉ PostScript (72 points/inch)
◯ Traditional (72.27 points/inch)

OK / Cancel / Prev / Next

Appendix D: Preferences

Continued.

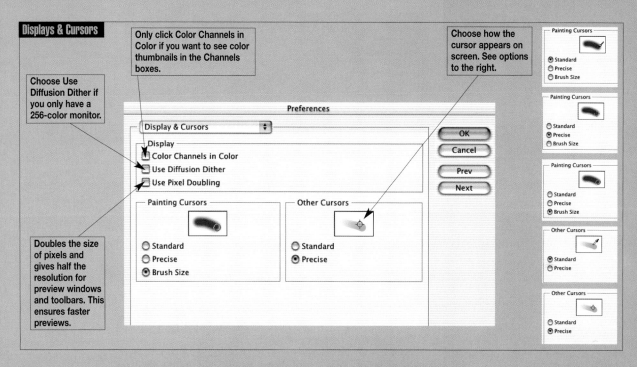

Only click Color Channels in Color if you want to see color thumbnails in the Channels boxes.

Choose how the cursor appears on screen. See options to the right.

Choose Use Diffusion Dither if you only have a 256-color monitor.

Doubles the size of pixels and gives half the resolution for preview windows and toolbars. This ensures faster previews.

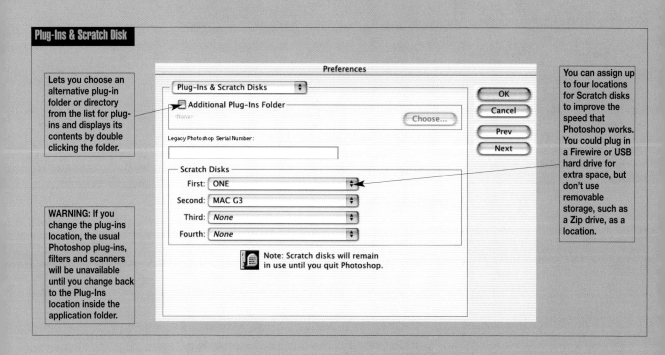

Lets you choose an alternative plug-in folder or directory from the list for plug-ins and displays its contents by double clicking the folder.

WARNING: If you change the plug-ins location, the usual Photoshop plug-ins, filters and scanners will be unavailable until you change back to the Plug-Ins location inside the application folder.

You can assign up to four locations for Scratch disks to improve the speed that Photoshop works. You could plug in a Firewire or USB hard drive for extra space, but don't use removable storage, such as a Zip drive, as a location.

Grid Colors lets you pick a gray pattern or a color.

The transparent areas of a document appear as a checkerboard pattern that can be varied in size. Choose None and the transparent areas in the layer will appear white.

The color and size of grid you select are displayed in the preview window

Use Video Alpha should only be checked if you have hardware with a chroma key facility.

Shows when colors in an RGB image won't print out correctly. Select a color by clicking on the square in this palette and any colors in your image that are out of the printer's gamut will appear covered with this warning color.

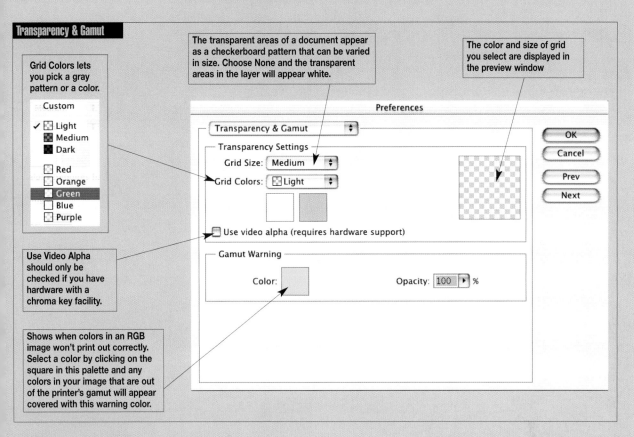

Pick a color for guides or the grid from the pre-selected range or from the Color palette. Choose one that will be seen above your images, such as bright yellow.

Choose straight lines or dashes for guides and grids.

Adjust the grid spacing by entering an amount in this box.

Enter an amount to subdivide the grid.

New to version 7.0 allowing slice line color and number of slice to appear.

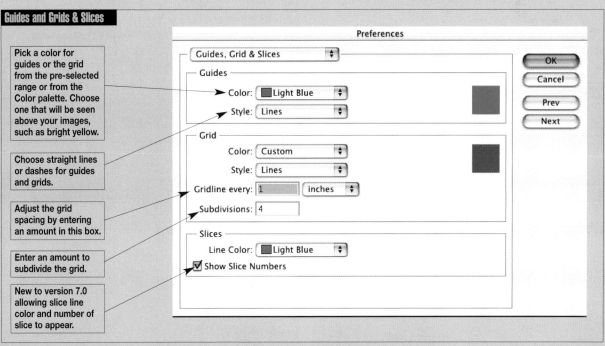

Appendix E: Useful Web sites

Adobe

<www.adobe.com/products/photoshop/main.html>

A slick design, as you'd expect from the masters of imaging software. The home page guides you to several areas including support and products. It's the Expert Centre where the action is. You have to register first and then you gain access to a stunning collection of material with lots of tips and tutorial pages, plus downloads and a training resource.

Barry Beckham

<www.bbdigital.co.uk>

Barry is one of the most enthusiastic digital photographers in the UK and although he's an amateur his work puts shame to many professionals. This site has 47 galleries of pictures with great examples of digital photography and manipulation. There are also loads of Photoshop tutorials and reviews.

PC Resources for Photoshop

<showcase.netins.net/web/wolf359/plugcomm.htm>

Stunning, that's the only word needed to describe this site – a veritable bonanza of interesting goodies for Photoshop owners. Nicely designed and crammed with useful stuff, including dozens of collections of filter effects by Andrew Buckle. Go here first.

Martin Evening

<www.evening.demon.co.uk/articles.html>

Martin is a professional photographer and Photoshop user. The site offers free PDF downloads of several Photoshop tutorials and examples of his work shooting fashion models for London hairdressing salons. Great inspiration and beautiful models There's also a plug for his book Adobe *Photoshop 7.0 for Photographers*.

Rice Information Technology

<www.rice.edu/Computer/Tutorials/ravl/pshop/>

A now dated site with loads of useful Photoshop material supplied by the Rice University, Houston Texax. It's based around Photoshop 3.0 but most of the info can be applied to newer versions of Photoshop.The layout is visually very basic but if you need to know about file formats, importing, editing, manipulating or printing, take a trip through this site.

The Plug Page

<www.boxtopsoft.com/plugpage/>

Go here to find interesting plug-ins to download and expand the flexibility of Photoshop. It's a dull looking site but you'll find some useful stuff.

Alien Skin

From the makers of Photoshop plug-ins, Xenofex and Eye Candy, along with the recently introduced Splat. You can download trials, read about features, see the effects the programs create or buy full versions.

Photoshop Cafe

A fussy designed site, but there's plenty to find of use. The sections are split into tutorials, tips, actions links, books, forum and gallery. Amongst the pages are some fantastic graphical tutorials and the guitar in this screengrab, would you believe, was created from scratch. More focused on the graphic design than photography but very useful if you want to learn more.

The Digital Dog

<www.digitaldog.net/tips.html>

The Digital Dog is Andrew Rodney, an authorized Photoshop trainer from the US who shares lots of information with us providing we don't mind downloading PDF files. The page illustrated has various PDF files that look at color management and various articles on scanners and digital cameras.

ePHOTOzine

<www.ephotozine.com>

I couldn't go without dropping a plug for my own Web site. This will suit photographers of all types. Digital photographers can pick up reviews of equipment, download Photoshop tutorials and check out the work of other digital image makers. It's crammed to the brim with useful stuff.

Adobe Photoshop Web reference

<www.adscape.com/eyedesign/photoshop/>

A very good reference site that has plenty of Photoshop info, but only on versions 3.0 and 4.0. Fortunately many of the features are available on the latest releases so it's well worth a visit.

There's a good section on Actions, palettes, shortcuts and Layers. And the section on filters shows an image change to the effect you select as you click on the filter.

Intangible

<www.intangible.org/Features/mcintyre/mcicontents.html>

I first came across Catherine's work while working on *Digital PhotoFX* magazine. Catherine sent in a portfolio of what I still think is some of the most beautiful images I've seen. The work combines the naked body with found objects on multiple Photoshop layers.

Catherine has since gone on to produce a book and more superb work using old photographs, animal skeletons and such like. This site is a great introduction to her imagery with an extremely well presented layout. Go here for inspiration.

Appendix E: Useful Web sites
Continued.

Planet Photoshop

`<www.planetphotoshop.com>`

A fast site to move around in, which is important when your time is precious. The menu items call up loads of great tutorials with lots of links and a mass of extremely useful tips, techniques and advice on all things Photoshop.

Human Software

`<www.humansoftware.com>`

Human Software is a site that makes and distributes software plug-ins and claims to have developed products that have been copied and used in recent graphic programs. The site has lots of interesting products, but no helpful tutorials or free downloads.

CoolType

`<webdeveloper.com/design/>`

If text is something you want to add to your pictures, go here for some, as the name suggests, cool effects. There are plenty of step-by-step techniques to help you improve the way text looks, including fire, bevels, charcoal and chalk.

Mccannas.com

`<www.mccannas.com>`

An odd site that offers loads of great tutorials, yet it looks like the designer of the site could do with reading a few of the tips. You are presented with a mishmash of styles, typefaces and layouts but it's worth putting up with for the large supply of great material within.

Sapphire Innovations

`<www.sapphire-innovations.com/>`

A large collection of patterns and effects that can be used as background layers or text fills. Some are crazy style some are more subtle... basically

something for every taste. Most of the plug-ins are for PCs. There are a few basic tutorials available too.

Xaos tools

`<www.xaostools.com/>`

Another site run by a software maker who produces Paint Alchemy and Terrazzo. The site gives overviews of the plug-in programs with examples of work, trial downloads and upgrades.

MyJanee

<www.myjanee.com/PSRL/tutfind.htm#photoart>

Very twee design, but the site includes a vast list of links that may be useful for Photoshop users and there are several step-by-step techniques and a gallery of pictures.

Apple

<www.apple.com/creative/resources/ttphotoshop/index.html>

One of the most useful sites for Photoshop movie tutorials with the work of Deke McLelland. Learn useful time saving shortcuts, how to use levels and much more in a very clearly spoken series of tutorials. Being part of the Apple site you first have to bypass the sales blurb and Deke also mentions Apple products a few times. This doesn't spoil the enjoyment though.

Boxtop Software

<www.boxtopsoft.com/ProJPEG/index.html>

Go here for a really fast and highly effective JPEG compressor. The plug-in can be downloaded from the site and costs $49.99. There are several other programs available for GIF compression and color optimization for the Web and a discounted pack of six can be bought in one go.

PS Workshop

<rainworld.com/psworkshop/>

Over 500 Photoshop tutorials covering everything from text to graphical effects. The tutorials are borrowed from other sites so it acts like a central resource. Nice idea and useful material.

The Plugin Site

Full of useful links to sites that offer plug-ins and a great selection of reviews with ratings of each product.

Trevor Morris

<user.fundy.net/morris/main.html>

Visit this site just to look at the superb design. Unlike most fancy designs that grind your PC to a halt, this one loads quickly. Trevor Morris is a graphic designer by trade so most of the material leans towards graphical effects with Photoshop, and there are some extremely interesting effects too.

Appendix F: Plug-in filters

Plug-ins offer additional features to the standard program. Photoshop supports third party filters that can be added to the plug-ins folder to increase the program's flexibility.

You can buy plug-ins such as Xaos Tools, Paint Alchemy, Kai's Power Tools, AutoFX Photo/Graphic Edges and Alien Skin's Eye Candy 4000. Others can be downloaded from the Web. Here's just a tiny selection of effects you can create.

AutoFX Photo/Graphic Edges is a useful plug-in that adds an edge to your image. The edges range from rough, ragged effects to elaborate designs. Some emulate the edges that you'd get using Polaroid – a technique that's often used by fashion photographers. AutoFX have recently revamped the interface (above right) making it fit in with their other new products DreamSuite and AutoEye. The three examples here include a typical soft edge (above right) a more encroaching ragged edge (right) and a modern artistic style (left). The program comes with hundreds more, plus patterns, frames and vignettes.

Alien Skin have an edge creating product in their new Splat software. Here's one example of an easy to create edge.

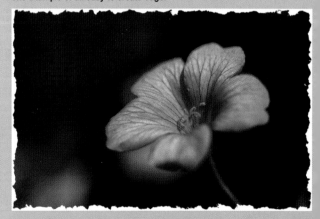

Corel took over Kai's Power Tools which was a great box of tricks and have added new effects over the last two versions and renamed it **KPT Effects**.

The interface is one of the most lively looking of all programs and offers excellent control over styles and effects. Material creator (above), Reaction (below) and Sky Creator (right).

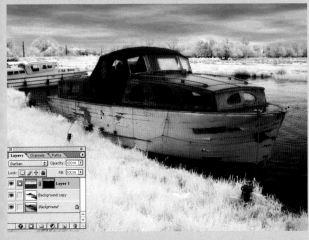

The Page Curl filter, from Kai's Power Tools 3, can be used for special effects in a presentation or brochure, but it may be too gimmicky for normal use.

Appendix F: Plug-in filters

Continued.

The Flaming Pear Web site has a range of downloads including these three sets of filters. From the top: Glitterato (a galaxy and space generator); Melancolytron (a color and softening tool); and Lunar Cell (a planet creator). The interface is based on a series of sliders that control the effects precisely.

A cloudy galaxy was created using Glitterato and this was blended with the Windmill image to create a misty, cloudscape.

Vivid Details Test Strip (below) is another program that's designed to make color correction easier. This one lets you change the color exposure and saturation in varying increments and view the results. You can also print out to check the effect your paper and printer will have. Use this for perfect results.

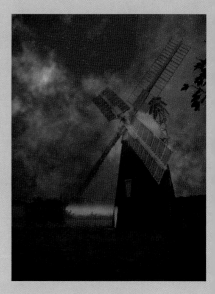

Alien Skin's Splat can be used to create tapestry style photos from your color originals. Here light pegs have replaced all color values in Patchwork mode.

Nik Color Efex Pro is a superb set of color effects filters that adds color and/or dreamy softness to pictures. It takes the Photoshop editing to a new level by adding some easy to apply graduated filters and color temperature filters, plus some crazy special effects.

Piccolo is not a plug-in, but it works alongside Photoshop. As well as being able to search through the contents of your computer's hard drive (PC only) and locate all the pictures, it also detects when a CD or memory card is inserted and automatically runs.

Folders that hold pictures appear in a directory window with a green icon next to them. If you click on a folder containing images the pictures are previewed in slide frames. Clicking on one brings up the individual image which can then be edited.

The print feature lets you print multiple pictures on one A4 sheet and change the size

and position within their areas on the sheet.

A Mac version of Piccolo is still in development, but the Mac brigade can opt for the Shareware programs QPict or ACDSee. Neither automatically detect a CD, but

both display pictures from folders. Click on a thumbnail to magnify it. Like Piccolo

you can print a contact sheet, but you can't resize pictures within the frames on QPict. It does have a very useful batch conversion process and creates Photoshop thumbnails.

All three are great programs if you want to view the results quickly before taking the best into Photoshop for serious editing. But Photoshop 7.0

users now have the File Browser that does a similar job.

Appendix F: Plug-in filters
Continued.

Xenofex, from Alien Skin, is a useful addition to the vast filter range provided with Photoshop. It has a collection of 16 additional filter effects that can be applied to your images. Ones that can be put to good use include Baked Earth (below) which gives a dry mud cracked appearance to an image and Lightning (right) that adds forks of lightning. Crumple gives a screwed up and reopened paper feel while Flag creates the wavy shape you'd see when a flag is blowing. The shot above is using the obvious Jigsaw puzzle filter. The pieces were then selected, cut and paste around the edge and a drop shadow was added.

This shot (right) is created using a clever filter called Stamper that repeats the image as thumbnails and colors them to make up a larger version of the image.

The Lightning filter can be used to create realistic streaks of lightning.

Alien Skin's Splat program was used here in Resurface mode where you can choose a texture or pattern and edit it to suit your photograph. This example was created using the weathered leather preset.

The Plastic and Marble effects are easy to produce using EyeCandy. Perfect for designers and Web Masters.

Weave adds a weave pattern over the image.

Above: Fur covers the picture in a fur-like pattern. Smoke and fire can be added to create a dramatic effect.

Above: Nik Sharpener Pro is useful if you need to sharpen pictures but don't want to mess up the picture through oversharpening. There are several sliding controls to help you match sharpness to the output device and size you intend to print to and view. AutoFX's Dreamsuite has several templates to make your photo look like it's a scanned film frame – 35mm came with Series 1 while roll film and 5x4in are available in series 2. Dreamsuite has loads of other useful filters including one to add digital sticky tape, along with a superb softening filter that lets you control the depth of focus (right).

Appendix G: Recording sheets

Use these to make notes of all your favourite filter settings.
Photocopy the sheets if you prefer not to mark this book

UNSHARP MASK

Photograph	Size	Amount	Radius	Threshold
Blue racing car	1280x960	123%	1.4	103

GAUSSIAN BLUR

Photograph	Size	Radius	Fade	Mode
Portrait of Katie	1760x1200	7.3 pixels	70%	Soft light

INNER & OUTER GLOW

Photograph	Mode	Color	Opacity	Noise	Technique	Spread	Size	Range	Jitter
Neon Text	Hard light	Green	75%	8%	Softer	4%	6px	50%	3%

BEVEL & EMBOSS

	Structure					Shading		Highlight			Shadow		
Photo	Style	Tech	Depth	Size	Soft	Angle	Altitude	Mode	Color	Opac	Mode	Color	Opac
Pencils	Inn.B	Sm	100%	5px	1px	30°	25°	Screen	Black	23°	Inner	Blue	23%

DUOTONES, TRITONES & QUADTONES

Photograph	Ink 1	Ink 2	Ink 3	Ink 4
Deeping village	Black	PANTONE 431 CVC	PANTONE 492 CVC	PANTONE 556 CVC

DROP SHADOW

Photograph	Mode	Color	Opacity	Angle	Global	Distance	Spread	Size	Noise
Web button	Multiply	Blue	75%	120°	On	5px	7%	8px	4%

FILTER MENUS

Photograph	Filter	Value 1	Value 2	Value 3	Value 4	Value 5
Portrait of Katie	Colored Pencil	4	8	25	n/a	n/a
Garden of delight	Underpaint	6	16	95%	4	top

LIGHTING EFFECTS

Photograph	Style	Light type	Intensity	Focus	Gloss	Material	Exposure
Stonehenge	*Crossing D*	*Omni*	*35*	*-23*	*39*	*-32*	*-23*

Ambiance	Texture channel	Height
-23	Red	88

HUE & SATURATION

Photograph	Hue	Saturation	Lightness
Robin	+27	-13	-8